THE MAN WHISTLER

The Man
WHISTLER

Hesketh Pearson

INTRODUCTION BY BENNY GREEN

TAPLINGER PUBLISHING COMPANY
NEW YORK

First published in the United States in 1978 by
TAPLINGER PUBLISHING CO., INC.
New York, New York

Library of Congress Catalog Card Number: 78-52949
ISBN 0-8008-5097-1

Printed in Great Britain

To
My Sisters
Elsie and Adèle

AUTHOR'S NOTE

The sources of everything noteworthy printed here for the first time are mentioned in the course of the narrative at the appropriate places.

CONTENTS

	List of Illustrations	ix
	Introduction	xi
I.	Adolescent	1
II.	Bohemian	10
III.	Bourgeois	20
IV.	Oriental	28
V.	Personal	39
VI.	Artistic	49
VII.	Temperamental	63
VIII.	Legal	78
IX.	Despotic	93
X.	Critical	113
XI.	Oratorical	126
XII.	Social	137
XIII.	Magisterial	156
XIV.	Mortal	174
	Authorities	191
	Index	193

LIST OF ILLUSTRATIONS
(between pages 106 & 107)

Whistler in the Seventies
(Radio Times Hulton Picture Library)

Algernon Charles Swinburne
(Radio Times Hulton Picture Library)

C. A. Howell by Mortimer Menpes
(British Museum)

Portrait of Swinburne by D. G. Rossetti
(Fitzwilliam Museum, Cambridge)

John Ruskin and Dante Gabriel Rossetti
(Radio Times Hulton Picture Library)

Harmony in Grey and Green (Cicely Alexander)
(The Tate Gallery, London)

The Little White Girl (Jo)
(The Tate Gallery, London)

Whistler giving evidence in the case of Pennell *v. The Saturday Review* and Another
(By permission of Birmingham Museums and Art Gallery)

Oscar Wilde
(Radio Times Hulton Picture Library)

Detail of The Peacock Room, showing *La Princesse du Pays de la Porcelaine*
(By courtesy of the Smithsonian Institution, Freer Gallery of Art, Washington, D.C.)

INTRODUCTION

In his utterly disarming autobiography, *By Himself*, Hesketh Pearson dismisses his book on Jimmy Whistler in a single paragraph. On the face of it this is surprising; most writers, having achieved such a book, might be excused for recommending it to readers, and Pearson's reticence on the subject tempts us to conclude that he so misjudged the quality of his work as to consider the book hardly worth mentioning at all. Such a conclusion would be a gross error of judgment, likely to be committed only by those unacquainted with the man's curious literary temperament, in which modesty forms an outrageous alliance with candour. Pearson, who published around twenty biographies, and who knew both artistic and commercial success with many of them, remained amusedly self-effacing about the whole business. If he thought no more of his book on Whistler than he did of his other biographies, it is doubtful if he thought any the less of it, and we ought not to be misled into indifference by the casual style with which he dismissed himself.

And yet the modesty was perfectly genuine. I can remember seeing Pearson towards the end of his life finding himself washed up on the unlikely shore of the Brains Trust, and modestly declining to set the world right between Sunday lunch and Sunday tea. Eventually, on being pressed by a despairing chairman, he calmly shattered the sepulchral quietude of the proceedings by announcing that, with regard to the subject under discussion – some piffling geopolitical frivolity – he knew nothing about it and cared even less, and therefore declined to say anything, with which he cheerfully resumed cleaning out his pipe-bowl with the wrong end of a pencil. What was significant about that incident was that his attitude accorded exactly with the impression one gathers from his books, of a man without the slightest pretensions to omniscience, deeply suspicious of political abstractions, and

sceptical to the brink of ribaldry about the advantages of an Oxbridge education; once when H. G. Wells challenged him to name one advantage of such an education, Pearson replied hopefully, "It helps one to take an interest in the Boat Race."

It is therefore hardly surprising that such a man should mention so fine a book as *The Man Whistler* with such casual unconcern; that was Pearson's way with all his subjects. For instance *Gilbert, His Life and Strife,* which broke new ground concerning family relationships, he mentions with belittling brevity in *By Himself* and moves on to more pressing matters with the breezily dismissive "Having polished off Gilbert . . ." Even his biography of his great literary hero Oscar Wilde, one of the very few books on that vexed theme to achieve a balance between idolatry and scopophilia, is referred to only as the background to some troublesome times during wartime air raids. In fact the only exception to this rule of underplaying is the famous *Bernard Shaw; His Life and Personality,* and that was due no doubt to the fact that of all the people whom Pearson "polished off", Shaw was the only one who was alive at the time of the polishing.

Already a pattern begins to emerge of Pearson's ideal subject. He revelled in those literary comedians whose wit scintillated on public occasions, Shaw, Wilde, Sydney Smith, Gilbert. He was also attracted by those literary prodigies whose list of published works suggests not one life but two, Sir Walter Scott, Dickens, although there was something else about Dickens which interested Pearson and tells us much about his own temperament. He says somewhere that so long as he recalled the abject sentimentality of Dickens in his worst moments of Little Nell excess, he had no interest in him as a subject, and turned away from him just as, later on, he turned away from Sir James Barrie, because he sensed something in the man uncongenial to him. But when the Dickensian scholar Bernard Shaw recommended Dickens as a subject, Pearson felt obliged to take due note of the recommendation, about which he writes a very revealing thing; when it was found that "in later life Dickens had helped a woman to 'fall' and had treated the mother of his large family with censorious callousness, I perceived the interesting connection between the extremes of his writing on the one hand, of his nature on the other." And

he goes on to say, "I did not altogether like the man but he fascinated me."

In the light of those remarks, Whistler as the subject of a Pearson biography seems inevitable, for apart from the fact that there is nobody in the cultural history of the Victorian age better qualified to enter that select company of sardonic wits whose antics so exercised Pearson's highly developed sense of the ridiculous, he had already made a few fleeting but highly diverting appearances in earlier books. In *Gilbert and Sullivan* and again in the Wilde biography, when Pearson comes to discuss the genesis of *Patience,* there Whistler is, hovering on the periphery of events, hinting at great fires of laughter banked against the day when Pearson will find the time to draw upon them. Moreover, Whistler's personality was positively rampant with contradictions which, if they were of a differing nature from those of Dickens — Whistler being altogether too wordly and cosmopolitan a character to equate sex with sin, for example — were just as striking, the contradictions between the calculated insolent levity of the social persona, and the heroic, unflinching dedication of the creative artist. "I wished to understand", explains Pearson, "the seemingly irreconcilable qualities of the poet who could paint the tender portrait of Carlyle or the lovely dream-picture of Cremorne Lights and the man whose bitter tongue suggested hate as his primary emotion." And again Pearson adds a telling afterthought: "Moreover, he was a wit, though a cruel one, and I felt sure he would amuse me. He did."

There was, however, at least one powerful impediment to the writing of the Whistler biography. Pearson had first to acknowledge the problem to which every biographer worth his salt has to address himself: was there any real need for such a book? And in deciding that there was, Pearson was entering the ring against James Laver, whose brilliant critical analysis of Whistler, first published in 1930, was reprinted in the very year that Pearson was preparing his own manuscript. In the event the two books proved so dissimilar as to achieve complementary status as indispensable assets to any student of the artistic life of the period, and it is typical of Pearson that he should so bluntly have indicated the way in which his approach differed radically from Laver's. The title *The Man*

Whistler tells us plainly enough the nature of the beast that Pearson is stalking. Of the fourteen chapters in the book only one is headed "Artistic", and although we need not observe the arbitrary divisions of the narrative with any more scrupulosity than Pearson did — he appears merely to have been providing for himself a firm vertabrate structure on which to extend his narrative — it is certainly true that while Laver is meticulous in relating Whistler's artistic contribution to its historical and stylistic context, a task he performs with exquisite elegance, Pearson revels more in the remarkable public demeanour of one of the most ingenious exhibitionists of his day. Candid as usual to the point of perversity, he quotes Laver three times, describes him as an author of "by far the best book that has been written on Whistler as an artist", and admits that so far as he, Pearson, is concerned, "Whistler was an odd choice in view of the fact that painting makes less appeal to me than any other art except perhaps sculpture."

Pearson is cheating just a little here, for Whistler, although indifferent to the published works of others, was intensely interested in his own, and was himself a prose artist of distinct if minor talent, one of the most intriguing literary amateurs of the nineteenth century who, like his deadly enemy George Moore, never ceased to adapt, emend, edit, embellish and recast his narratives in order to comply with the dictates of a septic ego. Pearson makes this point without labouring it when he gives us both the transcript of the Whistler-Ruskin trial and the eventual form Whistler imposed on his own profound persiflage in a subsequent publication, *The Gentle Art of Making Enemies*. The Whistler-Ruskin trial was, of course, the most deliciously absurd juridical charade in the entire history of Victorian England, when the painter took the critic into the courts after the critic, already half-demented, had libelled him in the matter of the "lovely dream-picture of Cremorne Lights". It should have been the great symbolic collision of the age, Ruskin, who, in his messianic frenzy had somehow managed to confuse chastity with perspective, versus Whistler, whose ability to destroy a man with a phrase is exemplified by his deadly shaft aimed at Henry James, of whom he is reported to have said, "As a writer he chews more than he bites off." But by the time the trial opened in 1878

Ruskin's eccentricities had drifted too far along the road to madness for him to risk an appearance, and the trial became transformed into a hollow dialectical triumph for the plaintiff; leading several of its principals into bankruptcy, financial for Whistler, moral for those artists like Burne-Jones, Millais and Frith, whose mealymouthed testimonies have exposed them as solemn noodles in the eyes of posterity.

The trial also brings out another virtue of *The Man Whistler*, the skill and perception with which Pearson has sketched in the supporting cast. Because of the nature of Whistler's vocation and the conspiratorial bellicosity of his temperament, people tended either to attach themselves to him, like Sickert and the Greaves brothers, or found themselves unable to detach themselves from him, like Leyland, Ruskin and Seymour Haden. Pearson brings them all to life with deceptive economy, displaying particular acumen in the case of the extraordinary Charles Augustus Howell, the great slapstick felon of the Pre-Raphaelite Movement. In William Gaunt's superlative *The Pre-Raphaelite Dream*, in which Howell makes such a brilliant comic entry, there is a portrait of him by Frederick Sandys showing the confidence trickster resting his handsome head on his left hand and staring vacantly down at the viewer's bootstrings, perhaps weighing the possibilities of absconding with them, perhaps merely showing the face of a master-rogue wearied by his own intricate peculations. In following the career of such a man, the reader repeatedly asks himself why anyone should have tolerated him for five minutes, and it is one of Pearson's several successes in the book that he should so adroitly have answered the question; his analysis of Howell's behaviour in the "Oriental" chapter is a pearl of the biographer's art.

If we were wise to read *The Man Whistler* when it first appeared, are we foolish to repeat the experience now that it reappears? The question must be asked because in the intervening twenty-five years there has been a positive explosion of Whistlerian, or as Ruskin would prefer it Whistleristic, scholarship and speculation. Roy McMullen's *Victorian Outsider* could be said to retill the ground once cultivated by James Laver, and Stanley Weintraub's enormous *Whistler* recapitulates the story of the career in much closer

detail than Pearson ever aspired to. And there has been a further, slightly bizarre development in the growth of the Whistler industry, and that is the assumption that the painter's personality was so elusive that all the engines of biographical research and reconstruction are baffled by its flamboyance, and that the only way therefore of coping with the enigma is to transmute Whistler into pure fiction, in defence of which peculiar tactic it might be said that that after all was exactly what Whistler himself was trying to do half the time. We have seen Ted Berkman's *To Seize the Passing Dream,* a huge baroque superstructure supporting the vision of Whistler as hyper-romantic hero; and the more urbane, more revealing *I, James McNeill Whistler* by Lawrence Williams, which playfully purports to be the complete manuscript of the autobiography that Whistler began but never finished. That such drastic measures have been deemed necessary by literate men is some indication of the difficulties confronting the Whistler biographer, and we can only applaud Pearson the more for writing what still remains the most convincing literary portrait of the Artist.

What are the qualities which Pearson brings to the biographer's art that his work should wear so well? First, an irrepressible sense of humour; when he says of Whistler "I knew he would amuse me", he is disclosing the prime demand he makes on all his subjects. Second, deep compassion, for Pearson was one of that tiny band who not only make allowances for a man's faults, which is not as difficult as people often suppose, but also for his virtues, which is very nearly impossible, and may explain why he remains to date the one biographer of any note to transmute the blue-serge stolidity of Conan Doyle into the stuff of romance without resorting to psychoanalytical quackery. Third, the ability to assimilate quantities of fact which are not only complex but very often contradictory, and resolve them into a coherent narrative. Fourth, his ability, which he once suggested might have something to do with his earlier career as an actor, to place himself inside the skin of the subject. Fifth, a natural gift for narrative; what strikes the reader most forcibly of all about *The Man Whistler* is the exhilarating pace of the action. Events follow on swiftly and smoothly, until in the end we are deluded

into thinking what a simple, straightforward job it must have been, and can only disabuse ourselves of the illusion by reading someone else's book on the subject, when the difficulties which Pearson must have overcome are suddenly all too apparent.

But the most priceless gift of the biographer's art, one which Pearson possessed in abundance, is the most nebulous one of all, and is perhaps indefinable. It is to do with the fact that when we pick up a biography set in a past time, we are setting out on a journey in the company of a companion-guide. We ask of that guide tact, wit, knowledge, confidence, style, the ability to sustain our interest during the journey and our desire to reach the end of it; above all we expect of him that when moving in the world of men he be a man of the world, unflustered by past moralities, unconcerned with current ones. It was Pearson's sublime amorality regarding his subjects which lends his accounts of other people's lives that curious quality of gently smiling urbanity; as he says of Dickens, "I did not altogether like the man, but he fascinated me." Pearson was always intensely *interested* in his subjects, and it is because he never fails to convey that intense interest to the reader that his work endures to a degree perhaps surprising to those who tended to dismiss him as an intellectual featherweight simply because he was so scandalously readable. There is a significant passage in *The Man Whistler* where, in discussing the painter's Nocturnes, he might almost have had his own books in mind – except that he appears to have been far too modest a man for the thought to have occurred to him:

Like all first-rate work in whatever art, his Nocturnes seemed too facile to be taken seriously by the critics, who always confuse an appearance of laboriousness with profundity of thought of feeling, until their judgments are upset by time.

As to the consistency of Pearson's excellence as a biographer over so wide a range, it remains to quote him only once more; the words explain why he remained enchanted at the thought of a new biographical venture even with twenty of those adventures behind him, and why, in the end, he even undertook the most foolhardy adventure of all, which was, of course, the exploration of himself. It was while ruminating on

the possibilities of Dickens that Pearson came to the conclusion that "if remarkable people were not radically dissimilar, their biographies would not be worth writing". In lighting upon Jimmy Whistler, Pearson certainly found a remarkable person radically dissimilar to anything England had ever seen before, or would see again.

BENNY GREEN

CHAPTER I

Adolescent

AN American accosted Whistler in the Carlton Restaurant, London: "You know, we were both born in Lowell, Massachusetts, and at very much the same time. There is only the difference of a year: you are 67 and I am 68." Whistler raised his eyeglass, secured the attention of the other diners with his sharp "Ha-ha!" and replied: "Very charming! And so you are 68 and were born at Lowell! Most interesting, no doubt, and as you please. But I shall be born when and where I want, and I do not choose to be born at Lowell, and I refuse to be 67!" Baltimore had been given as his birthplace by a French writer, and he did not object. "If anyone likes to think I was born in Baltimore, why should I deny it? It is of no consequence to me." He had also stated in a court of law that he was born at St Petersburg. But his real view was that a great artist occurs so seldom on earth that the precise spot of the occurrence is unimportant. "Burns was not Scotch", he once said: "in the turning around of the world, he, the genius, just happened to be born there."

The biographer must be more exact, recognising that place can be as significant as parentage in the life of a man. In the 17th century the Whistlers were an English family resident in the Thames valley or thereabouts, and one of them was as careless about his dates as his descendant became, for he was buried in the parish church of Goring at the age of 216. Another was a doctor, the friend of Pepys, who thought him "good company", and of Evelyn, who called him "the most facetious man in nature", both of which descriptions would have fitted our James, the similarity being emphasised by the fact that the doctor had a grave misunderstanding with the authorities at the Royal College of Physicians, while the painter never reached an understanding with the authorities at the Royal Academy of Arts. Though he refused

I

to admit it, the subject of this book inherited more of his nature from English eccentrics than from Irish and Scottish celts.

A branch of the family settled in Ireland. James was proud of his Irish connection, and late in life wrote to the priest of the parish where his family had lived asking for information concerning them. The priest replied that subscriptions were needed for the restoration of the church, and the correspondence closed. A member of the Irish branch, after serving for a while in the ranks of the British army, married, went to America, joined the United States army, became a Major, took part in the 1812 war against England, and begat fifteen children, one of whom was George Washington Whistler, father of the artist. This son George entered the Military Academy, West Point, at the age of 14. He seems to have been a lively lad, much given to joking and not wholly attentive to discipline, good at drawing and with a natural gift for exposition. Passing into the army at the age of 19, he served in the artillery for some fourteen years, mostly engaged on the building of railroads for private companies, such employment being permitted by the Government in the absence of any need for soldiering. Having reached the rank of Major, he resigned his commission in 1833 and became a civil engineer. Meanwhile he had twice married. His first wife, the daughter of an army doctor, died after bearing three children, one of whom, Deborah, we shall meet again. His second wife was the sister of a friend at West Point named McNeill, whose ancestors had emigrated from the Island of Skye in the middle of the 18th century and had settled in North Carolina. Shortly after leaving the army, Major Whistler was appointed engineer of locks and canals at Lowell, Massachusetts, and there, in a house that is now a Whistler Memorial Museum, the first child of his second wife was born on July 10th, 1834, being christened James Abbott. Many years later James dropped the Abbott and substituted his mother's name McNeill, for he liked to consider himself a southerner and a celt as much as he disliked "the taint of Lowell."

Between 1834 and 1842 Major Whistler had various engineering jobs, and in 1837 they moved to Stonington, Connecticut, in 1840 to Springfield, Massachusetts. His wife was a rigid puritan, and the boys were brought up strictly. Saturdays and Sundays were anticipated by the two elder sons with alarm and despondency. Every Saturday afternoon their heads were thoroughly

washed by their mother, who overhauled their clothes, locked away their books and toys, and got them into a becoming frame of mind for the Sabbath, when they attended church three times and read the Bible in their leisure moments. She wanted one of them to be a parson, and since James was her favourite she would have liked him to be the one; but even at the age of 2 he was displaying a contrary inclination, being found under his mother's dressing-table with a paper and pencil. "I'se drawrin", he explained. He was called Jimmy or Jemmy by his family, and was known throughout life to his friends and enemies by one or the other, as a rule the former, which will therefore be adopted by his biographer until, with the coming of manhood, Jimmy reaches the years of indiscretion.

At the age of 9 he accompanied his mother, two of his brothers, his half-brother George and his half-sister Deborah, to St Petersburg, where his father was busy constructing a railroad from the capital to Moscow, having been chosen for the job by a commission that had picked him out from the many engineers whose work they had inspected in Europe and America. On the way they stayed with Mrs Whistler's relatives at Preston in Lancashire, and sailed for Hamburg from London, where Jimmy had his first view of the river he was later to praise in paint. By carriage, coach and steamer they reached St Petersburg. The third boy of Major Whistler's second marriage had died before the family left America, and sea-sickness proved fatal to the fourth on the journey to Cronstadt. Mrs Whistler's diary during their stay in Russia is therefore more concerned with the health and physical appearance of the two survivors, Jimmy and Willie, than with anything else. Her eldest and favourite caused her much anxiety during the six years of their Russian exile. He was not as strong as Willie, had several rheumatic attacks, and was weakened by the diet and confinement which followed them. Moreover he could not be persuaded "to put up his drawing and go to bed while it is light." He was very excitable, but did not seem to care about anything except his drawing, and was perfectly happy and tranquil when looking at pictures or making them. Once, during an illness, a volume of Hogarth's engravings was brought to him. Pain and discomfort were forgotten, and days were passed in serene content as he studied these fascinating works. He was even grateful for the cause of the revelation: "If I had not been ill,

mother, perhaps no one would have thought of showing them to me." He never forgot the experience, and to the end of his life asserted that Hogarth was the greatest of English artists. But though his mother was delighted that he could derive so much pleasure from his pencil, she did not encourage such secular enjoyments. "I told him his gift had only been cultivated as an amusement, and that I was obliged to interfere, or his application would confine him more than we approved."

Major Whistler had a large salary, twelve thousand dollars a year, and they were able to take a country house for the summer months. The boys went to a good school, and Jimmy was allowed to enter the Academy of Fine Arts for a course of drawing lessons. But, like all instinctive artists, he learnt more from his own feeling and observation than the masters were able to teach him. During one holiday that he spent in London with his father he was having a hot footbath when suddenly he became conscious of the shape and colour of one of his feet. For some time he sat looking at it; then got paper and colours and began to make a study of it. Similar incidents often occurred in Russia. Before entering his 'teens he was criticising and even laughing at the work of recognised painters. He was also displaying a patriotic fervour on behalf of the United States of America, which, though it remained constant with the years, he was able to control when the opportunity of exchanging emotion for action presented itself.

By March '47 the railroad was completed; Major Whistler was embraced and decorated by Emperor Nicholas I; and the family spent the summer of that year in England, where Deborah married a young surgeon named Seymour Haden, who from the outset had made a bad impression on Jimmy by patting him on the shoulder and saying it was high time he went to school. "He's just like a schoolmaster, isn't he?" remarked the lad to his father. The following summer cholera broke out in St Petersburg, and Mrs Whistler again brought her two boys to England. Jimmy had only just recovered from another attack of rheumatic fever, and his mother was terrified lest he should succumb to the more serious epidemic. They went to Shanklin in the Isle of Wight, where great care was taken of Jimmy, who was careless of himself. One bright morning they drove to "Black Gang Chine", and stopped at the inn, whence Jimmy "flew off like a sea-fowl, his sketch-book in hand, and when I finally found him, he was seated

on the red sandy beach, down, down, down, where it was with difficulty Willie and I followed him. He was attempting the sketch of the waterfall and cavern up the side of the precipice. . . . "

They did not let him risk another winter in Russia; so when they went back he was left at the home of the Hadens, 62 Sloane Street, London, where he received instruction from a clergyman. In November '48 Major Whistler caught cholera, recovered, but died of heart-failure the following spring. In recognition of his services the Czar offered to have the boys educated at St Petersburg, but Mrs. Whistler wanted to go home. In London she took Jimmy to the Royal Academy in Trafalgar Square, where a portrait of himself, recently done by Sir William Boxall, was exhibited. Since this was the only work of art except his own that Whistler ever displayed on the walls of the various houses and studios he later occupied, he may have thought well of it; though perhaps it was piety or loyalty that made him prize it, for it was commissioned by his father and painted by a man who afterwards, by threatening to resign, compelled the Council of the Royal Academy to exhibit Whistler's portrait of his mother. Having paid brief visits to Preston, Edinburgh and Glasgow, the family left Liverpool for New York at the end of July '49, and, after a short stay at Stonington, settled down at Pomfret, Connecticut, where the boys went to school.

From twelve thousand dollars a year to fifteen hundred was a big drop, and Mrs Whistler had to practise economy. They lived in part of an old farmhouse, and the boys had to do a certain amount of manual labour, such as carrying wood, shovelling snow, mending doors. Their mother noted that Jimmy was still excitable, but indolent if not interested, and she never ceased to impress upon him the virtue of perseverance and the value of the Bible. A girl pupil at the same school thought him "one of the sweetest, loveliest boys I ever met", and he seems to have been a great favourite with everyone except the schoolmaster, who was a stiff, pedantic clergyman with a long neck which he tried to hide by wearing long collars. Jimmy arrived one morning at school with a paper collar so long that it covered his ears. Convulsions among the boys and girls; a glare of rage from the master; and Jimmy walked calmly to his desk. But it was not long before he said or did something to justify the inevitable explosion, and the master went for him with a stick. Jimmy dodged and took refuge

amongst the girls who sat on the opposite side of the hall. For a while there was a confused swirl of bodies, everyone getting into the way by the simple process of getting out of it; which was followed by a more definite sound, as the irate clergyman asserted his monopoly of long collars. Apart from this early criticism of authority, Jimmy's school career was undistinguished, though he drew maps better than anyone else, made caricatures, and seized any excuse, from reading a book to looking at a landscape, to draw a portrait or paint a scene.

As he showed no inclination to heavenly exercises, Mrs Whistler decided that Jimmy must be a soldier like his father, grandfather, several uncles and great-uncles, the profession of body-killer being the most respectable alternative to that of soul-curer; and at the age of 17 he entered the United States Military Academy, West Point, the head of which, during the greater part of his cadetship, was Colonel Robert E. Lee, later to be famous as commander of the Confederate army in the Civil War. Though pugnacious by nature and fully in sympathy with the profession of arms, Jimmy made as bad a cadet as he would have been a curate. He did not like the discipline, the clothes, the food, the riding, the drilling, the acquisition of uncongenial knowledge, nor the lack of humour incident to institutions. Consequently he was always getting into trouble for inefficiency and the assertion of individuality. When reported for being absent on parade without the knowledge or permission of the instructor, his defence was irregular: "If I was absent without your knowledge or permission, how did you know I was absent?" When he was observed to slide over his horse's head at cavalry drill, the commander remarked: "I am pleased to see you for once at the head of your class", but he consoled himself with the belief that he had done it "gracefully". On being told that a horse he had ridden was called "Quaker", he remarked: "Well, he's no friend." When reprimanded for wearing incorrect boots, his explanation closed with the words: "What boots it?"

He was popular with the other cadets, who called him "Curly" on account of his thick black wavy hair. He was full of fun and good at cooking. He risked punishment by obtaining buckwheat cakes, oysters, ice-cream, and other delicacies, at places out of bounds; and he made numberless caricatures of the authorities. In after years he took great pride in his West Point training.

"We were United States officers, not schoolboys, nor college students", he would say. "We were ruled, not by little school or college rules, but by our honour, by our deference to the un-written law of tradition." The code of West Point became the code of Whistler; individual behaviour was tested by it; cam-paigns had to be conducted on West Point principles, which meant in effect that wars waged by the United States were chival-rous, beautiful and glorious, while wars waged by other countries were dastardly, repulsive and scandalous. His memories, like those of so many people, were idealised by time, enhaloed by distance. He always talked with enthusiasm of the three years he had spent at the Military Academy; and when at the end of his life he heard that the cadets had begun to play football, he was dis-tressed: "They should hold themselves apart and not allow the other colleges and universities to dispute with them for a dirty ball kicked round a muddy field—it is beneath the dignity of officers of the United States."

But his experiences as a cadet were less romantic and more amusing than his later vision of the place suggested. At a history examination he was admonished: "What! you do not know the date of the battle of Buena Vista? Suppose you were to go out to dinner, and the company began to talk of the Mexican War, and you, a West Point man, were asked the date of the battle, what would you do?" Jimmy was indignant: "Do? Why, I should refuse to associate with people who could talk of such things at dinner!" A more serious gap in his knowledge was apparent in the chemistry examination, when he was asked to discuss silicon. It was a brief discussion. "Silicon is a gas", he announced. "That will do, Mr Whistler", said the professor of chemistry. It did. He was discharged from the West Point Academy in June '54, and faced the world at the age of 20, shaky on the subject of solids. "If silicon had been a gas, I would have been a general", he said at a later period. But it is easier to think of silicon as a gas than of Whistler as a soldier.

Although head of his drawing-class at West Point, it still did not occur to his mother that art was a feasible vocation; and as his father had been an engineer, it seemed to her that Jimmy should learn about engines, especially as his half-brother George was partner of a Baltimore locomotive works in which his younger brother Willie was an apprentice. Jimmy liked Baltimore so much

that in the years to come he chose it as a birthplace; but he did not at all like engineering; and beyond using up a lot of pencils and paper belonging to the other apprentices in the drawing-office, he took no part in the firm's business. After several months of this, he suddenly left for Washington, where he called on the Secretary of War, Jefferson Davis, with the suggestion that he should be returned to West Point. He explained that his little difference with the professor of chemistry was not of vital importance, that he had done well enough in the other subjects, and that, if reinstated, he would be quite willing to accept silicon as a metal. Davis, a West Point man, was extremely courteous and promised to consider the application. Jimmy then called on the Secretary of the Navy, with the suggestion that he should enter the Naval Academy, and that his time spent at West Point should count as three years of preparation for the sister-service. The Secretary could not agree, but the young man's self-assurance must have impressed him because a little later he offered Jimmy an appointment in the marines. By that time, however, Jimmy had got a job in the drawing division of the United States Coast and Geodetic Survey, Davis having recommended him to Captain Benham after explaining that the reinstatement of one cadet at West Point would establish a precedent and many others would expect similar treatment.

Jimmy commenced his third attempt at a profession that would satisfy his mother in November '54; but it was no more successful than the first two, and lasted three months. Washington was a very sociable city. Several people had known his father and found the son so attractive that he was soon receiving more invitations than he could accept. He loved dancing and took part in many gay assemblies. He went to the functions at the Legations, and got to know everyone of importance in diplomatic circles. Henry Labouchere, an attaché at the British Legation, liked him very much, and was amused to notice that at evening parties he wore a frock-coat, which he made to look like a dress-coat by pinning back the skirts. As his salary was a dollar and a half a day, and he had to pay ten dollars a month for a small room at the north-east corner of E and Twelfth Streets, he had nothing left over for clothes. But somehow he managed to do a little entertaining, because he once invited the Russian Minister to dinner. The Minister provided the carriage, Jimmy did the shop-

ping on the way, and then cooked the food while his guest looked on. His rent was occasionally in arrears, but he treated the landlord with consideration. "Now, now, never mind!" he said when the landlord complained of the sketches he had made on the walls of the boarding-house: "I'll not charge you anything for the decorations."

He did not allow business to interfere with social life, and always arrived late at the office, meeting one remonstrance with: "I was not too late; the office opened too early." Frequently he did not turn up at all, and his superior, Captain Benham, who admired him, asked a member of the staff to call for him in the morning and bring him to the office. As a result, the other fellow was an hour and a half late for work; so the experiment was not repeated. The records show that Jimmy put in about twelve days at the office during the months of January and February '55. Even when there, he spent hours at the window, making studies of people in the street, paying special attention to their clothes, and the rest of the time doing sketches on the walls. Nevertheless the short period he passed in the Coast Survey was of incalculable service to him, for he learnt how to etch. In those days the plans and maps were reproduced by this process, and he soon became an expert; though he could not help decorating the margins of his work with caricatures of his superior officers, which amused him but were considered unnecessary by Captain Benham.

His superiors were greatly relieved when he relinquished his post in February '55; but no more relieved than he, because at last he had decided that he must henceforth do the only thing in the world he wanted to do. He went home, resisted his half-brother's attempts to make him an engineer once more, and stated flatly that he intended to study art in Paris. It had already begun to dawn on his family that he was an artist or nothing, and they capitulated. They paid his fare to London, agreed to send him three hundred and fifty dollars a year in quarterly instalments, and dismissed him with cash and kisses.

CHAPTER II

Bohemian

INTENDING to make a good start, Whistler, now aged 21, took a first-class ticket from London to Paris. During the journey from Boulogne he alighted at a station and got into conversation with a black-bearded Irishman on the platform, continuing the journey in a third-class carriage because he wished to continue his conversation with the Irishman, who was a medical student anxious to complete his studies in French hospitals. Arrived at Paris, and disinclined to cease talking, they agreed to share rooms, and having explained their needs to a cab-driver were driven to the Hotel Corneille near the Odéon theatre. They separated after Whistler had made the acquaintance of several artists and had discovered lodgings more suitable to his small income and new companions. His curious American attire immediately gained the attention of the Latin Quarter. It was the summer of '55, the year of the first International Exhibition, and he dressed in white duck, his head, with its black ringleted hair, surmounted by a low-crowned broad-brimmed straw hat bound with black ribbons, the long ends of which hung down behind.

He studied under Charles Gabriel Gleyre, who "never drew a line without having first assured himself how Raphael would have proceeded", but from whom he learnt that the colours should be arranged on the palette before starting to paint a picture, and that black is the universal harmoniser, neither of which lessons he ever forgot. But the chief impression he made upon the other English students was that he did as little work as possible and seemed to be in Paris for the express purpose of enjoying himself. He was soon on familiar terms with a number of young men, some of whom were to recognise themselves forty years later in a popular novel called *Trilby*, the author of which, George Du Maurier, was also working in Gleyre's studio. Three of these,

T. R. Lamont, Joseph Rowley and Aleco Ionides, are remembered today solely on account of their appearance in that story as 'the Laird', 'Taffy' and 'the Greek'. Two others achieved distinction in later life: Edward Poynter became President of the Royal Academy, and Thomas Armstrong was made Director of the South Kensington (now the Victoria and Albert) Museum. Whistler himself was to appear in the serialised version of *Trilby* under the name of "Joe Sibley", described as an idler, always in debt, vain, witty, eccentric in dress, charming, sympathetic, "the most irresistible friend in the world as long as his friendship lasted —but that was not for ever." Unluckily, Du Maurier went on to portray a much later Whistler than the one he had known in the fifties; and as the later Whistler had no difficulty in seeing himself as "Joe Sibley", there was trouble, the result being an apology by the editor of *Harper's Magazine* in which the book was appearing and the omission of "Joe" from the published volume.

But there was no friction between him and his English friends in the fifties. All of them found him delightful, if eccentric; and though they did not much care for his disreputable French companions, they agreed in thinking him the best company in the world. Everything that he said or did, and everything that was said and done to him, seemed funny; at least he created an aura of comedy in his fanciful renderings of the incidents in which he took part. There were, for instance, the series of chances which enabled him to appear properly garbed at a reception given by the American Minister. Lacking a dress suit, he borrowed Poynter's, whose boots and gloves, however, were not the right size; so he persuaded the girl in a glove-shop to let him have a pair on credit, and then toured the corridors of the hotel after the inmates were in bed, tried on a number of boots left outside the doors, discovered a pair that fitted him (though he complained of their shape), removed them for the occasion, and duly replaced them. The British students were a little jealous of the invitations he received to such functions, since none of them could ever hope to be asked to receptions at the British Embassy; and his immunity as an American from the sterner measures of the police was provoking. When temporarily under duress he would claim the protection of the American Minister, and would even explain to angry commissaires that his banker was Rothschild, omitting to add that his sole connection with that financier was the cashing of dollar drafts

across the counter of his house. He refused to take part in the
vigorous exercises of Du Maurier, Poynter and the rest, who,
when not painting, boxed, fenced, swung dumb-bells, and gener-
ally exercised themselves in a way that Englishmen think essen-
tial to a sound mind in a sound body. "Why the devil can't you
fellows get your concierge to do that sort of thing for you?" he
asked when they were busy lifting weights. But he took a promi-
nent part in their lighter amusements, and kept them entertained
with stories and songs. Using a stick or umbrella in place of a
banjo, he warbled nigger ditties like this:

> De World was made in six days
> And finished on de seventh,
> According to de contract
> It should have been de eleventh;
> But de masons, dey fell sick,
> And de joiners wouldn't work,
> And so dey thought de cheapest way
> Was to fill it up with dirt.

The impression of laziness and heedlessness which he made on
the British students was due to the fact that he seldom turned up at
Gleyre's studio and spent most of his time with French artists of
shady appearance and questionable habits. He had steeped him-
self in Henri Murger's *La Vie de Bohême*, and had made up his
mind that while in Paris he would live among Parisians of the type
described in that book. He prided himself on his "no shirt"
French friends, and felt that his English ones were losing half the
fun of life by not mixing with the native inhabitants of the Latin
Quarter. While they were learning their job in a class-room, he
was observing life in a café; the street was his studio; and he found
it more exciting to call on an artist who painted pieces of furniture
on his bedroom walls in lieu of the real articles than to witness the
conscientious efforts of the British to harden their muscles.

While enjoying the spectacle of life he did not neglect his art,
though his early efforts were tedious enough. Not long after his
arrival in Paris an American commissioned him to copy pictures
in the Louvre at twenty-five dollars each. He was so hard-up that
he did not always put enough paint on the canvas; and when criti-
cised by fellow-students for the shortcoming, he replied that the
price he was paid did not justify a proper coat. Once he helped
himself to a box of colours, and when it was claimed by the owner

he expressed surprise, saying that he thought the boxes were for general use. His family kept up their promised payments, but he had usually sold his belongings to keep himself going before each instalment arrived. For several days one summer he walked about in his shirt-sleeves, having pawned his coat to obtain an iced drink. He paid a bootmaker with an engraving of Garibaldi, and obtained paper for his drawings by wandering round the book-stalls on the quays and extracting fly-leaves from the larger volumes. "I have just eaten my washstand", he informed an American friend who had climbed ten flights of stairs with his quarterly allowance. By that time the furniture had been reduced to a bed and a chair on which stood a jug and basin, and he explained that he had been living on his wardrobe while progressing storey by storey towards the attic, though he had seldom got as high as that before the draft came.

Whenever he received money it quickly vanished. French artists, much poorer than himself, were entertained; dances and other festivities were enjoyed; and female models were treated. He lived for two years with one of his models at a small hotel in the Rue St Sulpice. She shared his poverty, for he had nothing else to share. Her real name was Eloise; he etched her portrait and called her Fumette; others knew her as *La Tigresse* because of her furious tempers. She was a little sallow-faced girl, who pleased him with her songs and her recitations from de Musset. But her rages carried her beyond all bounds, and one day, in a jealous fit, she destroyed his drawings of people and places in the Quarter. On seeing what she had done, he wept, and rushed out to deaden his misery with alcohol in the company of friends. Having spent all the money they had between them except twelve sous, he insisted that they should go to an open-all-night restaurant in the Halles and try to get supper on credit. The few sous were sufficient for beer, over which he complimented the *patron* on his cuisine and its fame, taking advantage of the pleasure visible on the man's face by saying that it was not the habit of himself and his friends to pay for food immediately after consuming it. The *patron* ceased to smile and said that it was not the habit of his restaurant to be paid at any other time. So they went to another place, where Whistler suggested that they should eat first and discuss the question of payment afterwards. Supper over, they fell asleep. At daybreak, seeing that the others were still slumbering,

Whistler went off and borrowed money from an American friend, returning before his companions were conscious. When they awoke, he was asleep. Their plight called for speedy action; they did not leave him to enjoy his rest; and were amazed to find that he had enough money to pay the bill. He explained that an American painter had come to his rescue, but added: "He had the bad manners to abuse the situation; he insisted on my looking at his pictures."

Whistler soon got rid of Fumette, and in due course became intimate with a more civilised girl named Finette, well-known in the Quarter as a dancer. He etched her portrait, too, and lived periodically in harmony with her. But before the commencement of their liaison he had a curious experience with one of his "no shirt" friends, a painter named Ernest Delannoy, whose odd behaviour appealed to his sense of humour. For example, Ernest once completed a copy of Veronese's *The Marriage Feast at Cana*, a picture which was then so popular among rich people that there must have been a constant queue of poor artists awaiting their turn to reproduce it. Delannoy's copy, however, had not been commissioned. It was a large canvas, and a friend helped him to carry it across the Seine, where it was offered to all the big dealers for 500 francs. There being no demand, they recrossed the river and asked 250 francs of the small dealers on the left bank. Meeting with no success, they returned to the big dealers on the other side and suggested 125 francs as a sound price. No one agreeing, they tried the lesser fry on the opposite shore with 75 francs. Unlucky, they once more visited the right bank with a bargain offer of 25 francs. But the fashionable dealers were in no mood for bargains, and they traversed the bridge wearily with a rock-bottom valuation of 10 francs for the left-bank merchants, who however showed no disposition to receive the picture even as a gift. By this time they were exhausted, and as they passed the cafés they leant up against the chairs and tables. But food and drink were necessities, and once more they turned their faces towards the wealthier side of the river, intending to try the effect of a 5 francs irreducible offer. In the centre of the Pont-des-Arts they were simultaneously inspired. Lifting the picture and swinging it, they chanted "*Un . . . deux . . . trois . . . Vlan! . . .*" and over it went into the Seine. There was a cry from the onlookers, a rush to the side of the bridge, the arrival of *sergents-de-ville*, the stoppage of

vehicles, the putting out of boats; and the two artists returned to their studio, still hungry and thirsty, but delighted with the immense success of their inspiration. Such was Ernest Delannoy, with whom Whistler decided to visit an Alsatian of their acquaintance, who had been studying in Paris but had gone to his home at Zabern and invited them to spend a holiday there.

They set out, a curious pair, the one a ragamuffin, the other as smart as his wardrobe could make him. Then and always, wherever he went, Whistler wore the thin shoes that most men associate with dancing, but in which he would have climbed the Alps, had it been possible for him to face anything steeper than Montmartre. Dressed as carefully as if he were about to attend a reception at the Tuileries, the only unfashionable thing about him was a knapsack, in which were a number of copper plates for etching. Having just earned some money, or received an instalment from home, he was able to pay for transport to Zabern, where they made several excursions with their host and Whistler did one of his famous etchings. The fun started on their way back. At a Cologne inn they discovered that their money had run out. Ernest had no suggestion to make. Whistler was more practical: "Order breakfast", he said. After the meal he wrote letters to everyone who might be expected to answer in cash, and then told the landlord that as they were favourably impressed by the comfort and cooking at his inn they would remain for several days. When the necessary time had elapsed, they called at the local post office for letters. "*Nichts! Nichts!*" said the official. Every day they called, and every day received the same answer: "*Nichts! Nichts!*" At last their daily visit attracted the attention of the juvenile population, and whenever they were seen in the post office there was a chorus of "*Nichts! Nichts!*" from the mob of boys outside. As they quickly became objects of derision in the streets, they spent their days on the ramparts. At the end of a fortnight they realised that no one was interested in their fate except the younger generation of Cologne; so Whistler explained their plight to the landlord, and said that he would leave his copper plates as a pledge for the later payment of their bill. The landlord was sceptical as to the value of the plates; but Whistler assured him that they were the work of a very distinguished artist and would be redeemed at an early date, until which the greatest care must be taken of them. While the landlord was solely concerned

over his account, Whistler was worried about his etchings, and his anxiety must have convinced the innkeeper of their value, for he not only agreed to accept the plates as security but gave them a parting breakfast.

They left for Paris on foot, paying their way with portraits. The price of an egg was a sketch of the hen-keeper; a glass of milk meant a drawing of the farmer; a slice of bread cost a picture of the baker; and so on. They slept where they could, on straw. One day they joined a male harpist and female violinist, who were giving entertainments at fairs. Emboldened by this collaboration they beat a big drum and proclaimed themselves as famous Parisian artists, who would draw full-length and half-length portraits at five and three francs respectively, an offer that had to be reduced to five and three sous respectively. Whistler's patent leather shoes were dropping to bits which had to be patched together each evening, when he also washed his shirt and collar, a piece of fastidiousness that Ernest thought absurd. The weather was bad; and seeing Ernest trudging along in the mud, his hat cascading water, his coat a soused rag, Whistler, though limping painfully, screamed with laughter. The condition of his footwear probably made them take five days to cover the fifty miles from Cologne to Aix-la-Chapelle, where Whistler borrowed money from the American Consul. This was supplemented by a small loan to Ernest by the French Consul at Liège; and the rest of their journey was relatively comfortable. The moment they reached Paris, Whistler settled their debt to the innkeeper at Cologne and recovered his plates.

It took longer to pay his debts at Lalouette's, a restaurant where he and his friends often dined on credit, for he left Paris owing the proprietor three thousand francs, which were not repaid for some years. One day Lalouette asked his favourite customers to a country picnic. Whistler said he would join the party if he could bring *La Mère Gérard*, an old and nearly blind woman who sold matches and flowers at the gate of the Luxembourg and whose portrait he had been etching. His condition was approved, and her presence enlivened the trip. During the afternoon he painted her and promised her the picture; but when it was completed he thought it so good that, to her disgust, he gave her a copy instead. Some time later, after he had been staying with the Hadens in London, he happened to be passing the Luxembourg with a

friend. The old woman was too blind to recognise him, so his friend asked whether she had any news of her little American. She replied that according to report he was dead, adding "*Encore une espèce de canaille de moins!*" Whistler's laugh gave the game away, and he was known thereafter as *Espèce de canaille*.

The etching and the painting which he did of her show that he had not been so idle as his habits suggested. Since he danced nearly every night and seldom rose before midday, no one knew how he found time for work. But somehow he managed to finish the etchings he had done on the trip to Alsace, to have them printed by Delâtre, and to get them published. Two paintings of this period are also notable, in addition to the one of *La Mère Gérard*. The first was that of an old man, hungry and penniless, to whom he offered forty sous for a sitting. The old man agreed, but said that he must first get his *voiture*. Whistler was wondering how such a poverty-stricken creature could keep a carriage when his prospective sitter reappeared with a push-cart full of *pots-de-chambre*, which he left beneath the window while Whistler, singing comic songs to keep him entertained, painted him with a pipe in his mouth. The other picture was done during one of Whistler's visits to London. Called *At the Piano*, it shows his sister, Mrs Haden, in black, with her daughter in white, and clearly prefigures his later and greater portraits. He sent it to the French *Salon* in '59, but it was refused. A year later he sent it to the British Royal Academy, and it was accepted. He was delighted, and wrote enthusiastically from London to his friends in France begging them to join him in a country which extended both hands to young artists.

But before that happened two incidents had changed the course of his life in Paris. While spending a holiday with the Hadens he had given several of his "no shirt" acquaintances the freedom of his room, and on his return found that they had taken full advantage of it. The bath, the dishes, the furniture, the room itself, were filthy. He decided that there were limits to bohemianism, and thenceforward revealed a preference for shirts. Perhaps his visits to London confirmed this decision. There was a comfort about the Haden home and way of living that gave him a slight distaste for the dirty slapdash habits of the Latin Quarter, and there was clearly a better chance of getting rich in England. It was irritating to be compelled to borrow money for a journey to Manchester,

where he saw an exhibition of pictures by Velasquez, especially
as he was already in debt to the man from whom he borrowed it.
"Do you think I ought to ask you to lend me this money for the
Manchester journey?" was his diplomatic way of putting it.

But something of far greater moment than his visits to England,
his debts, or the unhygienic behaviour of his tenants, occurred in
the year '58, after he had spent three years in Paris. He was stroll-
ing through the galleries of the Louvre one day when he noticed a
young fellow copying *The Marriage Feast at Cana*, the subject of
which must have made a strong appeal to hungry students. He
paused and praised the reproduction. The artist turned round,
noticed *"un personnage en chapeau bizarre"*, and asked his name.
Whistler gave it, and was given the other's: Fantin-Latour. They
liked one another at once, and that same evening Fantin intro-
duced Whistler to Alphonse Legros and other fellow-artists at a
café they all frequented. Here the talk centred on "the master",
Gustave Courbet, who was leading one of those "modern" move-
ments which are as ancient as the hills. For some years the art of
painting had become stereotyped. The acknowledged masters
had been David, Ingres and Delacroix, whose subjects were classi-
cal or romantic, academic or anecdotal, and any artist who desired
the recognition of the *Salon* had to follow the fashion and paint
in one of the accepted styles. Courbet reacted against these
"schools", proclaimed himself a "realist", and interpreted the life
he saw around him instead of looking for inspiration in the past
and repeating what had already been done to death by repetition.
Like so many innovators in art, he was also a revolutionist in
politics, and so became unpopular with the officials of the Second
Empire as well as the professors of the *Salon*.

Courbet would have been dismissed as a madman at the studio
where Whistler was working, or supposed to be working; and
when he confessed to his new acquaintances that he was at Gleyre's
they told him that he was wasting his time. He had not wasted
very much of it, having been otherwise engaged; but from the
moment he met Fantin and Legros, Gleyre's studio saw him no
more. He formed what he called a "Society of Three", consisting
of Fantin, Legros and himself; he met Courbet, whom he thought
a great man; and henceforth he worked diligently in the studio
of F. S. Bonvin, to which Courbet frequently came and imparted
criticism and advice.

The first three years of Whistler's life in Paris had been spent in finding his way. In the fourth year he found it. And it took him to London. But he did not forget his French fellow-students, who had delighted in the company of *Le petit Vistlaire*.

CHAPTER III

Bourgeois

FOR some years Whistler spent his time partly in London and partly in Paris, but from the moment that he found inspiration in the Thames most of his time was spent in London, where for a while he stayed with his sister and brother-in-law. He was always fond of his sister's company, and at first he was charmed by the behaviour of Seymour Haden, who not only invited his French friends to stay at 62 Sloane Street but encouraged them by buying their pictures. Alphonse Legros was in so deplorable a condition just then that, according to Whistler, "it needed, well, you know, God or a lesser person to pull him out of it." No sign coming from heaven, Whistler lent a hand, and Legros was hospitably received by the Hadens. Another visitor was Fantin-Latour, who spoke of Whistler's *bonheur insolent*, which incidentally was of inestimable value to Fantin, whose fame and fotune were founded on his introduction to the rich friends of Whistler. The Sloane Street house was a paradise of splendour to these poverty-stricken artists, who drank champagne and ate roast beef and stood in awe of the butler and slept in snow-white sheets and had their underwear sent to the laundry. Even the disreputable Ernest Delannoy came for a brief stay, but the sound of a shower bath being turned on in the morning made him ask Whistler *"Qu'est-ce que c'est que cette espèce de cataracte de Niagara?"* and the condition of his boots placed him at a disadvantage with the servants.

After a little Haden began to assert himself as an expert in art, and trouble started. He had bought *L'Angelus*, a picture by Legros, and had, as he thought, improved it by the addition of a blazing Turneresque sunset. Legros was furious when he saw this, and with Whistler's connivance took the picture to the latter's studio, where he removed the offending sunset. Haden was

20

equally furious when he missed the picture, and rushed to the
studio. "Ah! so you have wiped it all out", he said: "Well, do
better." "*Oui*", replied Legros, his simple answer doing nothing
to ease the tension.

Whistler's studio was at No. 70 Newman Street, off Oxford
Street, and here he occasionally slept, though a good deal of his
time was passed at an inn close to the steamboat pier at Wapping,
or another inn at Cherry Gardens on the opposite side of the river.
In the midst of bargees, sailors, dockers, land rats and water rats,
he was busy etching. Though surrounded, according to his friend
George Du Maurier, by "a beastly set of cads and every possible
annoyance and misery", he was discovering beauty where his
contemporaries could only see ugliness, and creating romance out
of industry. No difficulty discouraged him, no discomfort wor-
ried him. Without knowing it, he had begun his lifelong mission
of revealing the Thames to the people who lived on it but had
previously only seen it as a stretch of water lined by wharves and
warehouses and dotted by boats.

For a time he shared his Newman Street studio with George Du
Maurier, who paid 10s. a week for it when alone, for which sum
he had the use of Whistler's bed, sheets, towels, a table, two
chairs, and a dress-coat and waistcoat when their owner did not
require them. Though there were etchings on the walls, Du
Maurier described it as a "blasted apartment", draughty, dis-
ordered, uncomfortable, wretchedly cold, illuminated by candle-
light, and darkened by clothes hanging all over the place. Du
Maurier was working hard, and Whistler's sudden irruptions from
the Thames-side made labour impossible. Even sleep was out of
the question while Whistler poured forth fanciful descriptions of
his adventures. "The grandest genius I ever met, a giant", noted
Du Maurier, and "a more enchanting vagabond cannot be con-
ceived." On one occasion the vagabond spent two nights at the
studio, and talked without stopping for forty-eight hours. He had
an astonishing variety of anecdotes, which he retailed with such
a wealth of Dickensian comedy that the house resounded with
bursts of merriment. "He *is* a wonder, and a darling", summed up
Du Maurier.

Both of them were great favourites with the Ionides family, at
whose house on Tulse Hill they almost invariably passed their
Sundays. Alexander Ionides was a wealthy Greek merchant and

a patron of art. His sons, Luke and Alec, were friends and ad-
mirers of Whistler, who was in love with their married sister.
But Whistler exceeded the average young man's allowance of
love-affairs. Most women who were reasonably pretty or well-
formed attracted him, and he had a way of winning their affec-
tion by keeping them constantly amused. Perhaps Du Maurier
slightly exaggerated his tactics when comparing him with another
fellow who scientifically studied a woman's peculiarities in order to
ingratiate himself with her: "Our friend Jimmy would be down
on his knees directly he saw her and pulling up her petticoat, etc."
All the same Whistler could even get drunk at a party without
alienating the female guests. In January '61 he took part in some
theatricals at the house of a family named Major. Apparently he
got very drunk at supper "and misbehaved himself in many
ways." One way was to take the hat of Rosa Major and keep it
on his own head. Later she discovered that someone had spat into
it, and thinking to shame Whistler gave it him on that account.
He accepted it with glee, saying "By jove, Miss Rosa, if that's the
way things are obtained in your family, I only regret I didn't spit
in your hand!" The hat was soon adorning the head of his model
and mistress, Jo.

She was an Irish girl with lovely gold-red hair. Her name was
Joanna Heffernan, and her father Patrick was a sort of stage-Irish-
man who, after Jo had graduated from model to mistress, spoke of
Whistler as "me son-in-law." She was intelligent, sympathetic
and pretty. For about ten years she lived with Whistler, posing
for some of his best early work, such as *The White Girl*, and *The
Little White Girl*, acting as his agent and house-keeper, selling his
pictures, keeping his creditors at bay, and managing his affairs.
She herself did a certain amount of drawing and painting, dispos-
ing of her work to art dealers who knew her as Mrs Abbott, the
christian name that Whistler had discarded. She must have been
of an accommodating nature, for some little time after they had
begun life together she adopted Whistler's natural son John, whom
he described as "an infidelity to Jo."

All Whistler's friends knew Jo, who accompanied him every-
where except to the respectable households where secrecy was the
one excuse for sexual irregularity. She was with him at Wapping,
where his friends visited him and took part in noisy dinner-
parties along with the local inhabitants, painters and publicans

in clamorous accord. In one of his pictures Jo appeared with rather more of her breast visible than, in the opinion of his friends, the Royal Academy would tolerate; but he threatened that if it were rejected because of that, he would expose more and more of her until he became an R.A. and compelled them to exhibit the picture. She went with him to France in 1861, and he worked, first in Brittany and then in Paris, where Courbet as well as himself did portraits of her. At the end of that year he had an attack of rheumatic fever and journeyed with Jo to the Pyrenees, staying at Guéthary, near Biarritz, at which he painted a famous picture, *The Blue Wave*, and nearly got drowned. He was swimming in a rough sea towards sunset when the waves overcame him and he swallowed a good deal of water while battling with them. The harder he swam the further he seemed to get from the shore; and it was exasperating to know that the unhelpful onlookers were commenting admiringly on his prowess: "But the *Monsieur* amuses himself; he must be strong." He yelled for assistance, but no one seemed to think he wanted it until his head had disappeared three or four times. Then Jo and a male member of the audience perceived his plight, dashed into the sea, and managed to pull him out of it.

They crossed the Spanish border and put in a few days at Fuenterrabia. He wished to visit Madrid in order to see the pictures of Velasquez, and wrote begging Fantin-Latour to make the pilgrimage with him. But nothing came of it, and Whistler returned to Paris, where in the Boulevard des Batignolles he completed *The White Girl* in a studio hung in white. Ernest Delannoy lived with them at Whistler's expense, and seems to have been facetious at Jo's expense, for there was a good deal of bickering between the two. Apparently Whistler caught the infection, and relieved himself by fighting a hackney coachman. But Parisian bohemianism was now to end, and for many years he was to live among the London bourgeoisie, against whom he maintained continual strife. It almost seemed as if he were planning a campaign of words, backed by a display of blows, for his pithy remarks about other men were already being quoted and he took boxing lessons from a professional pugilist whose place of training was behind the Regent Street Quadrant.

Some of his acid sayings about patrons and painters date from the early sixties. An old barrister named Sergeant Thomas was

keenly interested in Whistler's etchings, bought them, exhibited them, and helped him to print them. Then something happened to provoke disagreements, and Whistler began to send pungent notes. While their correspondence was in progress Thomas died, and Whistler's comment to Du Maurier was: "I wrote to the old scoundrel, and he died in answer by return of post—the very best thing he could do." No doubt the comment was repeated wherever he went. But Thomas gave him good prices, and the exhibition did him a lot of good. In 1863 he was able to take his first house, now 101 Cheyne Walk, not far from the cottage where Turner had lived a few years before; but Whistler was not impressed by the man who had brought distinction to the district. At a party given by an artist, Tom Jeckyll, there was a hot argument about Turner, and Whistler criticised him for being so particular about the way his work should be mounted. "Particular!" exclaimed someone; "why, he'd leave his pictures in his courtyard to be pissed against!" "Well, that accounts for some of the damned peculiarities we're obliged to swallow!" returned Whistler. At a much later date he was asked by a lady to determine whether a picture she had been advised to buy was a genuine or a sham Turner. Having refused to judge the question, he added: "But, after all, isn't the distinction a very subtle one?"

The trouble with a patron is that he is liable to patronise; and Seymour Haden, having bought Whistler's pictures, encouraged his friends, and introduced him to useful people, had begun to criticise his work. That was bad enough; but when Haden dared to criticise his conduct, the situation became intolerable. It was all the more maddening because Whistler had lately done a second and more remarkable painting of his sister's household, *The Music Room*, and a wonderful etching of his sister's daughter, Annie Haden. But fond though he was of his sister and niece, he could not endure to be lectured on morals or criticised as an artist by a man whose opinions he despised; and when Seymour Haden, replying to an invitation, refused to dine at Whistler's new house unless Jo were not present, the sparks began to fly. Haden had not objected to meeting Jo elsewhere; he had travelled with them, dined with them, painted with them, but he could not countenance her as the mistress of a house where his wife might call, the home of a respectable artist and taxpayer. Whistler, in a rage, went to 62 Sloane Street and spoke his mind. Haden, indig-

nant, severely reprimanded him. Whistler marched out of the studio at the top of the house and descended the stairs; Haden pursued him, scolding all the way. At the front door Whistler found that he had left his hat upstairs, said wearily "And now, have we to go through this all over again?" and went back for it. It was difficult to satisfy the Victorian sense of propriety. One of Du Maurier's friends, Bill Henley, broke the hearts of his mother and father by marrying his one-time mistress in order "to do her proper justice before the world." His parents spoke of him as "that ungrateful boy", refused to receive the female of whom he had made "an honest woman", and repulsed her when he took her to call on them. Du Maurier himself thought Bill's conduct heartless. It was an odd age.

But Jo had become a little awkward. She was rather inclined to act the *grande dame*, and some of Whistler's friends resented her superior airs. One of them was Legros, who lived with them. Such arrangements are never quite satisfactory, and there was trouble over money. Jo then took a dislike to him, and his relations with Whistler became cool. Later, it appears, Legros wanted to marry and become an Englishman. Whistler chaffed him unmercifully and rather disagreeably, and Jo was definitely rude to him. There were scenes and separations, but the final break did not occur until '67, when they met in the office of Luke Ionides and a quarrel started, the subject no doubt being Jo. Suddenly Ionides heard Legros say "You lie!" Whistler promptly hit him in the eye and knocked him down. Legros managed to pull some of Whistler's hair out, but the American won on points. After that they never spoke to one another. Legros achieved his ambition, married and became naturalised as an Englishman. On being asked why he had done so, he replied: "*Tiens!* by becoming an Englishman I have won the Battle of Waterloo." But the fact is that, as a Frenchman, he would have been compelled to pay his dead father's debts, a duty that did not appeal to Legros, who eventually became Slade Professor at University College, London. The "Society of Three" which Whistler had formed in Paris was not disbanded on account of this quarrel; but Albert Moore filled the place of Alphonse Legros.

Whistler must have had some tense moments with Jo before she left the house to make way for his mother, who quitted America at the outbreak of the Civil War and settled down with him at

Cheyne Walk, where the affectionate homage of her son was off-set by such shocks to her modesty as the sight of the parlourmaid posing for him in the nude.

Since his work was wholly out of tune with that of the older painters, and had little in common with that of his contemporaries, it cannot be said that his genius was unappreciated. Millais was much impressed by *At the Piano*, which was exhibited in 1860, and delighted Whistler with his praise: "I never flatter, but I will say that your picture is the finest piece of colour that has been seen on the walls of the Royal Academy for years." Thackeray wanted to meet the artist, but forgot to turn up at the house where they were to be introduced. Du Maurier thought his friend the greatest genius of the day, but was not displeased when the genius left him in peace, as "nothing is more fatiguing than an egotistical wit." Paintings and etchings by Whistler were exhibited every year in the early sixties at the Academy, though his picture of West-minster Bridge was hung so low in '63 that he threatened to cut it out of the frame with a penknife. Some sound judges consid-ered his etchings the best since Rembrandt's. His most original work, *The White Girl*, was however rejected by the Academy in '62, but exhibited in the Berners Street Gallery that summer and described by the proprietors, without his permission, *The Woman in White*. He had to contradict the impression that it had been inspired by Wilkie Collins's popular novel, which he had never read, and to assert that it illustrated nothing except itself: "My painting simply represents a girl dressed in white, standing in front of a white curtain." This was a daring statement at a time when every picture was supposed to tell a story.

While enjoying what he termed a *succès d'exécration* in London, *The White Girl* made a different sort of sensation in Paris, where Napoleon III had been influenced by the popular clamour against the *Salon des Beaux Arts*, which had just rejected works by Fantin-Latour, Legros, Manet, Bracquemond, Whistler and other artists. The Emperor therefore instituted a *Salon des Refusés* in 1863, which was held in the same building as the official *Salon*, and the works which the academicians had refused became the sensation of the hour. The two pictures which caused the greatest agitation were Whistler's *The White Girl* and Edouard Manet's *Le Bain* (afterwards known as *Déjeuner sur l'herbe*). The general public, faced with something unfamiliar, laughed at Whistler's effort and

were shocked by Manet's. The Emperor and Empress shared the public disapproval of *Le Bain*, on account of which there were to be no more *Salons des Refusés*. But some of the critics were encouraging, and one of them applied the word "symphony" to Whistler's picture long before it occurred to him that there was some relation between music and painting. He was admiring Rembrandt in Amsterdam when he heard of the excitement in Paris. Though he would have liked to participate in it, the temptation of the Thames was too strong for him, and he returned to the place where his soul was at home.

CHAPTER IV

Oriental

HE had etched the river, and had been hailed as a master of that art; but when his etchings became the rage of art-collectors he decided that etching was not a true art, destroyed many of his plates, and began painting the river in earnest. The critics told him that he was a born etcher but had no idea of colour, which convinced him that colour was his strong point and he studied closely the principles on which the Japanese artists had produced their remarkable colour-harmonies, mingling blue with green, placing different shades of the same hue side by side, and getting their effects by repetition. The purely decorative quality of Japanese painting became a major influence in his portraits, though gradually he individualised it and turned what was common to a school into something peculiar to himself.

The craze in the sixties and seventies for oriental pictures and porcelain was started in England by Whistler, who had introduced it from France, where Bracquemond had "discovered" Japan in a small volume of Hokusai which had been used for packing china and saved by the printer Delâtre. The volume caused great excitement among the painters, and very soon Edouard Manet, Fantin-Latour, Degas and Tissot were among the enthusiasts, while the Goncourt brothers, Baudelaire and Zola sang the praises of Japanese art. For Whistler it was a revelation, the benefit of which he passed on to Dante Gabriel Rossetti, who had been introduced to him by Swinburne in '63. Very soon Rossetti developed a passion for blue and white china, and he took Whistler to see the manager of an oriental warehouse in Regent Street named Lazenby Liberty, who afterwards opened a shop of his own at the height of the aesthetic craze. Thereafter Whistler and Rossetti bought and talked Chinese porcelain and Japanese prints, and led the cult which was so soon to make the fortunes of innumerable dealers.

Rossetti lived nearby in Cheyne Walk; both Swinburne and Meredith lodged with him for a while; and Whistler was a daily visitor. The four men, according to George Du Maurier, were "as thick as thieves", displaying contempt for everyone except themselves and admiration for one another. It is doubtful whether Meredith was as much in harmony with the others as Du Maurier suggests, for there was soon a quarrel between him and Rossetti, and many years afterwards Whistler gave an unflattering description of Meredith's contributions to their debates. They used, he said, to compete in wit: "Mine was spontaneous, as you may guess, and sometimes the others were not bad: at least they said whatever popped into their heads. But this fellow (Meredith) used to sit back, his head sunk in his chest, his eyes closed, looking like a stupid Buddha in a second-rate temple, and paying not the slightest attention to the rest of us. Then he would suddenly come to, heave himself like a mountain about to deliver itself of a mouse, and get off some pompous epigram apropos of nothing." Swinburne on the other hand was a very friendly little fellow, and Whistler liked him as much as he admired Whistler. He was devoted to Whistler's mother too, and recited his poems to her. Once he got carried away by the heady nature of his verse and fell down in a fit, being nursed back to health by Mrs Whistler. For some three or four years the poet and painter were on terms of friendly intimacy and aesthetic sympathy, and when Whistler painted *The Little White Girl* Swinburne wrote an ode on it which appeared in *Poems and Ballads* under the title "Before the Mirror". Whistler pasted the poem on the frame of his picture; and though the inevitable quarrel between the two men took place some twenty years later, Whistler was able to recall in the last year of his life that the ode had been "a rare and graceful tribute from the poet to the painter—a noble recognition of work by the production of a nobler one."

This was exceptional praise from Whistler, who did not treat with equal warmth a man he liked much better than Swinburne. When Rossetti framed a picture he had painted, he wrote a sonnet on the subject of the picture and read it to Whistler, who advised him to "take out the picture and frame the sonnet." In the early years of their acquaintanceship Whistler and Rossetti were more companionable than either of them became with anyone else. They had feelings, tastes and jokes in common, and each

had some effect on the other's work, though it must be remembered that it was Whistler who initiated the Japanese influence which was to revolutionise domestic interior decoration throughout England. At first Whistler thought Rossetti a great artist, but eventually came to the conclusion that he was not an artist but a gentleman, "the only white man in all that crowd of painters." What helped to cement their friendship was that they had a similar appreciation of the strange character and stranger antics of another human being, one of those curious folk who are liable to appear like tropical excrescences in any artistic, political or social movement, and who impress everyone connected with it by the bizarre, outrageous, irresponsible, flamboyant, piratical, adventurous, and endlessly comical qualities they impart to the routine of life.

There can never have been a more singular sample of this class than Charles Augustus Howell, who may or may not have been a Portuguese by birth but who decided to become a Portuguese aristocrat by adoption. An air of mystery surrounded him which he did his best to render opaque with a cloud of lies, each more monstrous and more amusing than the last. He had been the sheikh of a tribe in Morocco. He had earned his living as a diver for treasure. He had engineered a political conspiracy and fled for his life. In fact he had done everything possible to arouse the intense interest of those who would like to have done the same sort of things. He was Gil Blas, Robinson Crusoe, Aladdin, D'Artagnan; above all he was Münchausen, and his enormous fabrications, coupled with his picturesque personality, impressed a number of remarkable Victorians, who took him at his face's value and his tongue's truth, trusting him implicitly until he gave them cause to see him from a different angle and hear him with less faith.

The first to be disillusioned was Ruskin, who employed him as private secretary and almoner. Much money passed through Howell's hands, meant by Ruskin for those who needed it; but no one needed it more than Howell, and a good deal passed from his hands to his pockets. When all Ruskin's spare cash had been spent, and he discovered that Howell had been the chief beneficiary, he became bitter and thereafter suspected many people who deserved his confidence. Howell then formed an intimacy with Swinburne, who, following the inescapable revelation of villainy, expressed himself in stronger terms than Ruskin allowed himself,

calling Howell a pole-cat and "the vilest wretch I ever came across", phrases induced by the blackmailing tactics of Howell, who threatened to publish some letters of a childishly improper kind written by the poet. Burne-Jones was the next innocent marked out for sacrifice, but he was more reserved and prudent by nature than Ruskin and Swinburne, and did not lay himself open to theft or blackmail before he followed their example and renounced the ruffian.

When they discovered him to be a liar and thief, a forger and confidence-trickster, Whistler and Rossetti did not react to Howell's personality as Ruskin and Swinburne had done. They enjoyed the preposterous tales of his adventures, knowing quite well that they had never happened, and they laughed consumedly at his ridiculously funny stories, which were like no one else's. His features were striking, both powerful and intelligent, and his voice and manners were those of an actor. He could charm, fascinate, entertain, impress; he could produce fits of laughter with a story and dead silence with a glance; and he was always plausible, so that even those who knew him for what he was listened to him for what he was not. He would now be called a chain-smoker, for he never seemed to have a cigarette out of his mouth; and he was certainly a chain-talker, for his fortune depended on his powers of conversation.

He appointed himself a sort of middle-man for Rossetti and Whistler, selling their portraits and buying china for them. He ingratiated himself with everybody, persuaded people to meet one another, made himself indispensable to those who trusted him, borrowed money from all and sundry. Always in tearing high spirits, he exuded enthusiasm, bubbled over with schemes, threw out ideas; he was ingenious, exciting, captivating. He made himself extremely useful to Rossetti and Whistler, which was one of the reasons why they put up with him; and though he stole their works, he got them good prices for those he did not steal. The latest Howell exploit was always a theme for laughter between them, and balancing profit with loss they thought his personality a fair price for his infamy. Lord Redesdale rebuked Whistler for going about with Howell, whom he called a robber. "So was Barrabas", curtly rejoined Whistler. Howell shared his passion for collecting china, silver and other rarities, though Howell's main preoccupation was the collecting of cash. At the height of his for-

tune he made a house out of several cottages on Selsey Bill, where he gave treats to innumerable children, playing their games, telling them stories, and passing as a great benefactor in the neighbourhood, though the real benefactors were anonymous. He encouraged Rossetti to dabble in spiritualism, and persuaded him to consent to the exhumation of his wife for the recovery of the manuscript of poems that had been buried with her. Howell superintended the exhumation and restored the manuscript to Rossetti in October '69.

Whistler never tired of describing Howell's oddities and adventures, and Howell was sometimes amusing at Whistler's expense, as when he said that to go and see Whistler, who had decorated his Chelsea house in his favourite yellow colour, heightened by white in places, was like "standing inside an egg." But in time the novelty wore off, and when, after the Ruskin case, Howell exclaimed "If only I had been subpoenaed as a witness at the trial!" Whistler retorted "You would have won the case and we should all have been in Newgate." We may finish with Howell here, though the final rupture between him and Whistler did not take place until the issue of *The Paddon Papers* or *The Owl and the Cabinet*, privately printed in March 1882. Paddon was a diamond merchant who had bought some black Chinese ware from Howell, who had described it as of great rarity. But soon after the deal Paddon discovered black pots of a precisely similar kind in an Oxford Street shop, any quantity of which could be had for very little. This episode was the theme of some correspondence in *The Paddon Papers*, the rest of which was taken up by Whistler's account of a Japanese cabinet which a connoisseur named Sydney Morse wished to buy from him. Howell undertook to arrange the transaction, as Whistler was leaving for Venice. Having seen Morse and settled the price, which was immediately paid, Howell called on a pawnbroker and said that he wished to borrow money on the cabinet. After viewing it, the pawnbroker agreed to advance the money, which he would bring with him when he collected the cabinet. But that sort of collection was not in Howell's scheme. He wanted the money at once, and removing the top from the cabinet he told the man that he could take it as a guarantee if he would hand over the cash on the spot. The man did so. On the next day Morse sent for the cabinet, and Howell explained with regret that the top had been broken and sent to a cabinet-

maker for repair. Thereupon Morse took the cabinet minus the top. When the pawnbroker called for the cabinet, Howell told him that an accident had happened to it and that it was being repaired. This state of things lasted for some time, purchaser and pawnbroker getting angrier and angrier. When Whistler returned from Venice, he heard what had happened from Morse and the pawnbroker, paid the latter what he had advanced, redeemed the top of the cabinet, handed it to Morse, and then confronted Howell with his iniquities. Whistler told the story with relish wherever he went, but after he printed it Howell thought the joke had gone too far and closed an acquaintanceship that had been profitable to them both.

Howell's death was as mysterious as his life. He was found in a gutter outside a Chelsea public house with his throat slit and half a sovereign firmly fixed between his teeth. He died in a few days at the Home Hospital, 16 Fitzroy Square, on April 24th, 1890. When Whistler was told of the various objects left by Howell that were auctioned at Christie's, he gave the names of the real proprietors: "That was Rossetti's—that's mine—that's Swinburne's", etc. But he was not in the least annoyed: "Howell was really wonderful, you know. You couldn't keep anything from him, and you always did exactly as he told you. That picture"—he pointed to his own portrait of Rosa Corder—"is, I firmly believe, the only thing Howell ever paid for in his life. I was amazed when I got the cheque, and I only remembered some months afterwards that he had paid me out of my own money which I had lent him the week before."

It is curious to reflect that Whistler ever did as he was told. Normally, others did as he told them. He was by nature a master, not a disciple. Very early in his London years he began to collect followers, who expanded into a crowd of worshippers as time went on, and contracted into a selection of cautious appraisers as time went further on. His earliest disciples were two boatmen, Walter and Harry Greaves, whose father had rowed Turner about the Thames. The youngsters were ambitious to become painters, and in return for giving him lessons in rowing Whistler taught them how to paint. They spent hours together on the water, at night, in the dawn and in the evening, when Whistler made notes for his Nocturnes with black and white chalk on brown paper, painting his pictures from memory aided by these slight

sketches made in the dark or twilight. They were sometimes accompanied by Albert Moore, an artist for whom Whistler always expressed admiration, largely because he was devoted heart and soul to his work, thought of nothing else, sacrificed money and notoriety for it, lived for it, and shared Whistler's contempt for the academicians. While still in his twenties Moore was offered the job of decorating the frieze round the exterior of the Albert Hall; but a dispute arose about the price; he refused to accept the sum proposed, which was too small for the labour entailed; and the job was eventually done by a syndicate of artists, Poynter being one of them, each of the six adorning so many square feet. Moore was seven years younger than Whistler and died ten years before him; and though a coolness entered into their relationship towards the end, an atmosphere that seemed un- avoidable in the later phases of Whistler's friendships, the older man paid tribute to his companion of a less exacting period: "The greatest artist that, in the century, England might have cared for and called her own. How sad for him to live there; how mad to die in that land of important ignorance and Beadledom." Whistler was in Paris when he wrote those words, little realising that he would be smitten with a similar insanity.

But in the sixties they were young and carefree and unembit- tered by the critics and professors, and spoke their minds freely to one another as the brothers Greaves rowed them along the dark- ling Thames, with the lights of Cremorne Gardens on the north- ern side and the woods and fields of Surrey to the south. Whistler was still living a bohemian life. He kept open house and the oddest people congregated there, artists, models, organ-grinders, boatmen, parasites. One of the last, invited to stay the night because it was raining, remained for three years. He played the piano, was amiable, and, being unenthusiastic, restful. Whistler's mother objected to having a loafer permanently about the house, but Jimmy reasoned with her: "My dear Mummy, who else is there to whom one could say 'play' and he would play, and 'Stop playing' and he would stop right away?" He drank rather too much whisky, but when his host remarked on it he replied: "What can I do? I belong to a thirsty family, a family that needs whisky. My mother is always thirsty too." He lived with them until Whistler had a serious illness, when he was tactful enough to perceive that he was in the way, and went to stay with someone

else. Occasionally Whistler took a motley crew of males and females to Cremorne Gardens, a turbulent place of recreation, where brawls, free fights and forcible ejections often took place, and where the grounds were frequently illuminated by fireworks, the visitors no less frequently lit up by spirits. At home, too, life was inclined to be rowdy. Women called and sometimes quarrelled; there was a drunken captain next door the habits of whose pigeons were disagreeable, but who chased Whistler out of doors with a sword when he called to complain; and a hurdy-gurdy was played in the front garden at the artist's request when he felt the need of harmony. He was a regular visitor at the house of Mrs Greaves close to his own, and here he danced by the hour while one of the brothers or their sister played, and took part in games of cards, and amused everyone with his realistic imitations of people.

The Greaves brothers were for many years his pupils and slavish admirers, working for him in countless ways, and copying him in everything. All three occasionally attended an evening life class held by a Frenchman named Barthe in Limerston Street. They would come late, and the rest of the class would be made aware of their arrival by the sudden pulling back of the curtain before the door, the usher being Walter or Harry Greaves. Then Whistler made a royal entrance, said "Good evening" brightly to everyone, carefully removed his gloves, handed his hat to one of the brothers, who treated it like a mitre, wiped his brow and moustache with a handkerchief, arranged his materials, and took a seat. The brothers went through the same motions ritualistically, and sat on each side of him, industriously drawing, not from the model, but from his drawing of the model. When he rolled a cigarette, they did the same; when he puffed, they puffed; when he threw his away, they threw theirs. One of the students under Barthe was a future novelist, George Moore, who found Whistler's jokes disagreeable and noted that everyone crowded round him during the rests between work. The model, Mary Lewis, who also posed for Whistler in his studio, used to sit and talk with him at these intervals. But on one occasion Oliver, son of Ford Madox Brown, read a novel he had just written to the class, and Mary sat enthralled. She even asked him to go on reading when work recommenced. Temporarily neglected, Whistler looked "as cross as an armful of cats", Moore observed, and when the reading was

continued at the end of the sitting, and Mary stopped to hear it, Whistler departed in a pique. But this unsympathetic description may have been due to another episode. Moore went to call on Whistler and found him discoursing to a crowd of satellites on oriental art. Taking one of them aside, Moore asked him to explain how faces represented on a Japanese screen by two or three lines and a couple of dots could be considered well drawn. This blasphemous question terrified the man, who gave a hurried answer and quickly rejoined the circle round Whistler, who was laughing boisterously and rattling iced drinks from glass to glass. "I think that I despised and hated him when he capped my somewhat foolish enthusiasm for the pre-Raphaelite painters with a comic anecdote", wrote Moore some forty years later.

The Greaves brothers were faithful to the master for many years, but there was a fatality about Whistler's relationships. Sometime in the seventies he held an exhibition, and when it was over he asked if they had seen it. They confessed that they had not, which was tantamount to treason. Noting a dangerous look in his face, and to save their own, they assured him that they had not meant anything by not going, which made him almost inarticulate. "If you *had* meant anything . . .!" but language was a feeble medium for feelings such as his. Shortly afterwards they told a friend that they were painting pictures on Whistler's method up to Academy pitch. This information reached the master's ears, but his comment, if printable, was not reported.

While there was nothing academical about his method, the dons of painting were sufficiently impressed by his work in the sixties to accept it. *The Little White Girl* was exhibited by the Royal Academy in '65, and *La Princesse du Pays de la Porcelaine* by the *Salon*. Jo was the model for the first, Christine Spartali, daughter of the Greek Consul General in London, for the second. The English critics did not like the Girl, the French critics commented unfavourably on the Princess. Whistler was still under the influence of Japanese art, but he was beginning to develop his own style, which had nothing in common with the Pre-Raphaelites in England, nor with the Impressionists in France, and for many years his paintings aroused increasing hostility in both countries. It was in connection with the Princess picture that his famous Butterfly signature began to be evolved, though the sting was added much later for the benefit of his critics. The first offer

for the picture was made by a man who objected to Whistler's signature because it spoiled the composition. Whistler flatly refused to sell his work to one who was clearly unworthy to possess it. Rossetti then managed to find him another purchaser, and at the same time drew a sort of eastern design containing Whistler's initials. The drawing appealed to Whistler, who developed the idea until, out of the letters J.M.W., something like a butterfly appeared. The insect became more and more clearly defined, and gradually he perfected it to his own satisfaction. In time it appeared as an important detail in all his pictures, its exact placing being most carefully considered, and eventually it adorned his books and took the place of his ordinary signature in his letters to the press and his private correspondence.

The advent of the butterfly seemed to harmonise with Whistler's mood at that moment. He too showed a desire to flit without apparent purpose. His brother Willie, who had served with distinction with the Confederate army in the Civil War as a surgeon, came to England in the spring of 1865 with despatches from his Government. Within a week of his arrival in London, the southern forces were finally defeated, the war was over, and he remained in England, That autumn Whistler was painting at Trouville with Courbet, Jo being with them. But he was back in London by November, and met many ex-soldiers from the Confederate army, who were looking for easy jobs and longing for any adventure. Wars invariably breed in those who do the fighting an indifference to danger and a love of loot. Talking with these men Whistler was infected with their spirit, more especially as he was conscious that he had not shown the true West Point spirit by joining in the recent conflict and fighting side by side with some of his old comrades. He probably felt rather ashamed of himself and was ready for any opportunity to assert his manhood and prove that he was the son of his father, not to mention the grandson of his grandfather. Anyhow the chance came early in '66, when he left England with a number of other heroes to help Chile and Peru against Spain. His later accounts of what happened on this expedition varied considerably; but some of the details must have been true because they accord with our knowledge of him. In separating the chaff from the wheat, we must give prominence to the chaff as more likely to reveal the truth about himself.

He left Southampton for Panama, where the isthmus was crossed, "and it was all very awful—earthquakes and things." He wanted to return home. Arrived at Valparaiso, he could not for the moment enjoy the beautiful bay because bits of the English, French, American, Russian and Spanish fleets were fooling about inartistically in the middle distances. But a day after his arrival they sailed out to sea, all except the Spanish fleet, which took up a position fronting the town and began to blaze away at the Chilians, who made themselves scarce. Whistler with a number of government officials rode over to the opposite hills where they could obtain a good view of the show, which was conducted in a very courtly manner. Having ignited a few houses, the Spaniards felt that honour was satisfied, landed sailors to put out the fires, invited the other fleets back to the bay, and the point at issue was amicably settled in a few hours. But during the bombardment a stray shell happened to travel in the direction of the hills from which Whistler and the officials were enjoying the spectacle. "And then I knew what panic was", he afterwards related. "I and the officials turned and rode as hard as we could, anyhow, anywhere. The riding was splendid, and I, as a West Point man, was head of the procession." As they cantered back into the town after the performance was over, the little girls in the streets called out "Cowards!" but the circumstance did not spoil their appetite for breakfast. Having played at soldiering, Whistler began to paint in earnest, producing three pictures of Valparaiso harbour, one of which, his first Nocturne, survived a number of apochryphal adventures and is now in the Tate Gallery, London.

On the return voyage he made up for his lack of martial exploits in Chile by quarrelling with a negro from Haiti, to whom he always referred as the "Marquis de Marmalade". According to one of his accounts, he found the man in his cabin and knocked his head against the funnel. According to another, he objected to the nigger's swagger on deck and kicked him down the companion way. The captain would not tolerate these proceedings, and confined Whistler to his cabin for the rest of the journey. On arrival at Waterloo station in London, hostilities broke out afresh; Whistler fought with someone on the platform; and the only damage he sustained during his expedition to help the oppressed Chilians and Peruvians against the might of Spain was a black eye.

CHAPTER V

Personal

THERE is a sense in which Whistler suffered from a permanent black eye. That is, he always felt that other people were trying to hit him, and he was seldom without a feeling of injury in his social relationships. Part of this feeling was due to the anger of one who has injured his opponent, but the greater part came from something deeper in his nature. He was an American who had no roots in his own country and had even disowned the place of his birth. His English ancestry gave him something in common with the people among whom he lived, but his nationality and upbringing placed him at a disadvantage with them. "It was Whistler's incessant preoccupation to present himself as having sprung completely armed from nowhere", said one of his most devoted disciples, Walter Sickert. He acknowledged no influence as a painter and no ascendancy as a personality: he was an isolated phenomenon. This attitude was caused, in the first place, by his southern sympathies and northern domicile in a country where two nations lived at variance, soon to meet

in the intestine shock
And furious close of civil butchery,

and then strengthened by his impressionable years in Russia, his repeated failures as a young man in America, his frolicsome phase in Paris, and his ultimate residence in London. So it came about that he was a citizen without a city, a stranger in his surroundings, something out of place, a tropical flower in a temperate climate. The one fixed point in his life was West Point, and he had been expelled from that. With the pride of an American went the pugnacity of an Englishman and the prickliness of an alien. Also he was an original artist in a country that revered and rewarded conventional art; and since his own work was extremely individual, his genius was not recognised by the French painters who

39

were breaking away from the fashions of their time; nor could he give them the recognition which they withheld from him. Add to all this that he was reacting against an inborn puritanism, and there is quite enough to account for the perpetual friction between himself and his contemporaries. Thus the story of his life is frequently a tale of quarrels, assaults, insults and injuries.

Soon after his return from Valparaiso he went to Paris, and while traversing an alley in the Latin Quarter a workman sprinkled him with plaster. Possibly mistaking him for an art-critic, Whistler battered the workman, who appealed to the law. Whistler countered this by appealing to the American Minister, and received an apology from the magistrate. In Paris he ran up against his brother-in-law Seymour Haden, who now represented most of the things to which he objected: respectability, the air of a patron, and criticism of Whistler. There was a violent dispute in a café, followed by physical combat and Haden's sudden appearance on the other side of a plate-glass window, through which his wife's brother had pushed him. This time the magistrate was less polite, and Whistler was fined. He was also, by Haden's influence, expelled from the Burlington Fine Arts Club; and the two never spoke to one another again. Then came Whistler's quarrel with Legros, another onslaught, and another lifelong estrangement. It was sometimes said that these angry interchanges did not reveal the real Whistler, and one of his disciples even suggested that it was a sort of game, the real fun of the thing being the descriptions afterwards given by the master. For example, he once caught a man in the act of washing his face, dashed his head into the basin, and while the victim was busy getting the soap out of his eyes everyone in the smoking-room was roaring with laughter over Whistler's account of the occurrence. To this it must be answered that the soapy-eyed fellow-clubman did not enjoy the joke, and that, while one hostile encounter might be regarded as an accident, a succession of them argues design. The explanation lies in the curious amalgam of contrary influences already disclosed.

Whistler was often called conceited, and there is no doubt that hostile criticism, by putting a man on the defensive, sometimes creates the effect of self-esteem. To the question "Do you think genius is hereditary?" he replied "I can't tell you, madam. Heaven has granted me no offspring." And when someone,

annoyed by his bragging, grumbled "It's a good thing we can't see ourselves as others see us", he rejoined "Isn't it! I know in my case I should grow intolerably conceited." But though he was also reported as saying "I myself am compelled to stand on tip-toes to reach my own height", we must remember that such remarks, made on the spur of the moment with the intention of startling a bore or deflating another's pretentiousness, must not be taken as the expression of his true feelings, which will be apparent when we consider him as an artist. All that need be said here is that a modest man often seems conceited because he is delighted with what he has done, thinking it better than anything of which he believed himself capable; whereas the conceited man is inclined to express dissatisfaction with his performances, thinking them unworthy of his genius.

Of vanity, however, Whistler had a full share. He was intensely concerned with the impression he made on the world, especially with his wit and his appearance. His wit, the armour of a sensitive being who thinks himself misunderstood, was of an arrogant and biting kind. "I am not arguing with you: I am telling you", was the attitude he adopted to all who did not share his views; but when a girl asked him why he was so unpleasant to so many people, his explanation lacked conviction: "My dear, I will tell you a secret. Early in life I made the discovery that I was charming, and if one is delightful one has to thrust the world away to keep from being bored to death." Certainly he succeeded in keeping the world at a distance, but it was because people at close quarters could be so very annoying. Nevertheless, his personal appearance was carefully calculated to attract the wonder of the world, if not its approval. "If I had only an old rag to cover me, I should wear it with such neatness and propriety—with the utmost distinction", he once declared. And this was true. Even when working in his studio he looked neat and trim, and when walking in the streets or paying calls or lunching at a restaurant he was smart to the point of dandyism. The silk hat, with its tall crown and straight brim, the perfectly fitting frock-coat, the yellow gloves, and the slim wand-like cane, twice the length of an ordinary walking-stick, marked him out as a man of fashion and wealth, though the fashion was singular and the wealth imaginary. In the summer he might be seen wearing a short black coat, white waistcoat, white duck trousers, pumps,

a low collar and a thin black tie with one long end across the waistcoat.

The total effect was obtained with the utmost care. He spent hours at his tailor's shop, closely attending to the cut of his clothes, looking at himself in the mirror from every angle, posing and preening himself. "You know, you must not let the Master appear badly clothed; it is your duty to see that I am well dressed", he would say to the tailor if one of his disciples were present. He even solicited the interest of other customers who happened to be in the shop, asking for their opinions on the fit of his coat, and they were pleased to act as audience and take an interest in the business. Once the tables were turned and his advice was sought. A customer rushed into the hat shop which he patronised and mistaking him for an employee lodged a complaint: "I say, this 'at doesn't fit!" Raising a monocle, Whistler eyed him carefully all over and went further: "Neither does your coat." The barber was another to be kept on his toes while attending to Whistler, who directed the cutting of every lock of hair, after which he dipped his head into a basin of water, half dried his hair, carefully picked out his single white lock with a comb, wrapped it in a towel, and walked about for some minutes pinching it dry. This white lock, which he said was inherited, appeared fairly early in life and became a sort of flag. It was over the right eye. He called it his "white feather" and said that it should be seen first whenever he entered a drawing-room. In the street his hat was tilted back to make the white lock visible. Having given it special treatment, either at home or at the barber's, he then allowed the rest of his hair, which was both thick and black, to fall around it in decorative ringlets. At the conclusion of the performance he would admire the effect in a glass and sum up his feelings with the word "Amazing!" He was fastidiously tidy in everything concerning his personal appearance, and when visiting people would stop in the hall to straighten what may have been displaced by wind or movement, giving a touch to his cravat, a stroke to his hair, and so forth. In this respect he was like a woman, and if it had not been so much a part of his personality even his disciples might have considered him ridiculously affected; but somehow he carried it all off without people thinking him in the least effeminate. He always dressed for dinner, and was inclined to be censorious of those who did not. He had a quicker eye for clothes than for

their wearers. "So you recognised me from behind?" said a poor American artist when Whistler called after him in the street. "Yes, I spied you through a hole in your coat", was the answer.

The make-up revealed the man, who was as smart as his clothes, as glossy as his hair. He was short and dapper. Not more than 5 feet 4 inches in height, he was excessively alive and alert, and his aggressive qualities may have been emphasised by his lack of inches. His complexion was bright and fresh, his grey-blue eyes were sharp and restless, his eyebrows black and thick, his nose and mouth sensitive, his chin was prominent and pugnacious, his brow wide, his hands were slender, his fingers tapering, and his long nails a trifle claw-like. Perhaps the head was a little too large and the feet were a trifle too small for the body, but otherwise he was well-proportioned. He reminded one man of a brisk ring-master, whip in hand, another of a magician, nimble, vigilant, sprightly. There was a sparkling, perky air about him, and his challenging manner was as arresting as his voice, which was strident, high-pitched, and so piercing that "even genius could not excuse such a voice", someone complained. He spoke with a queer accent, inclined to be English when talking to an American, definitely American when talking to an Englishman, but when not put on for a purpose it was a combination of American, English and French. His manners were very courteous; he never swore, never used vulgar language, never told coarse stories even in a club smoking-room, though he let off steam occasionally by writing bits of Rabelaisian doggerel. His conversation consisted largely of stories, mostly of himself, occasionally about other people, all told with enormous animation and zest, and punctuated with vivid little gestures, darting glances, telling pauses, the fixing and dropping of his monocle, the quick "Eh, what?" of his demand for approval, the rising inflection of his "Oh! oh!" to express surprise or scepticism, the sudden delighted "Ha-ha!" of his sympathy, the rasping and very disconcerting "Ha-ha!" of his enmity. The stories were a strange mixture of fancy, comedy and artificiality. The majority were founded on fact, though all were heightened and adorned for effect, and most were transposed from the third to the first person. There was, for example, the story of the goldfish which had been stolen by a hungry student in the Latin Quarter from his landlady, cooked, and ravenously

eaten. In Whistler's version the hero was himself, and the episode was turned into a feat of angling and a feast of comedy. Thus:

"I had no money, and fish was cheap, so I lived on fish. Fish for breakfast, fish for dinner, always fish. My landlady could only think in fish. The lodgings reeked with fish. Even the Thames. which I had beautified, became for me merely the home of fish. I tried to paint a portrait, but the face of my subject seemed scaly. Then one day I looked out of my window and up at the clouds, and behold! a mackerel-sky. So I looked down. Could I believe my eyes? At least I could believe my nose. There, in a bowl of water on my landlady's window-sill, were three goldfish swimming tauntingly at their ease. I resolved to teach her a lesson. Soon she would be bringing me a meal of fish. She, too, should have fish for her meal. I affixed a bent pin to a piece of string, baited the pin with bread, and let it down from my window into the bowl beneath. I am not a skilled fisherman, and I had to play for my fish a long time before they could see the joke. But at last I was rewarded with a bite. I hooked my first fish. After that the other two wanted to come up. I helped them to come. I am a good cook, as you know, and I fried them to a turn. Then I lowered them, one by one, into the bowl, with a charming note: 'Madam, you have cooked so many fish for me that I have ventured to cook some for you.' She was cured. She gave me no more fish. She gave me notice instead."[1]

All this with a wealth of gesticulation, an abundance of "eh, whats" and "oh-ohs" and "ha-has", and a whole language of pauses and suggestive intonations. The company was convulsed with merriment, not so much over what he said, but at the way he said it. He startled people into laughter with an unexpected phrase, a look of amazement, a sudden manual trick, a quick lifting of his bushy eyebrows, a humorous grimace. His sensitive fingers, alive to the tips, were those of a mesmerist, and a necessary accompaniment to his speech. His eyes glittered with vitality, and even the hair on his head seemed to be active. The whole performance was one of personality. The show depended upon the showman.

Whistler laughed much and loudly at his own good sayings, which sometimes deterred others from joining in whole-heartedly. His piercing, disturbing, eldritch "Ha-ha!" became a feature of his

[1] This story was recounted to the present author by Robert Ross in 1916.

character, and could sound so diabolical that Henry Irving copied it when playing Mephistopheles in *Faust*. To the outside world, and especially to his critics, Whistler often seemed a satanic figure. But to his friends, for as long as their friendship lasted, and to his disciples, for as long as he remained their Master, he was a fascinating creature. Though, as he once said, he liked "carefully to exasperate" people, he liked still more to charm them, and when he wished to be pleasant he could hypnotise them into believing what he said and doing what he wanted. As a host he could persuade his guests that they had eaten well, though the meal had really been a barmecidal one. His Sunday breakfasts were famous throughout the seventies, while he was living at 96 Cheyne Walk, to which he moved after his return from Valparaiso.

Oriental influences were at work in the decoration of his new house. The dining-room was blue, the dado and doors being of a darker shade of blue. Walls and ceiling were decorated with Japanese fans. The studio was grey, the dado and doors being black. He slept in a large Chinese bed and fed off blue and white Chinese porcelain. The drawing-room was painted on the day of his first dinner-party. With the help of the Greaves boys, he worked up to the last moment, and by the evening the walls were pale yellow, with a suggestion of pink, the doors and wainscot being white. The clothes of the guests that evening partook of the colours against which they brushed. Though he worked on the hall at intervals for some years, the only room in the house to be perfected was the dining-room; and this was nearly always so. At each of his later residences in the eighties and nineties people remembered the lemon yellow of the dining-room walls, the white cloth on the table, with a centrepiece of 'Old Blue' (or a bowl of goldfish if the china were in pawn), the blue-tiled hearth, and the Six Projects (sketches for pictures that were never painted) hanging on the walls. The rest of the house might or might not be distempered, and his callers always had the impression that he was in the act either of moving out or of moving in. The stairs were often uncarpeted; unpacked crates stood in the corridors; visitors sat on boxes or walked about. There was no comfort anywhere. He disliked easy chairs and anything that suggested laziness. He was incapable of lolling on a sofa, his feet in soft slippers. His chairs were neat and upright; he was always doing something; and he wore patent-leather shoes. "If you want to be comfortable,

go to bed", he would say. No one ever saw him spending a quiet evening at home, reading a book in an armchair by the fireside. He disliked solitude, and his activity was tireless. He lived on his brains and nerves, his mind being so restless that he could only sleep for a few hours at night.

He loved to be surrounded by people, and was to be seen and heard at his best when breakfast was on the table, at noon if his guests were lucky, an hour or two later if he had been working up to midday and then had to have a bath before making his appearance. Sometimes he could afford a cook; usually he did the cooking himself. On this subject he had a word to say: "I can't think why people make such a to-do about choosing a new cook. There is only one thing that is absolutely essential. I always ask at once 'Do you drink?' and if she says 'No' I bow politely and say that I am sorry but I fear that she will not suit. All *good* cooks drink." Which rather suggests that in his opinion all good cooks occasionally got drunk. If so, Whistler himself was an exception to that rule. Though an authority on wine, he was a moderate drinker. Except in his early days he seems to have been abstemious, though fortunately there was an occasion when he overstepped the mark. He had dined rather too well at the house of an American artist, George Boughton, and had left the table at the call of nature to go upstairs. He managed the ascent with dignity but returned more expeditiously, falling down a whole flight. When helped to his feet by an anxious host, he asked "Who is your architect?" Norman Shaw, he was told. "I might have known it—the damned teetotaller!" he exclaimed.

Whistler served wine at his Sunday breakfasts, good red wine if his creditors were obliging, cheap white wine if he had to pay spot cash. It was his belief that Englishmen knew the difference between good and bad red wine but had no discrimination when they were given white. The company at his table was limited to people who could amuse him or whom he could amuse. Seldom less than ten, scarcely ever more than twenty, were gathered together; and there was Whistler in the midst of them, serving dishes, filling glasses, telling jokes, sampling the food, tasting the wine, talking of art, joking about critics, laughing at academicians, chaffing his guests, and chatting endlessly of himself and his adventures, interspersing his stories with a crackle of laughter and a series of "d'ye knows?" and "eh, whats?" Buck-

wheat cakes, nearly always cooked by himself, were the main attraction on the bill of fare. Served hot, buttered, and eaten with treacle, their consumption by the Master and his disciples was almost a religious rite, and if any British islander objected to them he was banished for ever from the Master's company and board. Though an excellent cook, Whistler had some queer culinary habits. To harmonise with the plates, apple-green butter and tinted rice pudding sometimes appeared. But the dishes were always good; and such was the fascination of the man, his liveliness, his continuous sparkle, the insinuating charm of his manner, the comedy of his mannerisms, that people were enchanted, and only realised some time after leaving his house that, though he had given the impression of dispensing a sumptuous repast, they had eaten very little. There were, in fact, occasions when there was very little to eat. An Italian landscape painter named Martini, on being asked whether he had seen much of Whistler lately, replied: "He asks me a little while ago to breakfast, and I go. My cab-fare two shilling, 'arf crown. I arrive. Very nice. Gold-fish in bowl. Very pretty. But breakfast! One egg, one toast, no more. Ah, no! My cab-fare back, two shilling, 'arf crown. For me no more!"

When creditors were very pressing, and it was necessary to sell a picture, he was full of stratagems to meet the situation. Once he borrowed a few shillings from a friend, bought three bottles of cheap claret, and sealed the top of each with a different coloured wax. Then, when the prospective buyer, his friend and himself had taken their seats at the table, he gravely asked the maid to fetch a bottle with a red seal from the cellar. For the next course he told her to bring a bottle with a blue seal. With the dessert he ordered a bottle with a yellow seal. The purchaser was impressed, the picture was sold, and Whistler felt certain that the sealing-wax had done the trick. As a rule the quality of his company intimidated his tradesmen, who occasionally benefited from his praise of them by the addition of a peer or peeress to their list of customers. In time it became a distinction to meet him, and when someone remarked "The Prince of Wales says he knows you", he observed pleasantly "That's only his side."

But whether people knew him or not, liked him or disliked him, everyone recognised that he was unique, and until the appear-ance of Oscar Wilde on the London scene he had no rival either

as a wit or as a personality. "The most remarkable men I have known were Whistler and Oscar Wilde", wrote Ellen Terry, who had met every notable figure of her time. "This does not imply that I liked them better or admired them more than others, but there was something about both of them more instantaneously individual and audacious than it is possible to describe." Another aspect of Whistler appealed to Graham Robertson, who had been on friendly terms with many leading men and women in the artistic world of his generation: "Certainly the two most vital people that I have ever known were Whistler and Sarah Bernhardt." But perhaps the most moving tribute was paid by a onetime disciple who was afterwards outlawed and publicly insulted by the Master. Five years after his death Walter Sickert described Whistler as "a beacon of light and happiness to everyone who was privileged to come within its comforting and brightening rays. If, as it seems to me, humanity is composed of but two categories, the invalids and the nurses, Whistler was certainly one of the nurses."

Artistic

IT is only by being unaware of the facts that one creates anything. That was roughly Whistler's feeling about painting and conversation. "When a tiresome person bears down on you with a stodgy array of learning and argumentation, what you've got to do is simply to say 'Stocking!' Don't you know? Ha-ha! That's it! That's controversy! 'Stocking!' What can they say to that?" Shakespeare felt much the same about it, dealing with astronomers, the main knowledge-purveyors of his time, in a less abrupt style:

> These earthly godfathers of heaven's lights,
> That give a name to every fixed star,
> Have no more profit of their shining nights,
> Than those that walk and wot not what they are.

Nature in the raw, or considered as a science, made no appeal to Whistler, who was an artist in its most artificial sense. He did not like rural scenery, rural pursuits, or anything that was rural. He was bored in the country, and used to beg his friends who lived therein to come up to town for a breath of fresh air. Once he went out shooting and peppered a dog, explaining that "It was a dog without artistic habits, and had placed itself badly in relation to the landscape." When someone expressed a wish to live in the country, Whistler wanted to know why. "The country is detestable", he said. "In Holland it is different. There I can see something." "But there is no country in Holland." "And that is just why I like it. No great full-blown shapeless trees as in England, but everything neat and trim. The trunks of the trees are painted white; the cows wear quilts; and it is all 'arranged' and charming."

He scorned pedantic accuracy and photographic actuality. "Those are trees, I suppose", said a visitor indicating a dark patch

in one of his Nocturnes. "Very possibly. I don't know", replied
Whistler. While he was drawing some chimneys across the river
Walter Greaves dared to say "But, Mr Whistler, they are not
straight." "But they are Whistler's", said he. Now and then he
disparaged his beloved river at night-time when he liked it best,
and a disciple would put in a good word for the sky. "The stars
are fine tonight." "Not bad, but there are too many of them."
The sun was never permitted to throw its rays into the studio
while he was working. "When I paint an outdoor picture in bril-
liant sunshine, I want to have all the sunshine I can get in my
studio", remarked a man who was not in sympathy with his
methods. "And so, I suppose, if you were a musician and wanted
to compose a blacksmith's chorus, you would go to the smithy's
and put your ear close to the anvil, and get all the noise you
could", Whistler rejoined.

His advice to artists was that they should paint exactly what
they saw, not in the style of this or that man, but just how things
appeared to them. Neither the sun or the moon could be painted
as it really was, nor a tree. Above all, he told his disciples not to
be what was known as "strong". Paint should not be applied
thick. It should be like breath on the surface of a pane of glass:
"When a picture smells of paint, it's what they call 'strong'." The
great curse of modern painting, he declared, was that with every
stroke of the brush the painter said to himself "That's another sove-
reign in my pocket." When he introduced the phrase "Art for
Art's sake" into England, he meant that art was its own justifica-
tion and reward, though he too was in revolt against the idea that
art should have any moral significance. A picture existed in its
own right, its merit having nothing whatever to do with any out-
side interest, religious, dramatic, emotional, legendary, literary or
local, with which it might be invested. In order to emphasise
this, he called his own pictures "harmonies", "arrangements",
"nocturnes", "symphonies", though he well knew that he could
make mor money if he gave them extraneous associations, such
as love, pity, patriotism, poverty, ecstasy, and so forth, the emo-
tion or the anecdote so beloved of the public and so lavishly sup-
plied by popular artists. To illustrate his meaning, he would
point to his picture of a snow-scene with a single black figure
making its way through the gloom to a brilliantly lighted tavern,
which he called *Harmony in Grey and Gold:* "Now that to me is a

harmony of colour only. I care nothing for the past, present, or future of the black figure—placed there because the black was wanted at that spot. All that I know is that my combination of grey and gold satisfies my artistic feeling. Now this is precisely what many of my friends will not grasp. They say 'Why not call it Trotty Veck, and sell it for a round harmony of golden guineas?' I reply simply that I will do nothing of the kind. Not even the genius of Dickens should be invoked to lend an adventitious aid to art of another kind from his."

Just as he disliked the hard actuality of day, so he loved the softness of twilight and the mystery of night. Most people, he said, liked "the sort of day when, if you look across the river, you can count the wires in the canary bird's cage on the other side." He liked the sort of day when the mist veiled the objects of nature and the works of man, giving them a transcendental quality which stirred his imagination. Apart from the inexplicable qualities in a human being which are manifested in works of genius, Whistler's strong attraction to the dim tones of nature after sundown expressed his dissatisfaction with the uncomfortable reality of life, and was the creative aspect of his hostile feeling towards the world and his bitter quarrels with his fellow-mortals. Thus we may trace his paintings to his discontent, his Nocturnes to his isolation.

But his joy and absorption in the work were intense. "The painting of Nature should be done at home", he asserted, and we again remark his objection to visual reality. His pictures were his imaginative recreation of what he had seen with his eyes, beauty based on verity. The Nocturnes, for all their apparent ease, were the fruit of great care and concentration. As already stated, he made his notes or sketches with black and white chalk on brown paper, either while rowing on the river or when strolling upon its shore. Leaning on the embankment wall, he would look long and steadily at a scene that appealed to his fancy, taking in all the details until the picture was stamped in his mind. If he had a companion, he would turn his back to the river and test his memory, saying in a sort of chant: "The sky is lighter than the water, the houses darkest. There are eight houses, the second is the lowest, the fifth the highest; the tone of all is the same. The first has two lighted windows, one above the other; the second has four . . ." and so on. If his companion said he was at fault on some point, he

would turn round, look again, correct his mistake, turn again, and once more recite from memory. This might happen a dozen times; and when satisfied that he had mentally photographed the scene aright, he would say "Good-night", go home to bed, and paint his Nocturne the following day. Sometimes his memory would fail him after he had started the picture. Then he would either stop work for the day or begin something else, and return that evening to refresh his memory. If Nature were in an obstinate mood and refused to reproduce the effect he wanted, he would patiently return, evening after evening, until she did.

Like all first-rate work in whatever art, his Nocturnes seemed too facile to be taken seriously by the critics, who always confuse an appearance of laboriousness with profundity of thought or feeling, until their judgments are upset by time. He did not help the process of appreciation by the praise he gave to his own work, his superlatives damping the ardour of admirers, who found it difficult and exhausting to cap them. The most slavish disciple would have been reduced to a mumbled affirmative on hearing him say: "In my pictures there is no cleverness, no brush-work, nothing to astonish and bewilder, but simply a gradual, more perfect growth of beauty. It is this beauty my canvases reveal, not the way it is obtained." But the remarks of his that went from mouth to mouth until they became household words were made with the impish object of startling fools and shocking simpletons; for instance his reply to the gushing lady who said that she had just come up from the country along the Thames, "and there was an exquisite haze in the atmosphere which reminded me so much of some of your little things. It was a really perfect series of Whistlers." "Yes, madam", he returned with the utmost gravity: "Nature is creeping up." Or that still more famous reply to the female enthusiast who said that there were only two painters in the world, Whistler and Velasquez: "Why drag in Velasquez?" Asked by the American artist, William M. Chase, whether he had said this seriously, Whistler replied: "No, of course not. You don't suppose I couple myself with Velasquez, do you? I simply wanted to take her down."

He was indeed as critical of his own creations as he was painstaking. Nearly everyone complained of his habit of destroying a day's work which in his view was not as good as he could make it. Once a friend remonstrated with him for wiping a canvas

clean after he had spent many hours of concentrated effort upon it, saying that he should at least have left it till the morning. "No", said Whistler, "for if I had left it till tomorrow I might have persuaded myself that it was good enough to leave permanently." Again and again he sacrificed the labour of months because he was not pleased with it. Sometimes a picture would come right in an hour; other times it would take weeks; yet other times, try as he might, he could not obtain the effect he wanted. "*Mon Dieu, que c'est difficile!*" he once exclaimed to Fantin-Latour after working for days on a seascape. Nothing but his best satisfied him. Asked by a young artist whether a first picture was tolerable, Whistler rejoined "What is your opinion of a tolerable egg?" But the sayings of his that were remembered and repeated were those which exalted himself at the expense of others; and when he overheard a passer-by in Paris remark "Whistler thinks himself the greatest painter on earth", he was sufficiently irritated to stop and address the speaker: "Sir, I beg your acceptance of these ten centimes. Go buy yourself a little hay."

With his portraits he took infinite pains. The artist, he declared, should "put on canvas something more than the face the model wears for that one day", should paint the man as well as his features; otherwise he was a mere photographer. The result did not always please the model. "You can't call that a great work of art", complained a man who did not see himself as Whistler had portrayed him. "Perhaps not", replied the painter thoughtfully, "but then you can't call yourself a great work of nature." To an acquaintance of unattractive appearance who had pestered him, Whistler at last gave in: "Yes, I will paint you, but I hope you will not be offended if I make the portrait like." More often he refused to consider such applications and had to be impolite: "You are nobody, nothing from my point of view—just a conglomeration of bad colours." Unwelcome visitors to his studio were liable to the same sort of treatment: "Your tie is in G Major, and I am painting this symphony in E Minor. I will have to start it again." Something in a face or a figure had to awake in him the desire to express the feeling it evoked. "One wants the spirit, the aroma, don't ye know?" he explained. "If you paint a young girl, youth should scent the room; if a thinker, thoughts should be in the air; an aroma of the personality. . . . And with all that it should be a picture, a pattern, an arrangement, a harmony, such

as only a painter could conceive. . . ." He had learnt from the Japanese that a picture is part of the decoration of a wall, the easel-picture having replaced the murals of churches and palaces; and the subject of a portrait, he said, should be presented as seen in a room at a certain distance from the eye, enveloped in a certain atmosphere, not in high relief and standing out, as it were, in front of the frame "with the iris showing the reflection of the window and the hansom cab beyond it, upside down!"

The first sitting was entirely devoted to the arrangement of the subject; every detail in the pose and clothes was important and had to be adjusted to his taste. His palette was a table, his brushes were three feet long. Having settled everything, he surveyed his sitter for some time, and holding a brush at the extreme end of the handle, his arms stretched to their full extent, the portrait was finished in a series of runs. A touch here, followed by his retire-ment to the other end of the room, a long look, a dart at the can-vas, the addition of a touch there, and so on, backwards and for-wards, working at a great pace and talking ceaselessly either to himself or to a companion. More often than not, when the por-trait was completed and looked perfect, he would stand back, gaze at the sitter and the picture, cry "Ha!", dash at it, and with a kind of fury wipe it out and start all over again. The final per-formance may only have taken an hour or two, but it had been preceded by any number of rehearsals. The work was completed with innumerable touches and retouches, a constant running to and fro, a perpetual cacophony of chatter. So absorbed was he that nothing else existed. He could live without food. Meals came, cooled, went: he disregarded them. His subjects became his victims; he had no pity for them, and was wholly indifferent to their sufferings. They were there in the service of art. If they had dropped dead from exhaustion before the picture was fin-ished, it would have been a pity; but if they remained alive for as long as it was being painted, they had justified their existence, and could die as soon after as they liked. "In a moment, just a mo-ment," he would say if they complained of feeling faint from hunger or paralysed from immobility. But the moment stretched out to a minute, the minute to an hour; and so it went on. They posed; they posed again; they posed for hours on end, fifty, eighty, a hundred times. They experienced anger, boredom, misery, despair. Whistler worked on, unconscious of everything

except his art, oblivious of their pains and their prayers, and the darker it grew the harder he painted. Occasionally he would be asked for a copy of some portrait that had taken the fancy of a sitter or dealer; but he always refused with the words "A hen can't lay the same egg twice."

As with his paintings of nature, so with his portraits of men and women; he was far more concerned with the decorative effect than with the likeness; he did not aim at a fleeting impression but at a satisfying arrangement; and at a time when the French painters, after passing through a phase of realism, were becoming impressionists, Whistler remained what may be called a compositionist. "There is—there can be—no Art Nouveau—there is only Art!" he said, claiming too that "the artist's work is never better, never worse; it must be always good, in the end as in the beginning." His disciple, Walter Sickert, learnt from him that "there can no more be a new art, a new painting, a new drawing, than there can be a new arithmetic, new dynamics, or a new morality. . . . The error of the critical quidnunc is to suppose that the older things are superseded. They are not superseded. They have been added to. That is all." But Whistler perceived a distinction between the example of the French and English painters of that period: "In France they teach the student which end of the brush to put in his mouth, but in England it is all a matter of taste." The treatment he gave his pictures was also a matter of taste, which amazed some of his English confrères, for he placed his oil-paintings in his garden to become seasoned by wind, sunshine and rain. "It takes the gloss off them", he explained; "that objectionable gloss which puts one in mind of a painfully new hat."

His opinion on the subject of ownership was uncommon: "People imagine that just because they've paid £200 for a picture, it becomes their property. Absurd!" He had given his portrait of La Mère Gérard to Swinburne, but some years later decided that "Time has changed the condition of the gift, and therefore of course, as will be understood among gentlemen, the gift must be returned." The owner of one picture, who had been asked to send it to his studio for revarnishing, had the bad taste to demand its return after several weeks. He exploded: "Just think of it! Ten years ago this woman bought my picture for a ridiculously small sum, a mere bagatelle, a few pounds. She has had the

privilege of living with this masterpiece for ten whole years; and now she has the presumption to ask for it back again. Pshaw! the thing's unspeakable!" He considered that the true owner of a picture was its painter, and that the payment of a few paltry hundred pounds merely gave the so-called purchaser the right to have it in his house occasionally. His view with regard to gifts was amplified when a friend wished to sell a picture which had been presented to him by Whistler, who took possession of it in order, as the friend hoped, to negotiate the sale: "This picture was a gift. Now a gift implies a certain relation of esteem and affection between giver and receiver, and so long as that relation subsists the gift preserves its character as evidence of the relation. On the other hand to contemplate selling such a gift would imply a cessation of the relations by which the picture came into your possession. If you invite me to sell that picture for you, those relations have obviously ceased, and in short the picture must revert to the giver." The reversion took place, after which it was quite clear to the late owner that his relations with Whistler had ceased. The only person who adopted a philosophical view of these arrangements was Henry Labouchere, who had bought Whistler's picture of Connie Gilchrist (*The Gold Girl*) and returned it at the artist's request for some alteration. "That is ten years ago," said Labby with a laugh. "He is still not sufficiently satisfied with it to return my picture and I don't expect ever to see it again."

Neither Frenchmen nor Englishmen could understand a man who talked as Whistler did, and it is not surprising to hear that Degas said to him: "Whistler, if you were not a genius, you would be the most ridiculous man in Paris." The average English critic denied him genius and was antagonised by his wit. His first serious brush with one of them was when P. G. Hamerton, in *The Saturday Review*, wrote of *The Two Little White Girls*, renamed *Symphony in White No. III* when exhibited in the Academy of 1867, that it was not precisely a symphony in white, as one lady had a yellowish dress, brown hair and a bit of blue ribbon, the other a red fan. He further observed that flowers and green leaves appeared in the picture, and that one of the girls in white had reddish hair, while both of them had complexions of flesh-colour. Whistler considered the state of Hamerton's mind in a note to *The Saturday Review*: "*Bon Dieu!* did this wise person expect white hair and chalked faces? And does he then, in his

astounding consequence, believe that a symphony in F contains
no other note, but shall be a continued repetition of F F F? . . .
Fool!" The paper, however, had a tender feeling for its critic
and did not publish Whistler's note, which first appeared in the
Art Journal twenty years later.

Academicians as well as critics failed to appreciate his best work.
One of his undoubted masterpieces was sent to the Royal Aca-
demy of 1872. This was a portrait of his mother, to whom he was
devoted. Back in his early Paris days he happened to mention her
casually. "Your mother?" exclaimed Lamont: "Who would
have thought of you having a mother, Jimmy!" "Yes, indeed I
have a mother", was the reply, "and a very pretty bit of colour
she is, I can tell you." He treated her with the utmost deference,
always conducted her to the Chelsea parish church on Sunday
mornings, bowing ceremoniously as he left her at the door, and
carried his affectionate consideration for her feelings so far as to
promise that he would not work on the Sabbath, keeping his
promise whenever he remembered it. He called his portrait of
her *Arrangement in Grey and Black.* "Now that is what it is",
he explained to an interviewer. "To me it is interesting as a pic-
ture of my mother; but what can or ought the public to care
about the identity of the portrait? It must stand or fall on its
merits as an 'arrangement', and it very nearly fell; that's a fact."
The committee of the Royal Academy gave one look at it and
condemned it to the cellar of the rejected; but shortly after they
had done so, Sir William Boxall arrived, and, happening to see
"Picture by Whistler" on the list, asked where it was. "Down
among the dead men", chorused the committee, several of the
members describing it as "a thing", "a confounded 'arrange-
ment' or 'symphony' or something of the kind." Boxall promptly
said that he would not belong to a body that condemned one of
Whistler's pictures after a hasty glance, and threatened to resign.
There was a sharp discussion; but when Boxall took up his hat
and made as if to leave the room, the committee gave way, the
Arrangement was brought up from the cellar, reconsidered, and
finally hung. It was the last picture by Whistler to be seen at the
Academy, and thenceforth he was at open war with the panjan-
drums of painting. There is no doubt that he would at any time
have eagerly accepted election to the Academy on account of the
prestige it would have given him; but his individuality as an

artist and his wit as a man were against him, and he had to suffer the usual fate of genius when judged by talent. Since committees wish to survive, they have to put safety first, and if Whistler had been an R.A. his colleagues would have lived in jeopardy.

Early in the seventies, not long after he had painted his mother, came the second great portrait from his brush. The most eminent resident of Chelsea at that time was Thomas Carlyle, whom Whistler, sitting on the embankment wall with the Greaves brothers, had frequently seen walking along in melancholy contemplation. "A fine day, Mr Carlyle", one of them would say. "Tell me something, mon, I dinna ken", muttered the sage, passing by without looking at them. One of his friends brought him to see Whistler's picture of his mother, which probably gave Carlyle the notion that the artist might make him equally tranquil and pleasing to contemplate. So he agreed to sit, especially as it would enable him to talk, and turned up for the first sitting with the words "And now, mon, fire away!" Seeing that Whistler was not in sympathy with this injunction, he added "If ye're fighting battles or painting pictures, the only thing to do is to fire away!" Then he began to talk, while Whistler began to work, and the strange thing is that the talker was the first to tire. He came again and again and talked longer and longer, and Whistler, taking no notice of his jabber, painted in and painted out his face, and put in a touch here and took out a touch there, until the talker became increasingly restive and the painter ever more engrossed. Whistler, however, pricked up his ears when the prophet spoke of how Watts had painted him. Screens and curtains hid the portrait from his view while the work was in progress, and "there was much meestification." Then, one day, the screens were removed, the curtains drawn, and the portrait was revealed to the sitter. "How do you like it?" asked Watts. "Mon, I would have ye to know I am in the habit of wurin' clean lunen!" was Carlyle's verdict; and he was pleased to note that Whistler gave him clean linen. But he grumbled at the length and number of the sittings, thought it absurd that the artist should cry out "For God's sake don't move!" whenever he wished to shift his position, and flatly rebelled when "the creature", as he called Whistler, seemed to take more interest in his coat than in his face. Eventually someone else had to sit for the coat; and the finished work was called *Arrangement in Grey and Black, No. II.*

In 1891 the portrait of the artist's mother was bought by the
French Government for the Luxembourg at the parsimonious
price of four thousand francs. Whistler did not mind, as he was
glad that it should be chosen for the national collection in that
country. But he was more business-like over the Carlyle, which
was first offered to the British National Portrait Gallery, the
curator of which, Sir George Scharfe, on seeing it, asked "Has
painting come to this?" and refused to consider the purchase.
Whistler's comment was that Scharfe's query should have been
retorted "No, it hasn't." The next move was from Scotland,
where it was suggested in 1884 that the portrait be purchased for
the National Gallery in Edinburgh. He named a price, five hun-
dred guineas, and a subscription was opened. But when the sum
had nearly been raised he heard that the subscription paper dis-
claimed any endorsement of his theories of art; upon which he
wired to the committee "The price of the Carlyle has advanced
to one thousand guineas. Dinna ye hear the bag-pipes?" Four
years went by, and a petition was signed by a number of artists
requesting the Glasgow Corporation to buy it. A civic deputa-
tion called on Whistler in London, the spokesman of which asked
whether he did not think a thousand guineas a large price, since
the figure in the picture was not even life-size. "But, you know,
few men are life-size", he observed. They offered him £800,
which he refused. "Now think it over, Mr Whistler, and we will
be coming back again", they said. Next day they returned for the
benefit of his thoughts, but he declared that he had been unable
to think of anything except the pleasure of seeing them again.
They gave him a cheque for a thousand guineas.

Before these two famous portraits were bought by France and
Scotland, Whistler had pawned both of them. He was so hard-
up in 1878 that, to raise a loan of a few hundred pounds, he
handed them over, together with two other pictures, as security.
But he found that he could not live without the Mother, and got
it back on payment of £50. Later he retrieved the lot, and when
the Mother was placed in the Luxembourg he took a room nearby
so that he could see it in the Musée as often as he pleased. "One
does like to make one's Mummy just as nice as possible", he once
confessed to a friend; and the portrait, like that of Carlyle, is an
idealised presentment. She was, as he had once claimed, "a very
pretty bit of colour", and much ruddier in complexion than he

showed her to be. There is nothing of the stern bibliolater in his portrayal, just as there is nothing of the harsh egotist and irascible neurotic in his Carlyle. Tranquillity and a sweet self-assurance are in the first, sadness and a wistful toleration in the second. His inner discomfort, due to causes already noticed, may be inferred from these fascinating and masterly essays in pictorial art, which depict his dreams of a parent and a philosopher, not the less pleasing aspects of a strict puritan and a violent prophet.

But where the reality was pretty and innocent he succeeded in conveying truth as well as beauty. During the later stages of the Carlyle portrait, its subject saw a little girl entering when he was leaving the studio, enquired her name of the maid, and learnt that she was Miss Alexander, whose portrait Whistler had already commenced. "Puir lassie! Puir lassie!" condoled the sage. Cicely Alexander was being painted at her father's desire, and she did not appreciate the honour. "I used to get very tired and cross, and often finished the day in tears", she wrote in after life. She stood, foodless, for hours at a time, with Whistler absorbed in his work and quite unconscious of her distress, and there were something like seventy sittings, or rather standings, and innumerable rubbings out, before he was satisfied. The picture, now in the Tate Gallery, London, is a perfect specimen of Whistler's art, not only in decorative design, but in truth of delineation when there were no disturbing features to be composed into a harmony. The discontent of the sitter, the slight pout of defiance, are apparent, without detracting in the least from the grace of the figure, the charm of the face, the exquisite pattern of what he called *Harmony in Grey and Green*.

Like every other portrait-painter of his time, Whistler was ambitious to capture on canvas the most picturesque figure and most remarkable personality of the age; and his vanity was such that he used to invent stories of how he had visited Lord Beaconsfield at Hughenden with this purpose in view. Here is one of them, as told to Joseph Simpson, who retold as much as he could remember of it for the amusement of the present biographer:

"Money was offered me, a great deal, enough to make me popular with my creditors for at least a fortnight; but it was the model I wanted far more than the money, d'ye see? I tried to meet him; I asked people who knew him to arrange something; I solicited the interest of a duchess; I even called at his house, and,

against all my instincts, treated his secretary as an equal; but nothing came of it. So I determined to beard him in his retreat. I even braved the country for his sake. Since he would not see me, I would see him, and I travelled down to Hughenden. I had heard he was fond of his trees and his park; so I looked at his trees and I strolled in his park. At last he came into view—or was it the keeper?—no, it was he: a note of black in a symphony of green. The great moment had arrived. The Butterfly was about to alight on Beaconsfield. Ha-ha! I introduced myself. He was charming. 'I so much admire your pictures' he said. 'Which have you seen?' 'None. That is why I can admire them. Seldom does one admire what one sees.' This was delightful. At once we were on cordial terms, in complete artistic accord. 'You must have been to an exhibition at the Academy', I said. 'The sepulchre of art', he sorrowfully agreed. Then I asked him to sit for a portrait. 'My life is spent in sitting', he complained: 'Parliament does nothing else.' He advised me to paint him from the gallery. I said that I would have to arrange him before painting him. He did not care to be arranged. It was very sad. He would have made a wonderful arrangement in white and black, or perhaps, in his robes, a harmony of red and gold. But he refused to be immortalised, and I had to be content with his promise that, if he sat to any artist, it would be to me. You know what happened? He kept his promise: he sat to no artist: instead, he posed for Millais. It was a dreadful thing to do, and he was rightly punished for it. One day he caught sight of the portrait. True, it was not finished; but even in that state it was bad enough. Think of it! A picture by Millais—the post-pre-Raphaelite. Deadly, eh, what? As he looked at it, the aged statesman remembered what might have been; he remembered Whistler; and he went home and died."

In giving this account, and others like it, Whistler imitated Beaconsfield's voice and manner. But not a syllable of the story was true, except his keen desire to make an "arrangement" of the Prime Minister. What actually happened was less agreeable to his vanity. In St James's Park one day he saw the model of his dreams sitting in solitude, the far-off look in the eyes denoting complete absorption in thought or abstraction from life. It took all Whistler's courage to approach the motionless enigmatic figure and make himself known. But the graven image showed no

consciousness of having heard his name nor of a wish to hear it.
Disheartened but not baffled, Whistler then spoke of his ambition
to paint the great man. He might have been addressing the seat on
which the figure sat. There was no response, not a movement to
suggest that Dizzy had heard him or was aware of his presence.
But when the artist again began to speak, the lips of the statue
were seen to part, and a few words, mumbled in a hollow voice,
were audible: "Go away, little man, go away." Whistler went.

Temperamental

WITH the commencement of Whistler's great period as a
painter in 1871 Jo ceased to look after him, though his
natural son continued to live with her. Her place both
as mistress and model was taken by Maud Franklin, also red-
haired but not so beautiful as Jo: in fact a totally different type.
She may be seen in *The Fur Jacket*, *L'Américaine*, *Effie Deans*, and
many etchings, lithographs and water-colours. She had promi-
nent teeth and a thoroughly English appearance. She was more
intelligent and sophisticated than Jo, and quite as devoted to
Whistler; but being more independent and jealous their relation-
ship was frequently strained by quarrels and stormy scenes, both
having quick and violent tempers. She called herself and was
known as Mrs Whistler, though he usually spoke of her as
"Madame", and his disciples followed suit. Like Jo, she became
his business-manager, agent, housekeeper, cook, adviser and
factotum. They lived together for about fifteen years, and she had
a daughter by him. It is possible that he had other children by
Maud as well as Jo, but the son who was an "infidelity" to the
latter and the daughter who resulted from the fidelity of the
former were his only known offspring. Like her predecessor,
Maud did not accompany Whistler to the houses of his more
respectable friends and acquaintances. Sometimes indeed she
proved an embarrassment at the places they did visit together,
and he had to take her away if some unexpected guest showed a
disinclination for her company; but they were seen together at all
sorts of functions, at theatres, picture galleries, public receptions,
and private parties.

Three more of Whistler's notable portraits were done in the
seventies. In 1876 Henry Irving was playing the part of Philip II
in Tennyson's *Queen Mary*, and Whistler was greatly taken by his

appearance, writing to him "It is ridiculous that Irving should not be painted—and who else shall paint him!" Irving agreed, and gave Whistler two or three sittings, which were several times interrupted by the arrival of creditors demanding payment of their bills. There was no fire in the studio, and Irving shivered in the cold, but the painter seemed impervious alike to draughts and duns and produced something that satisfied him but failed to please Irving, who much preferred the portrait of a good-looking nonentity which Millais afterwards made of him.[1] Whistler would have liked to paint Irving in all his characters, but the actor did not see himself with the eyes of the artist, and showed no wish to acquire the Philip II, which however was knocked down to him for £30 at Whistler's bankruptcy and hung in the Beefsteak room at the Lyceum. After Irving's death it was sold at Christie's for £5000 and eventually came to rest in the Metropolitan Museum, New York.

The subject of Whistler's most fascinating portrait of a woman was Rosa Corder, an intimate friend and a favourite model, whose beauty and dignity inspired him to create a perfect design that was also characteristically lifelike. "To look at this picture is to recapture the thrill of a discovery", says Mr James Laver in by far the best book that has been written on Whistler as an artist, " . . . One wonders why women did not flock to the painter of such a picture as they might have hurried to the creator of some new gown—to be made more elegant."[2] Rosa Corder was an artist herself, owning a studio at Newmarket, where she painted famous racehorses. She was devoted to horses, and a good rider; and in some recondite manner Whistler contrived to suggest this; at least a man who was completely ignorant of the subject divined from her portrait that she knew a lot about horses and lived among them. She posed for Whistler about forty times, against the dark doorway of a shuttered room, and on two occasions fainted with fatigue. The moment she considered that the picture had reached a stage at which further work on it would be risky, she struck; and as Whistler did not seriously oppose her decision, he must have felt she was right, though he usually enjoyed

[1] Bernard Shaw wrote that the statute of Irving in Charing Cross Road, "though possibly quite accurate in its measurements, gives no notion of what he was like; and even the portrait by Millais is only Irving carefully drest up to be as unlike himself as possible, the ghostly impression of his Philip II by Whistler being more suggestive of him than either."

[2] *Whistler* by James Laver, second and revised edition, 1951.

touching up a completed portrait at the expense of a desperate or half-dead sitter.

The further history of this *Arrangement in Black and Brown* is interesting as evidence of the artist's feeling for his best work and of its rising estimation by the world. As we already know, Charles Augustus Howell originally bought the picture in the seventies, paying a hundred guineas previously borrowed from Whistler. At Howell's death in 1890 it was bought by Graham Robertson for about £130. On learning the name of the purchaser, Whistler wrote to ask if he might call and see the picture, expressing a desire to know the collector "who so far ventures to brave popular prejudice in this country." Robertson was thrilled at the prospect of meeting the artist, who duly called and fascinated the proud owner. "The meeting between the painter and his masterpiece, 'Rosa Corder', was quite touching", wrote Graham Robertson forty years afterwards. "He hung over her, he breathed softly upon her surface and gently stroked her with his handkerchief, he dusted her delicately and lovingly. '*Isn't* she beautiful', he said." In 1903 an American, Richard A. Canfield, offered Graham Robertson £1000 for the picture. Robertson refused. Canfield doubled the offer. Robertson jumped at it. Describing the deal, Canfield added: "Why, the darned fool, if he had held on he could have had five!" Before the portrait went to America Whistler saw it for the last time, again wiped it caressingly with his silk handkerchief, and once more said, this time in a tone of triumph: "Isn't she beautiful!"

Another of his outstanding portraits during this period was an *Arrangement in Black*, the subject being Frederick Leyland, a prosperous Liverpool shipowner, who first suggested that he should call his twilight scenes "Nocturnes". Whistler at once perceived that the word was exactly right; moreover it annoyed the critics, with consequent satisfaction to himself. Oddly enough, in view of his Nocturnes, Symphonies and Harmonies, he had no sense of music whatever. He admired the dexterity of the great violinist Sarasate and painted him, but music meant as little to him as literature. He would sing one song in a displeasing falsetto for months on end, usually a popular one like "We don't want to fight, but by Jingo! if we do", and then sing another for more months; an extremely irritating and inharmonious proceeding. His taste in literature was no better. He pecked at books instead of

reading them, and considered Bret Harte, probably because he was an American, a greater genius than Dickens or Thackeray. Indeed he went so far as to say that he could find no possible excuse for Dickens, whose realism and emotionalism must have made him feel uncomfortable. Leyland did not share his indifference to the other arts; but then Leyland was rich, socially aspiring, and, like so many north-country industrial magnates, anxious to show that the making of money was not incompatible with the finer feelings.

Leyland's mother had sold pies in the streets of Liverpool, and Bibby, the shipowner, sometimes bought them, and liked them so much that he engaged her son Fred to sweep his office out and run errands. Frederick Leyland then improved on the story-books which show the ascension of good boys and the declension of bad boys, and became one of the wealthiest shipowners in the world. After that he had time to cultivate the arts and taste to appreciate Whistler, who was introduced to him by Rossetti. He bought *La Princesse du Pays de la Porcelaine*, and commissioned the artist to paint his wife, himself, his son, and his three daughters. Both Whistler and his mother became very friendly with the Leyland family and often visited their home, Speke Hall, near Liverpool, for long periods. Leyland, as befitted a money-magnate, was inclined to be pompous, but he was generous and fond of Whistler, who admired and was greatly attracted to Mrs Leyland. When the family were in London for the season, but business enforced the temporary absence of the shipowner, Whistler and Mrs Leyland were seen together in public on all sorts of occasions, and it was rumoured that she would elope with him. In later years she admitted that, had she been a widow, she might have married him; but in the seventies their close friendship was guardedly expressed by his engagement to her youngest sister, which did not terminate in marriage.

As usual, he took great pains with the family portraits. Much though they liked the painter, the children hated the restriction of their liberty entailed by perpetual posing, and the son rebelled after three sittings. Leyland himself was too busy to give the artist much time; but Mrs. Leyland endured the strain, and did not even grumble when she saw him rubbing out what appeared to her an almost completed picture, because he kept her continually entertained and no doubt flattered her very agreeably whenever

she showed signs of distress. The only portrait of the family to be finished was that of Frederick Leyland, whose fate it was to have another and less attractive resemblance done by the same hand.

Leyland was not content with being an important person in Liverpool: he wished also to be a notable personality in London, and to become one on a lavish scale. He took No. 49 Prince's Gate, Hyde Park, and determined to make it, so far as the interior allowed, a palace fit for an Italian magnifico of the fifteenth century whose taste was influenced by British art of the nineteenth. On the advice of a well-known art-dealer and expert named Murray Marks, he engaged the architect Norman Shaw to make the necessary structural alterations, and another architect Tom Jeckyll to arrange the decorations. Northumberland House in Trafalgar Square had just been demolished, and the staircase with bronze balustrade was erected at 49 Prince's Gate, the interior of which was made sumptuous with oriental rugs, Venetian statuary, mosaic floors, carved screens, oak and walnut panellings, Beauvais tapestry, inlaid cabinets from India, Germany, Portugal and Italy, Chippendale chairs, modern chairs, French bureaus, Renaissance bronzes, vases from China, tables from Milan, velvet curtains from Genoa, hangings and ornaments from various climes and centuries, and pictures by Rossetti, Botticelli, Burne-Jones, Lippo Lippi, Watts, Albert Moore and Ford Madox Brown. Altogether a remarkable conglomeration.

Much attention was devoted to the dining-room, where Leyland's collection of blue and white china was to be displayed. Tom Jeckyll was entrusted with the job and he hoped the result would establish his reputation. For £1000 he obtained some Cordova leather which Katherine of Aragon had brought to England and which had been hanging since her time in a Tudor house in Norfolk. Its dull colour was relieved by the painting upon it of pomegranates and red flowers. Jeckyll covered the walls of the dining-room with this ancient leather, which served as a background for the carved gilt shelves containing the blue and white china. The ceiling was panelled, the floor was spread with a red-bordered rug, and Whistler's *La Princesse du Pays de la Porcelaine* was hung over the mantelpiece, space being left for another of his pictures on the wall exactly opposite. When the work was completed, Whistler who had been painting the panels of the dado in the hall,

was asked to approve the general effect of Jeckyll's scheme. He did not approve of it at all. His picture of the Princess was the only thing that mattered to him, and the room was merely a setting for it. To be worthy of it, everything else must be changed. The leather was too dark for it, the red flowers on the leather clashed with it, the red border of the carpet did not harmonise with it. But he did not say so all at once. He merely suggested that the red flowers should be lightened up with patches of yellow. Jeckyll not being present to protest, Leyland agreed, went off to Liverpool, and left the artist to make the necessary improvements. Then the fun began. Whistler removed the red border from the rug and gilded the red flowers on the leather. The effect was ghastly, as he must have known it would be, and he decided on his own responsibility to treat the lovely old leather simply as a canvas and paint a gorgeous mural design which he had once planned for another client.

He then proceeded to convert the entire room into a peacock's paradise. Walls, woodwork, window shutters, panels, ceiling, were covered with peacocks, their tails spread in the air or sweeping the ground, the sole unpeacocked space being that facing his picture of the Princess, where another of his works was to be hung. It was a superb Harmony in blue and gold, and Whistler worked on it as he had never worked before. He started without any sketch or design, and the inspiration came with the labour. For twelve hours a day and more he was hard at it, being helped by the Greaves brothers, and all three of them sometimes appeared as gold and blue as the walls. Right through the summer of 1876 he worked, cancelling visits he had planned to France, Holland, and Italy. He was in the fever of creation and communicated his excitement to others. Lord Redesdale went to Prince's Gate that autumn and discovered Whistler on the top of a ladder, looking like a goblin. Redesdale wanted to know what he was doing. "The loveliest thing you ever saw", he replied. Redesdale enquired after the old Spanish leather, and asked whether he had consulted Leyland. "Why should I? I am doing the most beautiful thing that ever has been done, you know, the most beautiful room."

Rumours of his activity got about, and many people dropped in to see the result. He held receptions, he gave teas, he discoursed to visiting royalty, he even waltzed with one caller. He

was in a delirium of joy over his masterpiece of decoration; he could think, talk, dream of nothing else. With shouts of pleasure he greeted his friends, with cries of delight he displayed the marvel. On December 8th an article on the Peacock Room appeared in *The Morning Post*. Leyland read it and was greatly disturbed, but business kept him in the north. At Whistler's invitation, the critics came on February 9th, 1877, to see what he had done. A leaflet explaining his scheme was distributed to them, and the notices in the press were enthusiastic. The original decorator, Jeckyll, heard what everyone was talking about, and wondered what had happened to his old Spanish leather. He called, saw the army of peacocks, was dazzled by the mass of blue and gold, shuddered at the sound of Whistler's laugh which reminded him of a peacock's scream, rushed demented from the house, managed to get home, began to paint the floor of his bedroom gold, and a few weeks later died in a lunatic asylum. On hearing of his death, Whistler remarked: "To be sure, that is the effect I have upon people."

The publicity given by the press brought Leyland down from Liverpool. His private house had been turned into a public gallery; his sanctum had been invaded by Society; his employee had behaved like an owner; and himself had been made to look ridiculous. The sight of the room did not appease him: his porcelain had been killed by the peacocks. He was furious, and told Whistler that he had wasted his time and ruined the room. Whistler was deeply hurt because he believed that he had produced the most glorious bit of interior decoration in the world. "You should be grateful to me", he informed the shipowner. "I have made you famous. My work will live when you are forgotten. Still, perchance in the dim ages to come, you may be remembered as the proprietor of the Peacock Room." Leyland asked how much Whistler wanted for his work, and was told two thousand guineas. Leyland thought this excessive, and offered one thousand pounds. Whistler accepted it because he needed the money, but he never forgave Leyland for paying in pounds instead of guineas, because by British standards, reinforced in this case by a West Point code of honour, gentlemen were paid in guineas, whilst only tradesmen were paid in pounds. Whistler felt insulted; and though Leyland said that he would give the whole sum if only Whistler would leave the house, the artist

preferred his revenge to the cash. In the empty space reserved for another of his pictures, opposite the Princess over the mantel-piece, he painted a Rich Peacock and a Poor Peacock, and under the claws of the Rich Peacock were the silver shillings which Leyland had knocked off the cheque. Though this caricature faced Leyland every time he sat down to dinner, he did not touch it; indeed his behaviour then and thereafter was wholly admirable. He was seriously affected by the quarrel, which may have caused his premature death. But Whistler throve on hostility, and it is difficult to say how many improvements he might have made to the Peacock Room if it had not been for Mrs Leyland, who returned unexpectedly to London one day, let herself into the house, and as she was passing the door of the dining-room over-heard Whistler speaking of her husband: "Well, you know, what can you expect from a parvenu?" She walked in, ordered him to leave, and when he returned in a day or two he was refused admission.

Though he had been treated for years as one of the family and had found in Leyland his most generous and forbearing patron, Whistler remained vindictive, and not long after the episode just narrated he painted The Gold Scab—Eruption in Frilthy Lucre, in which Leyland, who usually wore a frilled dress shirt, was quite recognisably depicted as a monstrous leering reptile, with arms and legs thin and scaly like a bird's, playing a piano and oozing golden sovereigns. It was a colourful but horrible piece of work, and a somewhat extravagant reminder of the artist's resentment at the loss of a thousand shillings. After the sale of Leyland's house in June '92, the Peacock Room was exhibited in Bond Street, bought by Charles L. Freer, and transported to Detroit in the United States.

Mitigation of Whistler's behaviour to Leyland may be found in the fact that he had been agitated by the strangely impercipient criticisms of the London and Parisian press. Because he was a foreigner in England and France, and had not the temperament to develop a contempt for the opinions of strangers, he was extremely sensitive to criticism, and being outside the main tendencies of painting in both countries the criticism he received was peculiarly stupid. He had not the self-sufficiency to ignore it, and lived in a constant itch of irritation whenever he was not lost in his work. In the middle seventies he exhibited a few pictures

at various galleries in the two countries, but no critic had the feeling or intelligence to appreciate his efforts, and when in '76 he arranged at 48 Pall Mall his first one-man show, which included his best portraits, some river scenes and etchings, the grey walls of the gallery, the blue pots, the palms and the flowers were sufficient to shock the pundits without the strain on their imaginations caused by such queer nomenclature as Arrangement, Nocturne, and so forth.

Not only his paintings but his decorative effects were considered eccentric and funny, and encouraged by the critics people laughed at what has since become so common that the modern fashion is to laugh at what preceded it. Though he undermined the authority of the academicians and awoke people to the enchantment of modern cities, his painting was too individual to have much influence on the art, or to found a school; but he revolutionised interior decoration, and everything he said or did in that matter has now been accepted and followed. He was the first to paint rooms white, and to substitute plain walls of different colours for the elaborately patterned wall-papers of Morris and his predecessors. He used to say that the room he liked best in other people's houses was the white-washed pantry. He introduced and eventually popularised the decorative use of yellow. White woodwork as well as white rooms came into fashion as a result of his precepts; and the famous "blue and white" porcelain, no less than Japanese matting, owed their ultimate prevalence in England to him, "His taste for simplicity antedated that of the rest of England by more than a generation", writes James Laver; and it is no exaggeration to say that the great majority of domestic interiors of today owe whatever decorative merit they possess to him.

For this reason he was associated in the public mind with the aesthetes who caused so much amusement to our forefathers in the pages of *Punch* and the patter of *Patience*. George Du Maurier ridiculed him in the former, and George Grossmith as "Bunthorne" made up to look like him in the latter, with eyeglass, white lock of hair, moustache and imperial; while W. S. Gilbert helped the identification with references to

Such a judge of blue-and-white and other kinds of pottery—
From early oriental down to modern terra-cotta-ry—

and the "greenery-yallery" of Grosvenor Gallery. Yet Whistler
had about as much in common with the average aesthete as
Gilbert had, and apart from their genius both of them were more
like soldiers than artists, Whistler with his West Point imperial,
Gilbert with his Heavy Dragoon moustache. What is sometimes
referred to as the Aesthetic Movement was no coherent action
on the part of a group devoted to the same object or animated
by the same desire, but simply the reaction of individual artists
against the conventional beliefs, styles, ideals and standards of the
age. To speak of the Aesthetic Movement is therefore as inaccur-
ate as it would be to speak of the Anarchistic Movement. No
ideas were held in common, no directions to be followed. There
were a number of writers, painters, sculptors, architects, actors,
each of whom was going his own way; and though some of them
may have travelled along part of the road together, they did not
keep in step and had no agreed goal. But, as usual when some-
thing novel is in the air, followers were attracted and the sense of a
united movement was created. Inevitably the followers managed
to make the reaction look ridiculous; and Gilbert and Du Maurier
found the source of their satire in the attitudes and absurdities of
the tyros and votaries, though they were thought to be laughing
at this man or that.

 The great event of what may more truthfully be described as
the Aesthetic Agitation was the exhibition of paintings at the
Grosvenor Gallery, Bond Street, in the spring of 1877. A rich
banker, Sir Coutts Lindsay, supported by an artist, Charles Hallé,
and an art-critic, Comyns Carr, wished to strike a blow at the
deadly domination of the Royal Academy and to give modern
artists a chance. The show was admirably organised; the decora-
tive effects were striking; a restaurant was provided; the Prince
and Princess of Wales attended an inaugural banquet; Society
drove up in such numbers that the committee of the Royal
Academy were almost disquieted; and, in short, the exhibition
was the sensation of the season. But in view of the fact that it
focussed the public eye on aestheticism, and gave Gilbert a rhyme
at the expense of the aesthetes, we may now wonder at the excite-
ment it provoked, since the artists who were invited to exhibit
belonged to antipodean schools of painting. It would be impossi-
ble to reconcile with any particular "movement" the works of
Whistler and Richmond, Burne-Jones and Alma-Tadema,

Holman Hunt and Leighton, Watts and Poynter, Walter Crane and Millais. But as Burne-Jones stole the show, the exhibition was really a triumph for the Pre-Raphaelites.

Among the pictures that Whistler sent to the Grosvenor were the portraits of Irving and Carlyle, together with several of his Nocturnes, including *Old Battersea Bridge* and *The Falling Rocket*, in the last of which he had tried to suggest in paint the after-effect of an exploded rocket sent up from Cremorne, a sight he had often witnessed from Cheyne Walk. His fellow-exhibitors were not enthusiastic over his contributions, their attitude being summed up by Millais, who paused for a moment to look at one of his pictures, said "It's damned clever; it's a damned sight *too* clever!" and rapidly passed on. As usual the critics were inept, treating him with facetious condescension. But one of them, the most important of all, the leading art-critic of the age, a man of enormous reputation and influence, went further than the rest, went much too far. He was John Ruskin.

The nineteenth century was peppered with prophets, and most of them were Jeremiahs. But Ruskin was made for better things. He had a keen appreciation of nature, a love of beauty in art, and a generous disposition. Unlike most prophets and reformers, he gave away most of the money he earned and inherited to other human beings. His father was a wealthy wine-merchant, his mother a possessive puritan who inoculated him with the Bible. He was an only child; but though pampered, he grew into an unselfish man, ready to champion the misunderstood to the utmost of his ability and assist the unfortunate to the limit of his resources. He was the first to recognise and advertise the achievement of Turner, and he rescued the Pre-Raphaelites from the derision of the other critics. His activity was incessant, and all of it was devoted to philanthropic and artistic causes. His private benefactions were immense and his published books on painting and architecture opened people's eyes to beauties hitherto concealed from them. Up to the year 1860 he was, one may say, an expositor. Then the influence of Carlyle converted him into a preacher, and he began a crusade against the materialism and the industrialism of the age. He developed a strong social conscience, and felt that he could no longer enjoy beauty in the midst of ugliness. In fact he became a man with a mission, and like all such his head was gradually affected by a belief in the significance of his message,

and, a sure corollary, a sense of his own importance. An unhappy marriage contributed to his feeling of injustice and wrong, and his polemics were aggravated by frustration. His propaganda and his discontent were promulgated in a monthly letter addressed to British workmen under the herculean title of *Fors Clavigera*, the success of which made him the unofficial but generally acknowledged Voice of the Age; and when the Slade Professorships in Fine Art were founded at Oxford, Cambridge, and University College, London, the Oxford chair was offered to him. He accepted the post in 1870, and put as much energy into the artistic regeneration of the University as he had previously thrown into the social reform of the universe.

It goes without saying that such a man would regard Whistler, who lived for his art alone, who could make beauty out of factory chimneys, and who had the affectation to call his pictures Harmonies, as a subject for chastisement; and in 1873 he referred in one of his Oxford lectures to an impudent daub which he had seen in some exhibition, describing its title as nonsensical and its total effect as "absolute rubbish", which cannot have taken more than a quarter of an hour to scrawl, had no pretence to be called painting, and was priced at 250 guineas. Though the artist was not mentioned by name, the picture was by Whistler, who probably remained in ignorance of the outburst. But when next Ruskin relieved himself on the subject, the hundred thousand readers of *Fors Clavigera* as well as Whistler were made acquainted with his views. By this time the Slade Professor had succumbed to the delusion, common to all messiahs, that his Word was God's:

> As who should say, 'I am Sir Oracle,
> And, when I ope my lips, let no dog bark!''

In 1875 he was overwhelmed by a tragedy, the death of Rose La Touche, a girl with whom he was in love, and a year later he experienced the first symptoms of mental breakdown. Apart therefore from the abnormality induced by his prophetic zeal, he was not in a condition to give a judicial opinion on any subject that outraged his personal taste, and his criticism of the first Grosvenor Gallery exhibition was that of an almost demented dictator. Quite a number of things about it aroused his unfavourable comment, but we are here solely concerned with what he had to say about *The Falling Rocket*:

For Mr. Whistler's sake, no less than for the protection of the purchaser, Sir Coutts Lindsay ought not to have admitted works into the gallery in which the ill-educated conceit of the artist so nearly approached the aspect of wilful imposture. I have seen and heard much of cockney impudence before now, but never expected to hear a coxcomb ask two hundred guineas for flinging a pot of paint in the public's face.

Now although eminent Victorians were accustomed to invective, speaking and writing of one another in a manner that makes the most hostile criticism of today seem like flattery by comparison, there was something particularly galling to one of Whistler's temperament in the public statement by a prominent man that he, as painstaking an artist as ever lived, took no trouble with his work. The word "coxcomb" was vexatious, too, for it emphasised and gave authority to the attitude of the critics and professors who continued to decry his paintings. As for the phrase "cockney impudence", the ex-cadet of West Point must have seen red. But when the passage was brought to his notice he merely remarked "It is the most debased style of criticism I have had thrown at me yet." "Sounds rather like libel", a friend suggested. "Well, that I shall try to find out", said Whistler. Apparently he received comforting advice from his solicitor, and the good news spread through the social world that he had entered an action against Ruskin for libel. It was a plucky thing to do, for Ruskin not only regarded himself as infallible but was accepted as such by the general public. "It's nuts and nectar to me", he said on hearing that Whistler intended to bring the matter into court, and he saw himself in the self-appointed rôle of law-giver, making weighty pronouncements from the witness-box which would be "sent over all the world vividly" in press reports. His one fear was that Whistler might think better of it and withdraw from the action. But he did not know his man, who never had to confess, as Fantin-Latour did when asked for an account of his exploits in Paris during the siege, "I hid in the cellar. Je suis poltron; moi."

Whistler's real difficulty at the moment was lack of money. He was heavily in debt and his pictures were not selling. After Ruskin's criticism his Nocturnes were regarded as jokes, and no one was brave enough to be painted by him. In order to exist he had to pawn the portraits of his mother and Carlyle, as well as

several of his Nocturnes; and this at a time when popular artists like Millais, Poynter, Leighton, and Alma-Tadema were making money as fast as they were covering canvas. It was one of the occasions when Charles Augustus Howell came to Whistler's rescue by reviving his interest in etching and selling the prints for him. He also experimented in lithography; but his main interest between the publication of Ruskin's libel in '77 and the hearing of the case in '78 was the house then being built for him in Tite Street, Chelsea. Its architect was E. W. Godwin, whose views on art were very much the same as Whistler's. Godwin had lived with Ellen Terry, and one of their two children, Gordon Craig, was to have as much influence on stage production as his father had on stage costume. But Godwin was an architect by profession and Whistler, who hoped to make money by taking students, decided that this was the only man who could build him a suitable house for the purpose, and who would produce something simple and beautiful. The design was rather too simple for the Board of Works, accustomed to the Balmoral school of architecture, and certain decorative details had to be added in order to satisfy official taste. It was an Arrangement in green and white (green slates, white bricks) which struck the passer-by as odd because the windows were not symmetrically placed but distributed about the house where required, in different sizes as needed. It was never made habitable during Whistler's occupation, owing to his customary dilatoriness in such matters. The visitor saw huge packing-cases full of things that would never be unpacked, observed all the necessary preparations for papering and carpeting; but though the walls were distempered yellow and matting was on the floors and some blue and white porcelain was in the dining-room, the rooms remained unfurnished, and the only sign that the proprietor was not a temporary lodger, using the place as a luggage depository while moving from one residence to another, was the collection of invitations to dinners and fashionable receptions arranged in a semicircle on the mantelpiece of the studio at the top of the house.

As things turned out, the owner was indeed but a transient tenant. He took possession of The White House in October '78; he was dispossessed of it in May '79, being declared bankrupt as a result of the Ruskin case. But his stay there, though brief, was a gay one. Everyone who knew him called to see the place, sat

where they could, usually stood, and listened to his tales, his mockeries, his short sudden laughs, his quick enthusiastic approvals of his work—"Pretty, eh?" "Perfect, what?" "A gem, ha?" Two visitors were especially welcome. In 1876 Godwin married one of his pupils, Beatrice Philip, a daughter of the sculptor John Birnie Philip. She was twenty-one years of age, a brunette, handsome, French-looking, an amateur in several arts, very anxious to be a painter, bohemian by nature, and rather given to hero-worship. She watched Whistler at work and was captivated by him. As she was clever and sympathetic, he was attracted to her and gave her lessons. The friendship between himself and the Godwins became closer the more they saw of one another; there was mutual admiration between the two men, and a more intimate emotion developed between Whistler and Mrs Godwin.

CHAPTER VIII

Legal

IN the course of his evidence in the Ruskin case, Whistler remarked that he had no memory for dates. He also suffered from an inability to remember facts, or a reluctance to leave them alone. He began his statement from the witness-box with the words: "I am an artist, and was born in St Petersburg. I lived in that city for twelve or fourteen years . . ." Two thumping lies in the two opening sentences, the Whistlers having spent a total of six years in Russia. In like manner he edited the report of the case when reprinting it from the newspaper accounts in *The Gentle Art of Making Enemies*, sometimes altering passages to increase their effect. So indifferent was he to dates that, at the very beginning of his record in *The Gentle Art*, he gives November 15th, 1878, as the day on which the lawsuit was heard, whereas the actual days were Monday and Tuesday, November 25th and 26th of that year. However, there were very full accounts of the evidence in the *Daily Telegraph*, *Morning Post* and *Standard*, though not in the *Times*, and from these we may approximate to *ipsissima verba*.

The action, in which Whistler claimed £1000 for the damage done by Ruskin's criticism to his reputation as an artist, was heard in the Court of Exchequer Division before Baron Huddleston and a special jury. Ruskin was just recovering from the first of his brainstorms and could not appear. Three witnesses were called on his behalf, and three on Whistler's. The Attorney-General (Sir John Holker) and Mr Bowen were counsel for Ruskin, Sergeant Parry and Mr Petheram for Whistler. It may be doubted whether in the history of the arts there has ever been a more stupid, famous, ridiculous and significant case: stupid because a British judge and jury were the last people on earth to decide on the nature of criticism or the merits of painting; famous, because of the stature of the protagonists; ridiculous, because

a number of people who ought to have known better made solemn fools of themselves; significant, because it was the eternal fight of the rebel against conventions, of the artist's attitude against the academic attitude, of the individual man against the institutional herd. Whistler saw it as a conspiracy: "They all hoped they could drive me out of the country or kill me; and if I hadn't had the constitution of a government mule, they would!" But therein he flattered himself. Edward Burne-Jones and W. P. Frith were loath to give evidence for Ruskin, and far more imbecility and ignorance were displayed in the proceedings than conspiracy and virulence. The chief adversary of Prometheus is indifference, not concern; laziness, not counter-activity. Whistler must have known this instinctively because much of his life was spent in trying to wake people up; and what Ruskin had hoped would be nuts and nectar for him turned into myrrh and vinegar by the time Whistler had concluded his evidence. After his counsel, Parry, had opened the case, Whistler stepped into the witness-box, and, having made his personal statement, was examined:

"Since the publication of this criticism, have you sold a Nocturne?"

"Not by any means at the same price as before."

"What is your definition of a Nocturne?"

"I have perhaps meant rather to indicate an artistic interest alone in the work, divesting the picture from any outside anecdotal sort of interest which might have been otherwise attached to it. It is an arrangement of line, form and colour first; and I make use of any incident of it which shall bring about a symmetrical result. Among my works are some night pieces, and I have chosen the word Nocturne because it generalises and simplifies the whole set of them."

He was then cross-examined by the Attorney-General, Sir John Holker:

HOLKER: You have sent pictures to the Academy which have not been received?

WHISTLER: I believe that is the experience of all artists. (*Laughter.*)

HOLKER: What is the subject of the Nocturne in black and gold? (*The Falling Rocket.*)

WHISTLER: It is a night piece, and represents the fireworks at Cremorne.

HOLKER: Not a view of Cremorne?

WHISTLER: If it were called a view of Cremorne, it would certainly bring about nothing but disappointment on the part of the beholders. (*Laughter.*) It is an artistic arrangement.

HOLKER: Is two hundred guineas a pretty good price for a picture by an artist of reputation?

WHISTLER: Yes.

HOLKER: It is what we who are not artists should call a stiffish price?

WHISTLER: I think it very likely it would be so. (*Laughter.*)

HOLKER: Artists do not endeavour to get the highest price for their work irrespective of value?

WHISTLER: That is so, and I am glad to see the principle so well established. (*Laughter.*)

HOLKER: I suppose you are willing to admit that your pictures exhibit some eccentricities; you have been told that over and over again?

WHISTLER: Yes, very often. (*Laughter.*)

HOLKER: You sent them to the Gallery to invite the admiration of the public?

WHISTLER: That would be such vast absurdity on my part that I don't think I could. (*Laughter.*)

HOLKER: Did it take you much time to paint the "Nocturne in black and gold"? How soon did you knock it off? (*Laughter.*)

WHISTLER: I beg your pardon?

HOLKER: I was using an expression which was rather more applicable to my own profession. (*Laughter.*) How long do you take to knock off one of your pictures?

WHISTLER: Oh, I knock off one possibly in a couple of days, (*Laughter*)—one day to do the work, and another to finish it.

Whistler's own account of this passage in *The Gentle Art* gives himself the correct West Point tone. He makes Holker say "I am afraid that I was using a term that applies rather perhaps to my own work. I should have said 'How long did you take to paint that picture?'" To which Whistler replies: "Oh, no! permit me; I am too greatly flattered to think that you apply, to work of mine, any term that you are in the habit of using with reference to your own. Let me say, then, how long did I take to—'knock off', I think that is it—to knock off that Nocturne. Well, as well as I remember about a day."

HOLKER: And that was the labour for which you asked two hundred guineas?

WHISTLER: No; it was for the knowledge gained through a lifetime.

This remark was greeted with considerable applause, and the judge said that if such a manifestation of feeling were repeated he would have to clear the court. Whistler improved his famous reply in *The Gentle Art*, where it reads "No—I ask it for the knowledge of a lifetime", but the reports in all the leading newspapers give the above version.

HOLKER: You know that many critics entirely disagree with your views as to these pictures?

WHISTLER: It would be beyond me to agree with the critics. (*Laughter.*)

HOLKER: You don't approve of criticism?

WHISTLER: I should not disapprove in any way of technical criticism by a man whose life is passed in the practice of the science which he criticises; but for the opinion of a man whose life is not so passed I would have as little regard as you would have if he expressed an opinion on law.

HOLKER: After finishing these pictures, do you hang them up on the garden wall to mellow?

WHISTLER: I should grieve to see my paintings mellowed. (*Laughter.*) But I do put them in the open air that they may dry as I go on with my work.

The picture representing Battersea Bridge by moonlight was shown in court, and the judge took a hand:

HUDDLESTON: Is this part of the picture at the top Old Battersea Bridge?

WHISTLER: Your lordship is too close at present to the picture to perceive the effect which I intended to produce at a distance. The spectator is supposed to be looking down the river towards London.

HUDDLESTON: The prevailing colour is blue?

WHISTLER: Yes.

HUDDLESTON: Are those figures on the top of the bridge intended for people?

WHISTLER: They are just what you like.

HUDDLESTON: That is a barge beneath?

WHISTLER: Yes. I am very much flattered at your seeing that.

The thing is intended simply as a representation of moonlight. My whole scheme was only to bring about a certain harmony of colour.

The court adjourned, and the jury went to inspect a number of Whistler's pictures at the Westminster Palace Hotel. Following the reassembly of the court, *The Falling Rocket* was shown to the jury:

HOLKER: This is Cremorne? (*Laughter.*)

WHISTLER: It is a Nocturne in black and gold.

HOLKER: You have made the study of art your study of a lifetime. What is the peculiar beauty of that picture?

WHISTLER: It is as impossible for me to explain to you the beauty of that picture as it would be for a musician to explain to you the beauty of harmony in a particular piece of music if you had no ear for music.

In *The Gentle Art* Whistler dramatised the foregoing, and the fiction is certainly more amusing than fact: "'Do you think now that you could make *me* see the beauty of that picture?' The witness then paused, and examining attentively the Attorney-General's face and looking at the picture alternately, said, after apparently giving the subject much thought, while the Court waited in silence for his answer: 'No! Do you know I fear it would be as hopeless as for the musician to pour his notes into the ear of a deaf man'. (*Laughter.*)"

HOLKER: Do you not think Mr Ruskin might have come to the conclusion that it had no particular beauty?

WHISTLER: I think there is distinct evidence that he did. (*Laughter.*) I do not think that any artist would come to that conclusion. I have known unbiased people express the opinion that it represents fireworks in a night scene.

HOLKER: You offer that picture to the public as one of particular beauty, as a work of art, and which is fairly worth two hundred guineas?

WHISTLER: I offer it as a work which I have conscientiously executed, and which I think worth the money. I would hold my reputation upon this as I would upon any of my other works.

The witnesses for Whistler were then called. William Michael Rossetti, brother of Dante Gabriel, being a friend of both parties in the action, testified unwillingly on Whistler's behalf. Of the

latter's pictures in the Grosvenor Gallery, he said: "Taking them altogether I admired them much, but not without exception." Sir John Holker then catechised him about *The Falling Rocket*:

"Is it a gem?"

"No."

"Is it an exquisite painting?"

"No."

"Is it very beautiful?"

"No."

"Is it eccentric?"

"It is unlike the work of most other painters."

"Is it a work of art?"

"Yes, it is."

"Is two hundred guineas a stiffish price for a picture like that?"

"I think it is the full value of the picture." (*Laughter.*)

The next witness was Albert Moore, who said that Whistler's pictures were exquisite works of art:

"Is the picture with the fireworks an exquisite work of art?"

"There is a decided beauty in the painting of it."

"Is there any eccentricity in these pictures?"

"I should call it originality. What would you call eccentricity in a picture?" (*Laughter.*)

The third and last witness who had the temerity to protest against the Ruskin canon was William Gorman Wills, who had done a certain amount of portrait-painting but whose reputation was made as a playwright, especially with three dramas produced by Henry Irving, *Charles I*, *Olivia* and *Faust*. He affirmed that Whistler's works were artistic masterpieces painted by a man of genius. After which the Attorney-General submitted that there was no case. But the judge did not agree; Sir John Holker made the usual Buzfuz speech; and witnesses for Ruskin were called.

Edward Burne-Jones thought the picture of Old Battersea Bridge "bewildering in its form":

"And as to composition and detail?" he was asked by examining counsel.

"It has none whatever. A day or a day and a half seems a reasonable time within which to paint it."

"Does this picture show any finish as a work of art?"

"No, I should call it a sketch. I do not think Mr Whistler ever intended it to be a finished work."

He was then questioned as to *The Falling Rocket*:

"Is it in your opinion a finished work of art?"

"It would be impossible for me to say so. I have never seen any picture of night which has been successful; and this is only one of the thousand failures which artists have made in their efforts at painting night."

"Is that picture, in your opinion, worth two hundred guineas?"

"No, I cannot say it is, seeing how much careful work men do for so much less. Mr Whistler gave great promise at first, but I do not think he has fulfilled it. . . ."

William Powell Frith was the next witness. In an unlucky moment he had confessed that it had been a toss-up whether he became an artist or an auctioneer. "He must have tossed up", was Whistler's comment. In spite of the large sums given for his *Railway Station* and *Derby Day*, the last of which almost converted Victorian sportsmen to a belief in art, he was a better artist than Whistler thought him. But his vivid compositions show that he was not in sympathy with Whistler's style of painting, his attitude to which was that of an academician or a juryman. He began by saying that the pictures exhibited to the court were not works of art. Asked if *The Falling Rocket* was a serious work of art, he replied "Not to me" and did not think it worth two hundred guineas. He also said that the picture of Old Battersea Bridge failed to convey the impression of moonlight to him, and that a picture lacking composition and detail could not be called a work of art.

"You attend here very much against your will?" asked examining counsel.

"Yes, it is a very painful thing to be called on to give evidence against a brother-artist. I am here on subpoena. I had been previously asked to give evidence, but declined."

He was cross-examined by Whistler's counsel, Sergeant Parry:

PARRY: Is Turner an idol of Mr Ruskin's?

FRITH: Yes, and I think he should be an idol of everybody.

PARRY: Do you know one of Turner's works at Marlborough House called *The Snowstorm*?

FRITH: Yes, I do.

PARRY: Are you aware that it has been described by a critic as a mass of soapsuds and whitewash?

FRITH: I am not.

PARRY: Would you call it a mass of soapsuds and whitewash?

FRITH: I think it very likely I should. (*Laughter*). When I say Turner should be the idol of everybody, I refer to his earlier works, and not to his later ones, which are as insane as the people who admire them. (*Laughter*.)

HUDDLESTON: Somebody described one of Turner's pictures as "lobster and salad." (*Laughter*.)

FRITH: I have myself heard Turner speak of his own pictures as salad and mustard. (*Laughter*.)

PARRY: Without the lobster. (*Laughter*.)

Following these specimens of legal light relief, Frith left the witness-box, and was dismissed by Whistler in *The Gentle Art* with "A decidedly honest man—I have not heard of him since." But Whistler enjoyed consigning to oblivion all those who offended him by opposition, pretending that they were dead, and usually that he had killed them. The third witness for Ruskin was a case in point. Tom Taylor, who held a government post, was editor of *Punch* and art critic of *The Times* for some years. When first he saw Whistler's portrait of Miss Alexander he suggested an improvement, but tolerantly added that it was a matter of taste. Whistler did not agree: "I thought that perhaps for once you were going to get away without having said anything foolish; but remember, so you may not make the mistake again, it's not a matter of taste at all; it's a matter of knowledge. Goodbye!" Taylor was the pompous know-all kind of critic, and had been very unpleasant to many painters in his time; but they were about to be avenged. "All Mr. Whistler's works are in the nature of sketching", he pontificated from the witness-box, treating the court to a recital from his various articles, and saying that he still adhered to his written opinion that the paintings under discussion only came "one step nearer to pictures than graduated tints on a wall-paper."

Shortly after this Whistler wrote an article in which he scornfully quoted what Taylor had once said about Velasquez. Taylor replied in a letter to *The World* complaining that Whistler's quotation had misrepresented his true opinion of Velasquez. Whistler retorted in the same paper "Dead for a ducat, dead! my dear Tom: and the rattle has reached me by post", advising him to leave criticism alone and stick to his job as a Poor Law Commissioner.

Taylor then apologised for having taken Whistler seriously, and got this reply: "Why, my dear old Tom, I never *was* serious with you . . . Indeed, I killed you quite, as who should say, without seriousness, 'A rat! A rat!' you know, rather cursorily." This closed the correspondence, and Taylor obligingly died a year or so later, an event which depressed Whistler, who obeyed the injunction to love his enemies because they kept him busy and up to the mark, either fighting them or proving them idiots. Upon being asked why he was looking so glum, he explained "Me? Who else has such cause to mourn? Tommy's dead. I'm lonesome. They are all dying. I have hardly a warm personal enemy left."

The result of the Ruskin trial was unsatisfactory to both sides. Whistler's counsel was incapable of putting his case in its proper light to the jury, who were incapable of understanding it in any light, and the judge made it clear that the contemptuous farthing damages awarded to Whistler indicated that the matter should never have been brought into court. It was the opinion of Bernard Shaw that Whistler should have claimed damages on behalf of his commercial, not his artistic, reputation, urging an enormous loss of income sustained by Ruskin's attack: "That sort of thing can be understood by lawyers, and he would have been awarded £1000. But in talking about his Artistic Conscience he could only raise a farthing—that being all conscience is worth in the eyes of the Law." Though each party had to pay his own costs in the action, Whistler regarded the verdict as a personal victory; and when a friend stepped forward to express condolence, he grasped the extended hand warmly and exclaimed: "I was sure you would see what a great triumph it is!" Ruskin took the verdict as a defeat and resigned the Slade Professorship, writing that he could not hold a Chair from which he had "no power of expressing judgment without being taxed for it by British Law", and forgetting in his irritation that the judgment to which Whistler had objected was printed in a widely-read paper, not privately delivered from an Oxford Chair. In the result he was luckier than Whistler, because his admirers subscribed to pay his costs, upon hearing which Whistler wrote to his solicitor suggesting that it would be equally appropriate for his admirers to pay *his* costs, "and in the event of a subscription", he added, "I would willingly contribute my own mite." He was almost the only contributor.

Though harassed by creditors, he occupied himself immediately

after the case by writing a pamphlet entitled *Whistler v. Ruskin: Art and Art Critics*, which he dedicated to Albert Moore. In it he repeated his assertion that only an artist should criticise art, though what he really meant was that all criticism of his own work should be favourable. His argument does not bear analysis, but he made some good points. It had been urged that Ruskin had devoted his life to art, but Whistler objected: "A life passed among pictures makes not a painter—else the policeman in the National Gallery might assert himself. As well allege that he who lives in a library must needs die a poet." He declared that Ruskin's views on the Masters were expressed with a verbosity "that would, could he hear it, give Titian the same shock of surprise that was Balaam's, when the first great critic proffered his opinion." And he noted one or two possible analogies: "The Observatory at Greenwich under the direction of an Apothecary! The College of Physicians with Tennyson as President! and we know that madness is about. But a school of art with an accomplished *littérateur* at its head disturbs no one!" One of his points was taken up by a writer in *Vanity Fair*, who stated that Balaam's ass had been right, for he had seen the Angel of the Lord, thus saving the life of his master, who had seen nothing. Whistler acknowledged the touch, but deftly hit back: "I fancy you will admit that this is the *only Ass on record* who ever *did* 'see the Angel of the Lord' and that we are past the age of miracles." A copy of his pamphlet went to the Military Academy at West Point, with the inscription: "From an old cadet whose pride it is to remember his West Point day s." He never softened in his attitude to the ex-Slade Professor, though he did not let it develop into a clan-feud; and when some years later an old lady informed him at dinner that she was Ruskin's cousin, he reassured her: "Really, madam, you must not let it distress you too much. We all have our relations of whom we are ashamed."

The addition of about £500 in solicitors' fees to his already considerable list of debts resulted in the beleaguerment of The White House. Directly it was known that he only had a farthing to play with, a host of creditors demanded the payment of their bills, most of which had been gradually accumulating over many years. He had also borrowed nearly £2000 from various friends, and building costs had necessitated the mortgaging of his new home. Howell was helping him to sell his prints and pledge his

belongings, but all Howell's actions tended to personal profit, and though he may have pulled Whistler out of some holes he pushed him into others. The Arts Club applied for long-overdue subscriptions, and Whistler answered flippantly that the presentation of a picture might meet the difficulty. The secretary was equal to the occasion: "It is not a Nocturne in purple or a Symphony in blue and grey that we are after, but an Arrangement in gold and silver." Many tradesmen lived to regret that they had not accepted his offer of Nocturnes instead of cash. One of them, his picture-frame maker, called for payment and was invited to take a glass of wine, which he refused, saying "You will pardon me, Mr Whistler, but while you find yourself unable to settle my bill, I am surprised that you are able to indulge in the extravagance of champagne." "Oh, don't let that worry you", was the reply; "I don't pay for that either." Another creditor was less courteously received. Whistler was going out and found him at the front-door. The usual promises and excuses failed to impress him, and at last Whistler burst out: "I suppose you think I haven't the money to pay your wretched bill?" The tradesman said "Oh, Mr. Whistler!" deprecatingly. "Well, you'd be right, because I haven't!" and instead of going out the Master went in, slamming the door in the other's face.[1] In order to steady the nerves of his more pressing creditors he ordered a grand piano, the mere sight of which made them feel that their accounts were safe. His own nerves were under perfect control; and when a friend who was also being dunned complained that he was kept awake thinking of his creditors and spending the nights walking up and down his bedroom floor, Whistler advised: "Better do as I do: go to bed, and let your creditors do the walking up and down."

When the first writ arrived he opened a bottle of champagne and politely pressed the bringer to join him over a drink. But the serving of writs soon became too common for hospitality, and instead he requested the bailiffs in possession to assist him in entertaining his other guests. Somehow he managed to hire liveries for them, and they waited ceremoniously at his breakfasts. "Your servants seem to be extremely attentive and anxious to please you", said a lady as they rose from the table. "Oh, yes, I assure you they wouldn't leave me", he replied. But one of them became restless after a week's service and asked him for money.

[1] Personal information from James Pryde.

"I have nothing", said Whistler. "I thought the creditors paid you." The man complained that his family were penniless and wanted food. Whistler was extremely sympathetic, and said he would paint something which the other could sell. But that would not do: immediate help was needed. Whistler had an inspiration. "Why not put a man in possession? Then you'll be able to get along as I do." Apparently the fellow followed his advice; but his family did not approve of the arrangement; because when Lady de Grey chided Whistler for having two male servants to wait at table when he was always complaining of being hard-up, he whispered "Hush! One of them is the man in possession, and he has consented to act as footman for the day; but he asks me to settle up as soon as possible, for he too has a man in possession at his own place and wants to get rid of him." He could neither settle up nor settle down, being as restless as ever, and it is recorded that during this period he attended a fancy-dress ball in the garb of Hamlet, though not in the mood of Hamlet, his loud 'Ha-ha!' being heard above the music and chatter as he explained to acquaintances that his house was being well protected by officers of the law, who, having helped him to dispose of the bottles in his cellar, were now engaged in a close study of modern art under his personal supervision: "Drunken bailiffs are apter pupils than sober critics."

On May 8th, 1879, he became a bankrupt, his debts amounting to £4641, his assets to £1924. There was a meeting of creditors, Leyland being present as chief creditor; but instead of explaining the situation Whistler made a speech against plutocrats, aimed of course at Leyland, which might have emanated from a soapbox socialist orator whose sole object was to down the rich. Ever since the quarrel over the Peacock Room he had experienced nothing but ill-luck, and this he attributed to Leyland, who again proved himself a friend by persuading the other creditors to deal with the situation in a manner favourable to Whistler: that is, by arranging that his affairs should be liquidated, which meant that the creditors could on their own account discharge him from debt instead of his remaining a declared bankrupt until the Court discharged him. Leyland, Howell and Thomas Way formed the committee of examiners chosen by the creditors to deal with the business, and they went to The White House to draw up an inventory. In the studio they found three paintings: *The Gold*

Scab, The Loves of the Lobsters—an Arrangement in Rats, and *Mount Ararat*, in all of which Leyland's shirt frills appeared prominently. Whistler had already destroyed a number of his uncompleted paintings, or such as he deemed unsatisfactory, and neither his anger with the critics nor his fury against Leyland dimmed his artistic sense. He sent a few pictures to the Grosvenor Gallery in the spring of '79; and when the posters announcing the sale, which had been pasted on the walls of The White House, were loosened by the rain and fluttered by the wind, he got the men in possession to mount a ladder and paste them down again. "You will know the house by the bills of sale stuck up outside", he wrote to a friend on an invitation card.

On the eve of the sale a curious thing happened. Carlo Pellegrini, an Italian artist whose caricatures as "Ape" in *Vanity Fair* had, according to Whistler, "taught all the others what none of them had been able to learn", lived opposite The White House. Looking out of his window one September night, he saw Whistler, accompanied by his son John, emerge from the house with a candle, place a ladder against the wall, climb it, and write something on the lintel of the front-door. It was Whistler's last joke in the home that he had occupied for less than a year. With a bottle of ink he wrote an inscription on the stone which took several days to erase: "Except the Lord build the house, they labour in vain that build it. E. W. Godwin, F.S.A., built this one." He had been well grounded in the Bible by his mother and knew much of it by heart, his prose style revealing its influence, though it is doubtful whether he read it for pleasure after the years of reading it with pain, for he was once heard to say: "The Bible is a book which, once put down, can never be taken up again."[1]

The White House was sold on September 18th, 1879, together with its contents, which, except for the pictures, were not of much value. But no one at that time set much value on the pictures, which went for a song. Some other paintings and the Chinese porcelain fetched £329 at Sotheby's five months later. The house itself was knocked down for £2700, and the purchaser was Harry Quilter, graduate of Trinity College, Cambridge, art critic of *The Spectator* and after Tom Taylor's death of *The Times*, amateur painter, collector, writer, who, having earned Whistler's

[1] Personal information from Mary Coleridge (1906).

contempt, now gained his animosity, and was henceforth to be ridiculed in print as "'Arry."

It started in *The World*, a paper founded and edited by Edmund Yates, whose pages of gossip, signed "Atlas", were a new feature in journalism. Yates, who had been a friend of Dickens and the immediate cause of the quarrel between Dickens and Thackeray, was by nature a bully, feared and disliked by those who worked for him. The fact that he welcomed Whistler's crisp comments on people shows that he enjoyed making others feel uncomfortable.

Whistler's first shot at Quilter appeared in *The World* on May 18th, 1881, when he pointed out that the art critic of *The Times* must have been suffering from chronic catarrh, as he had failed to distinguish between an oil painting and a water-colour. If the critic's sense of smell was unreliable he should have enquired of the fireman in the gallery, said Whistler, who claimed by this exposure to have slaughtered 'Arry. A couple of weeks later Atlas printed a note to his "dear James" mentioning that The White House had been acquired by Harry Quilter, recently appointed art critic of *The Times*. A year after this Whistler addressed a letter to Atlas, which duly appeared, stating that 'Arry was making a habit of visiting the Grosvenor Gallery: "To have seen him was my privilege and my misery; for he stood under one of my own 'harmonies' . . . himself an amazing 'arrangement' in strong mustard-and-cress, with bird's eye belcher of Reckitt's blue; and then and there destroyed absolutely, unintentionally, and once for all, my year's work! Atlas, shall these things be?" The following year Whistler told *The World* about the alterations Quilter was making to The White House: "Shall 'Arry, whom I have hewn down, still live among us by outrage of this kind, and impose his memory upon our pavement by the public perpetration of his posthumous philistinism? Shall the birthplace of art become the tomb of its parasite in Tite Street?"

In February '86 Atlas noted in his columns that Quilter was a candidate for the Slade Professorship at Cambridge in succession to Sidney Colvin, and suggested that a testimonial from "dear James" might help him to get it. Dear James replied that he had slain 'Arry long ago, but that as he had done the same office for Colvin it was merely a case of substituting one dead body for

another, and the authorities, "ceasing to distinguish between the the quick and the dead, will probably prop up our late 'Arry as professor, long to remain undetected in the Chair! Atlas, *tais-toi*! —Let us not interfere!" Next month Whistler announced that he had come upon "the posthumous paper of 'Arry—his certificate of character, and printed pretension to the Professorship of Slade—and O! the shame of it—and the indiscretion of it! Read, Atlas, and seek in your past for a parallel. ..." In submitting his name as a candidate the unfortunate Quilter had enclosed a few testimonials and declared that he had received favourable letters from Alma-Tadema, Marcus Stone, Briton Rivière, and other R.As. "What!" exclaimed Whistler: "is the Immaculate impure?—and shall the Academy have coquetted with the unclean?" Quilter's further statements received parenthetical interjections from Whistler. He had worked in a portrait painter's studio. ("A portrait by 'Arry!") He had travelled for a year in the East. ("'Arry in the East!") For the last ten years he had written every article upon art which had appeared in *The Spectator*. ("A confession, Atlas, clearly a confession!") He had produced a critical life of Giotto. ("He did indeed, Atlas!—I saw it—a book in blue—his own and Reckitt's—all bold with brazen letters: 'Giotto by 'Arry' ... and then I killed him!")

But before Whistler despatched Quilter in the manner related above, the two had met in Venice, to which Whistler had repaired in September '79 just before the sale of The White House. In the spring of '80 Quilter stayed there for a few weeks, and was busy drawing in a narrow canal one morning when Whistler arrived in a gondola and claimed the site as his. They argued for some time, and at last, as there was only room for one gondola to be moored at that particular spot, Quilter suggested that Whistler should sit in his. Whistler agreed; characteristically pretended that he did not know to whom he was talking; and spent the morning working and discoursing on the crimes of one 'Arry Quilter, art critic of *The Times*. On his return to London, Whistler took a ground-floor studio at 13 Tite Street, adjacent to The White House, and complained to everyone who would listen that as 'Arry could not appreciate Godwin's architecture he ought to hand the place back to its rightful owner: "He obstinately stays there in the way, while I am living in this absurd fashion, next door to myself."

Despotic

THE visit to Venice came at exactly the right moment.
Through the influence of Ernest Brown, a friend too
recently acquired to be an enemy, the Fine Art Society had
just bought some plates of Whistler's London etchings, with
which they were so well pleased that they needed little persuasion
on the part of Brown to commission the artist for twelve more
plates with Venice as a subject. He could have asked for nothing
better than to get away from brokers, bailiffs, and all the sordid
details of bankruptcy, into the Adriatic sunshine, and to do for the
Rialto what he had done for Rotherhithe. For years he had
longed to go there, and now circumstances brought about the
realisation of his desire. But there was little sunshine when he
arrived in the city. The weather was cold and the skies were
grey, and he did not see the Venice which Turner had romanti-
cised in paint, nor that which Ruskin had glorified in prose, for
which he may have been thankful. He wandered about, looking
at the famous paintings, the churches, the squares, alleys and
unsuspected corners; and though he was much impressed by all
he saw, he decided that the ceiling of the Peacock Room was
finer than the dome of St Mark's, thought Piccadilly Circus
preferable to the square of St Mark's, and considered the Thames
in mist more beautiful than the canals under ice. In fact he longed
for London when he was first in Venice as much as he had longed
for Venice when he was last in London. But the winter passed,
Maud arrived to take care of him, and the charm of the place took
possession of him.

For weeks he did nothing but stare and ramble. No progress
with the etchings was recorded, and the Fine Art Society wanted
to know whether they could expect the plates they had com-
missioned in the three months they had specified. But Whistler

began to produce pastels, not etchings, and asked for more money. A furious correspondence ensued. They were warned by people who did not like him that he would never do the plates, that their money had been thrown away, that he would not return to London, that he was a charlatan, a waster, a cadger, an idler, and so forth. His letters failed to reassure them, and they resigned themselves to the worst. Meanwhile he was beginning to etch, and enjoying himself in the company of several American art students who were under the tuition of Frank Duveneck. As usual he gave the impression of doing very little, telling the American Consul that idleness was the virtue of the artist; but he was slowly absorbing his surroundings, and as soon as he was in the mood for it he worked harder and with more concentration than anyone else, starting with the light and finishing in the dark, and spending the very late or very early hours with his young American friends in the cafés that never closed, such as Florian's, the Orientale, the Quadri. Somehow money was also found for the Sunday breakfasts to which he was addicted, when he cooked dainty dishes over a spirit-lamp and Maud presided. She was accepted by all his student acquaintances as his wife, and everyone spoke of her, and to her, as "Madame", But occasionally there were misunderstandings, and one artist, more advanced in years and retarded in morals than the rest, was indignant when he discovered that the lady to whom he had been introduced as Mrs Whistler held a less reputable position in the studio of her quasi-husband. He swore that he would never speak to them again, and for some weeks kept his oath. But one day he came upon Whistler, who was etching out-of-doors, and said "Good-morning." Taking no notice of the salutation, Whistler lifted his head, called up to the window above him "Maud, Maud, little Robins isn't going to cut us!" and bent to his work again.

Two things happened at Venice which suggest that the combination of the Ruskin case, the critics, the bankruptcy, and the public treatment of him as a joke, had developed what was least attractive in his nature: his autocratic and bellicose qualities, originally brought out by the early circumstances of his life. Feeling himself to be unique, cut off even from the brotherhood of of his fellow-artists, he became overbearing and aloof. Knowing himself to be the subject of mockery, he became more than ever

ready to hurt his real or imaginary opponents. And so he began, self-consciously and in self-protection, to act a part. He would give people something to laugh at, and he would make his enemies squirm. Up to now his actions had been impulsive; in future they would be meditated; and the emphasis of his life would henceforth be shifted from his art to the artist. The alteration first became noticeable when the American Consul introduced him to Duveneck's students near the Grand Canal. "Boys, let me introduce you to Mr Whistler", said the Consul. "Whistler is charmed", said the Master, shaking each by the hand. When Otto Bacher, who recorded these details, was introduced to him as the boy who etched, he said "Ah, indeed! Whistler is quite charmed, and will be glad to see your work." The lads were a little bewildered by this godlike approach, but they were impressed by his fame, quickly surrendered to his charm, and asked him to join them in the Casa Jankowitz, where he took a studio which commanded one of the best views in Venice.

They observed that he wore no tie with evening dress, pre-sumably for the effect its absence created. "Only Whistler would do it", said he. Conversation with him was full of surprises. In speaking of certain paintings by Corot, he remarked "They've been done before." "Who did them?" "Whistler". When Bacher found an ideal spot for an etching, he showed it to the Master, who both approved and disapproved: "This is a good subject. When you find a good one like this, you should not do it, but come and tell Whistler." He read aloud the letters he was sending to the Fine Art Society and other correspondents, relishing their more biting phrases and lingering over their more ambitious prose passages. Sometimes he pretended not to like the frank opinions of his listeners: "Bacher, you don't know to whom you are talking—you are talking to Whistler." But Bacher was very helpful, carrying things about for him and manipulating the old printing-press on which his plates were proved. He was displeased with the first plate of one of his finest etchings, *The Traghetto*. Having pulled a proof, he began to improve the plate, and spoilt it. "Whistler has decided to do *The Traghetto* all over again", he said. "Whistler will take this first copperplate to his Italian coppersmith and have him make a duplicate. . . . When Whistler gets the new one, he will prepare

it with his swellest ground, as you know only Whistler can do. . . ." He did a few water-colours as well as pastels; but his sojourn in Venice is mainly notable for the etchings, and whenever he went out he carried a book, between the leaves of which were grounded plates.

The care he took with his own work did not prevent him from laughing at the misapplied care which other artists bestowed on theirs. One of them, R. Bunney, had devoted his life to an elaborate reproduction of St Mark's, in which every detail of the building would be shown. One day Whistler stood behind him affecting to take a deep interest in his minute brushwork. The other was absorbed, did not perceive that Whistler was chalking on the back of his coat in large letters "I am totally blind", and could not understand why more passers-by than usual paused to admire his painting. This incident brings us to the second of those happenings in Venice which denote a hardening in Whistler's relations with the outside world. Looking up from his work he saw a scorpion, which he impaled on his etching-needle, and while it was hitting out frantically in every direction he cried delightedly: "Look at the beggar now! See him strike! Isn't he fine? Look at him! Look at him now! See how hard he hits! That's right! That's the way! Hit hard! And do you see the poison that comes out when he strikes? Isn't he superb?" This gave him the idea of the scorpion's sting which thereafter was added to his "butterfly" signature.

On the whole he enjoyed himself at Venice, as indeed he did everywhere, and took part in all the amusements of the younger fellows. He went out swimming with them and displayed a wish to dive as well as they. After one dive he remained under water long enough to make them feel anxious, when suddenly his voice was heard from where it was least expected: "Was that a good dive? Were my knees all right? They didn't hit the water first this time, did they? It was a good dive, wasn't it? Not so high, perhaps, as it should be, but Whistler will do that by and by." But all the time he was hankering after London, and by the autumn of '80, having spent a year in Venice and finished what he wanted to do, his talk was constantly reverting to the theme: "How can Whistler get back to London?" . . . "Whistler must plan to get back to London as Whistler should" . . . "Whistler must get back to the world again. You know Whistler can't remain out

of it so long." He returned in November 1880, with a number of etchings that appeared to be by a different hand from that which had produced the earlier ones of the Thames. Asked which of his etchings he liked best, "All of them" was the reply. Perhaps he was not aware of the gradual change of feeling within himself which accounted for a seeming change in technique. To quote from James Laver's admirable summary: "Instead of etching the roofs of Venice tile by tile as he had etched the warehouses of the lower Thames twenty years before, he lavished all his skill on dark doorways through which hardly anything could be seen . . . suggestions of shimmering light on water, and phantom outlines of churches and palaces seen in the dim light across the lagoons." Regarded solely as manifestations of his personality, apart from their merit as etchings, they reveal the man Whistler moving further away from reality into his own dream-world, where the critics ceased from hurting and professors were no more.

At the age of forty-six he came back to London prepared to fight the philistines, and he fought them, armed with a scorpion's sting, for another ten years. The first thing he did on arrival was to visit an exhibition of etchings by the Fine Art Society and make everyone feel uncomfortable. He drove up in a hansom and entered the gallery carrying his long cane and leading a white Pomeranian dog by a ribbon. He spoke to no one, but his presence was felt everywhere and there was a hush while he fixed his monocle and gazed at the prints on the walls. "Dear me! dear me! Still the same old sad work! Dear me!" he commented audibly. Seymour Haden, then making a reputation as an etcher, was talking to Ernest Brown about Rembrandt. A loud "Ha-ha?" from Whistler and Haden vanished from the building.

The Fine Art Society, having written him off as a bad debt, were so delighted to hear that he had brought home forty plates, from which they could choose twelve, that they took two rooms for him in Air Street, where a press was set up and he started to print the etchings, which were exhibited at the Society's gallery in December '80, and treated as jokes by the critics. An exhibition of his pastels followed in January '81, and this was a financial success. He decorated the gallery in gold, green and brown, and arranged the pictures in a manner that delighted E. W. Godwin but annoyed the critics, who objected to everything. The Duke of Teck was asked to the private view, and Whistler was with

difficulty dissuaded from beginning his letter of invitation "Prince", being told that "Sir" was the correct usage. Millais thought the pastels "very cheeky, but fine." Someone else said that sixty guineas was a lot to pay for one, but Whistler repeated a passage from the Ruskin case: "Not at all! I can assure you it took me quite half an hour to do it!" The majority of visitors thought the pastels as droll as the pastelist, but the selling was brisk, totalling £1800, and Whistler was able to redeem some of the paintings on which he had raised money before leaving for Venice. Fortunately for him, the dealer did not think them worth £25 apiece, and would have scouted the notion that within a generation the value of each would be over a hundred times that sum.

A second exhibition of his etchings was held early in '83, when fifty-one prints, including some recently completed of London, were on view. The decorative scheme in the gallery was white and yellow, with the livery of the attendant to match. Yellow also were the neckties of the assistants, the flowers, pots, chairs, and Whistler's socks at the private view. He prepared the catalogue with every intention of exasperating the critics, quoting their more ridiculous estimates of his work after each number, and printing on the title-page "Out of their own mouths shall ye judge them." One estimate of his paintings by a well-known critic, Frederick Wedmore, should have read "There is merit in them, and I do not wish to understate it"; but the printer accidentally substituted "understand" for "understate", and Whistler howled with joy when he read the proof, thanked the printer for his intelligent misquotation, and insisted that it should not be corrected. Naturally Wedmore was displeased, and referred to it in *The Academy*. Whistler was waiting for this and had his reply ready for *The World*: "Mr Frederick Wedmore—a critic—one of the wounded—complains that by dexterously substituting 'understand' for 'understate', I have dealt unfairly by him, and wrongly rendered his writing. Let me hasten to acknowledge the error, and apologise. My carelessness is culpable, and the misprint without excuse; for naturally I have all along known, and the typographer should have been duly warned, that with Mr Wedmore, as with his brethren, it is always a matter of understating, and not at all one of understanding."

Whistler took as much trouble over the placing of his pictures

as he did over everything else, and while he was on a ladder hanging the prints before the show opened he heard people whispering that no one would be able to see them. "That's all right", said he. "In an exhibition of etchings, the etchings are the last things people come to see." At the private view he distributed little yellow and white butterflies to select friends, and at the moment when the crowd was thickest the Prince and Princess of Wales arrived. The gallery was cleared while Whistler entertained Royalty. The Prince was amused by the catalogue, but a little confused by the prints, and the Princess said "I am afraid you are very malicious, Mr Whistler." The Fine Art Society would have agreed with her. They had refused to pay him anything until the close of the exhibition; but he badly needed money and was determined to have it. Choosing a Saturday, when the gallery was full, he took up a prominent position and gaily announced: "Well, the show's over!" This created a sensation, and the attendants tried to silence him. But he repeated in a loud voice: "The show's over. Ha-ha! They will not give me any money, and the show's over." An official of the Society rushed to the scene and promised him a cheque on Monday. He had originally asked for £200; now he raised it to £300. The official, in a panic, would have promised anything, and the sum was agreed. "All right", announced Whistler; "the show can go on." It went on, and he went off.

High-handed conduct of this sort was dictated in some measure by shortage of cash, in greater measure by the necessity of amazing and delighting his followers, a number of whom quickly gathered about him on his return to London. As a rebel, an original, and a character, he appealed strongly to young artists, and his mesmeric personality completed what his fame, wit and irreverence had begun. He was always impressing them by his startling behaviour or pleasing them by his charming manner. Life to them was like watching a thrilling play and then being taken behind the scenes and introduced to the "star" performer. He inspired admiration and devotion in about equal degree. The mixture of impertinence and masterfulness in his business dealings with tradesmen and others gave them the comforting sensation that he was fighting their own battles and asserting the dignity and importance of artists. When alone he probably acted in a normal way during these transactions, but when accompanied by a

disciple his manner was unusual and gratifying to his followers.

There was, for instance, the occasion when he called on his landlord, who had threatened to put a man in possession unless he received the rent already demanded a dozen times. Instead of listening to an apology and a promise of early payment, as he had expected, the landlord heard something different: "What do you mean by sending me all these papers that I have received from time to time? Each notice has become more vicious in colour and in character, and at last the colouring has become so atrocious that I have come to demand of you what you mean by arresting an artist in his career? And I want you to understand that it is not always convenient to lay down one's work to attend to sordid details of this kind. . . ." Whistler flung the notice on the table and left the landlord speechless. He was not even mollified when the shoe was on the other foot and he called for payment of a picture which a dealer had sold for him. The cheque was given to him in an airy indifferent fashion, and the dealer was treated to a lesson in good manners: "This is careless of you. You push the cheque toward me, and you do not realise what a privilege it is to be able to hand it to the Master. You should offer it on a rich Old English salver, and in a kingly way."

The followers who witnessed such incidents did their best to merit the privilege by copying the Master slavishly in all things. They adopted a high tone with lesser breeds, aped his manner, repeated his sayings, dressed as nearly in his style as possible, liked what he liked, disapproved of what he disapproved, were amused by the same things, and scoffed when in duty bound. They went to the same restaurants, encircled him in clubs, accompanied him in the streets, attended him at art-galleries, acted as his publicity agents, and in general made themselves thoroughly ridiculous. "The devotion of this group became infatuation", wrote his biographers, the Pennells. "Families became estranged and engagements were broken off because of him." His methods as a painter were soon theirs, and they found it possible to imitate everything except his genius. Having exercised his fascination and reduced them to a condition of abject discipleship, he was an arbitrary taskmaster, and made their thraldom complete. They were not permitted to have opinions of their own; their time was wholly at his disposal; they were at once his courtiers and his bondsmen, always in attendance, always

ready to obey his commands, to fetch and carry, to butter his bread and black his boots.

Very few artists with any pride or individuality would submit to such servitude, whatever the genius of the Master, however magnetic the man. Philip Wilson Steer was one who could not endure the playboy aspect of Whistler, his spectacular clothes, his quarrels, assaults, libels, letters, debts and duns. One of his disciples, however, was rather above the ruck of followers, and another was quite outside their orbit. The first was Mortimer Menpes, the second Walter Sickert. Menpes, a young artist fresh from Australia, was completely bowled over by Whistler at their first meeting, left Edward Poynter, then principal of the National Art Training Schools at South Kensington, and grovelled before the new apocalypse. He helped Whistler with his printing, carried about a packet of copper plates carefully grounded and ready for use in case the Master suddenly spotted a subject and wanted to make an etching, posted his letters, opened his front-door to callers, ran messages, trotted after him like a dog, served him like a dog, and of course was treated like a dog for his pains.

The first rift between them occurred when Whistler and he visited the International Exhibition in Brussels and the Master came across two lots of etchings by Menpes and Sickert, which they had sent without telling him. "How dare you!" shrieked Whistler, and continually reverted to the theme during the next few days: "Why have you kept this from the Master? What excuse can you find for yourself? . . . Do you realise that you have been behaving badly? Do you realise that I lifted you more or less out of the gutter, artistically? I found you in absolute degradation, studying under E. J. Poynter at the Kensington Schools; and what did I do? Saved you, cleansed you, allowed you the intimacy of my studio. I even made a pupil of you, my favourite pupil. More than that, I made a friend of you: I gave you my friendship. Now, don't you feel ashamed of yourself?" The rage of the Master was so terrible, his own penitence so complete, that Menpes wanted the earth to open and swallow him up. After he had existed in misery for several days, Whistler forgave him completely, and the sun shone again.

But it was the tranquillity that precedes an avalanche. Menpes committed the unforgivable sin of visiting Japan, which should

have been reserved for the Master, who had revealed its art to the English people. On his return Menpes held an exhibition of his Japanese pictures, which were noticed favourably in the *Pall Mall Gazette*. Whistler went to the exhibition, accused Menpes of having inspired the laudatory notice, and said: "You have stolen my ideas. The eccentric hanging of this gallery brings ridicule upon the Master. Now, what do you propose to do? Your only hope of salvation is to walk up and down Bond Street with *Pupil of Whistler* printed in large letters on a sandwich board at your back, so that the world may know that it is I, Whistler, who have created you. You will also write to the *Pall Mall Gazette* and tell them that you have stolen my ideas; also you will call yourself a robber." Later Whistler came across Menpes making a sketch on the Thames embankment, and stopped to say "How dare you sketch in my Chelsea?" Later still Menpes distempered the walls of his house in Fulham, the colour being Whistler's peculiar lemon-yellow. This gained some notoriety in the British and American press, being described as "The Home of Taste", and Whistler wrote to *The World* claiming the colour as his invention, but doing so "at the risk of advertising an Australian immigrant of Fulham—who, like the kangaroo of his country, is born with a pocket and puts everything into it." He also sent a note to Menpes: "You will blow your brains out, of course. Pigott has shown you what to do under the circumstances, and you know your way to Spain. Good-bye!" Richard Pigott, forger of the Parnell documents, had recently fled to Madrid and shot himself to avoid arrest.

An eight-years friendship, if it can be termed so, was thus killed by Whistler, who, whenever the deceased friend was mentioned, would say "Eh, what? Meneps—who's Meneps?" and, if prompted, would admit "I believe there was a sort of person— I mean to say a *creature*—of that name." Menpes, in short, had ceased to exist. But unfortunately he arrived at a dinner given to Whistler, arm-in-arm with Justin McCarthy. Everyone else being seated, his appearance could not be overlooked, and Whistler instantaneously decided that, if not extinct, the fellow was at least contagious. "Ha-ha! Have you forgotten? Damien died!" he called out to McCarthy, the reference being to the death from leprosy of Father Damien who had ministered to a leper settlement. "Well, I don't know how it is, but Providence sends

me these little things", Whistler afterwards confessed, relishing the quip.

At the height, or depth, of his discipleship, in the winter of '83-4, Menpes spent some weeks with Whistler and Walter Sickert at St Ives in Cornwall. As with many others, Whistler had hypnotised Sickert at their first meeting. Sickert had been studying at the Slade, but he was easily persuaded to leave that and help Whistler to print his etchings. The inevitable declension from pupil to serf took place, and Sickert was soon running about on his Master's business and joining the chorus of yes-men. For a while he was a sort of chosen disciple. "Nice boy, Walter!" said Whistler; but the boy had to pay for being nice. In the evenings they would go in a cab to the Café Royal or elsewhere, accompanied by a weighty lithographic stone in case inspiration should visit the Master either during or after dinner. Sickert was charged with the care of the stone, and the waiter was ordered to bring an extra table for it. The evening over, and the stone untouched, Sickert bore it back again. In 1883 Whistler's portrait of his Mother was exhibited at the *Salon*, and Sickert was graciously permitted to take it across the Channel, see it through the Customs, travel with it on the railway journeys, and be wholly responsible for its safe arrival. This was an honour which he fearfully undertook but fully appreciated. During his stay in Paris he was Oscar Wilde's guest at the Hôtel du Quai Voltaire, and he presented letters of introduction to Degas and Manet, to both of whom he explained that Whistler was "amazing", having been instructed to tell them so by Whistler. Dictatorial and exigent though the Master could be, there was always a twinkle in his eyes when he made his most outrageous claims and assertions. Once, when Sickert dropped a plate that he was biting, Whistler snapped "How like you, Walter!" Shortly afterwards Whistler himself dropped one. "How unlike me!" he drawled. Another time Sickert wished to introduce D. S. MacColl, paving the way by saying that the critic had written an article entitled "Hail, Master!" in which he had given high praise to Whistler. The latter was unimpressed: "Humph! that's all very well—'Hail, Master!'—but he writes about other people, OTHER PEOPLE, Walter!" And his eyes sparkled with fun as he said it. Sickert's selfless attitude was not shared by his sister, who could not talk about painting and found that painters could

talk of nothing else. "Miss Nellie, why do you hate me so?"
asked Whistler when they were alone one day. She stammered a
negative. "You do! You do! You just *hate* me!" he repeated.
She was probably a little resentful at his complete ascendancy
over her brother.

Throughout the weeks he spent at St Ives with Menpes and
Sickert his dominion over them was absolute. He got up at
cockcrow and taunted them into doing likewise: "Walter, you are
in a condition of drivel! There you are, sleeping away your very
life! What's it all about? . . . Menpes, is this the sort of life you
live in the bush?" They listened gravely as he delivered a lecture
on the scientific cutting of bread while their breakfast was
getting cold, and the landlady attended closely as he explained the
necessity of serving gentlemen with coffee after dinner. In those
days St Ives was a fisherman's village, not the tourist's centre it
has since become, and the inhabitants stared with astonishment
at Whistler's weird straw hat and strange footgear. Dancing
shoes are not ideally suited to cobble stones. Sickert, having
stayed at St Ives before and made friends with the fishermen,
was constantly receiving gifts of fish. This made Whistler
jealous: "Why don't they give me fish? It is the Master who
should receive these gifts." He wasted a great deal of flattery,
artifice and comedy on them, but all his efforts failed to win a
single mackerel; and when one of them was tactless enough to
praise a Royal Academician who had stayed there, he was upset
and fretful. The dutiful attention of his pupils helped him to put
up with the tedious country and the fishermen's lack of attention.
They mixed his colours, cleaned his brushes, baited his hook
when he descended from art to angling, and neither fed nor did
anything else without his permission.

For many years Sickert talked and wrote about Whistler,
explaining the unique qualities of the man and artist in the press of
Great Britain and America. He even attributed some of his own
pithy sayings to the Master. The *Westminster Gazette* once
published a *mot* in dog-Latin which Sickert had fathered on
Whistler, who, on hearing of it, made a suggestion: "Very nice
of you, very proper, to invent *mots* for me. The Whistler *mots*
propagation bureau. I know. Charming! Only when they are
in languages I don't know, you had better advise me in good time,
and send me a translation. Otherwise I am congratulated on them

at dinner-parties, and it is awkward." Eventually Sickert ceased to worship his hero and developed his own individuality as artist and man. Though he remained grateful to the end of his life for the inspiring influence of his Master, it cannot unfortunately be said that the Master remained grateful for the decade of ungrudging service and unstinted adulation of his pupil; for in the years to come Whistler was to speak contemptuously of Sickert in a court of justice.

The Sickert and Menpes pupillage lasted over the period of Whistler's connection with the Society of British Artists, which was formed early in the nineteenth century as a sort of protest or at least a defence against the monopoly of the Royal Academy. Apart from a few promising periods, the Society had been steadily losing ground, and when Whistler was asked to become a member it was suffering from comparison with the Academy on one hand, the Grosvenor Gallery on the other. Even the older members felt that something or someone was necessary to pull the Society out of the slough of apathy into which it had sunk and make it a lively go-ahead concern. For the younger members there was but one solution: Whistler must be asked to join. The older members shook their heads; they had not envisaged such drastic treatment; but they were over-ruled, and a deputation waited upon Whistler, who was told how the land lay. Early in December '84 *The Times* announced that "Artistic society was startled by the news that this most wayward, most un-English of painters had found a home among the men of Suffolk Street, of all people in the world." Whistler had seen his fellow-students of the old Paris days rise to positions of eminence. Poynter, Leighton, Armstrong and Du Maurier were honoured in the land, men of respectability, pillars of the establishment; whereas he was still an outsider, an alien, an eccentric, distrusted and feared by those who had achieved, or who wished to achieve, the solidity of official distinction. It was natural that he, less appreciated as an artist of fulfilment at the age of fifty than he had been as an artist of promise at the age of twenty-five, should welcome the recognition of a Society which, at present moribund, might be turned into an instrument for the propagation of his own ideas. No doubt he visualised the possibility of a grand campaign: Whistler *v* The Royal Academy. At any rate it would give him the publicity he needed, and, as a side-line, plenty of fun.

The fun started fairly soon. A Royal Academician named Horsley gave a lecture before the Church Congress in October '85, deprecating representations of the naked human form, and speaking of "the degradation enacted before the model is sufficiently hardened to her shameful calling." In December the Society of British Artists held a Winter Exhibition, and beneath one of his pastels of a nude woman Whistler affixed a label with the words: *Horsley soit qui mal y pense*. The older members were alarmed because the Academy might be annoyed, and the label was removed; but the incident was reported in the press, which gave Whistler an opportunity to speak of Horsley's attitude as "the unseemliness of senility."

The new member at once took a keen interest in the affairs of the Society, invited the President and others to breakfast, suggested that Sunday receptions should be held in the Suffolk Street Gallery, and proposed that photos of the exhibits should be sold, a practice that has since become popular. As the Society was in financial difficulties, he advised that the banquets given to the critics should be discontinued; but the barest hint of doing anything to antagonise journalists was too fantastic to be considered. For the press view which followed the rejection of his notion he sent a frame containing no picture. The committee telegraphed for the canvas. He telegraphed back "The Press have ye always with you. Feed my lambs." It was at one of the first exhibitions after he had become a member that a critic said to him "Your picture is not up to your mark; it is not good this time", and he made the famous answer: "You shouldn't say it is not good. You should say you don't like it, and then, you know, you are perfectly safe. Now come and have something you do like—have some whisky." With the critics on these occasions he was invariably courteous and helpful, though they did not invariably appreciate his services. He led one of them by the arm to a picture and imparted valuable inside information: "It is very small, isn't it? Very small indeed. And if you come quite close you can smell the varnish. That is a point, distinctly a point. It will enable you to discover that the picture is an oil colour. Don't you make any mistake and call it a water colour. . . ."

The history of the world is a record of how energetic minorities who know what they want impose their wills and governments on lazy majorities who do not. Whistler was elected Presi-

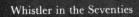
Whistler in the Seventies

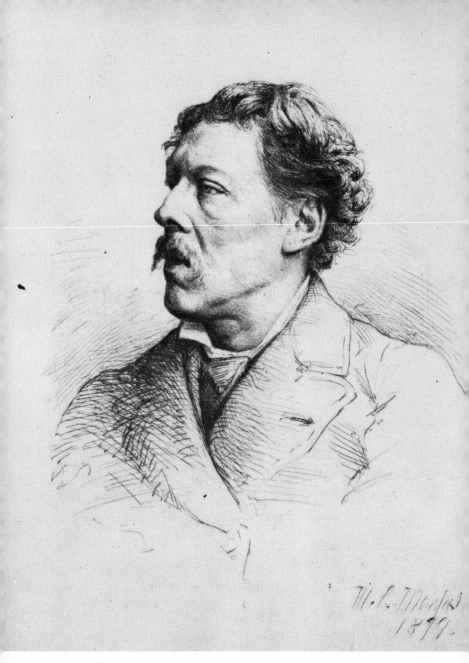

(*above*) C. A. Howell by Mortimer Menpes (*opposite, above*) Algernon
Charles Swinburne (*opposite, below*) Portrait of Swinburne by Dante
Gabriel Rossetti

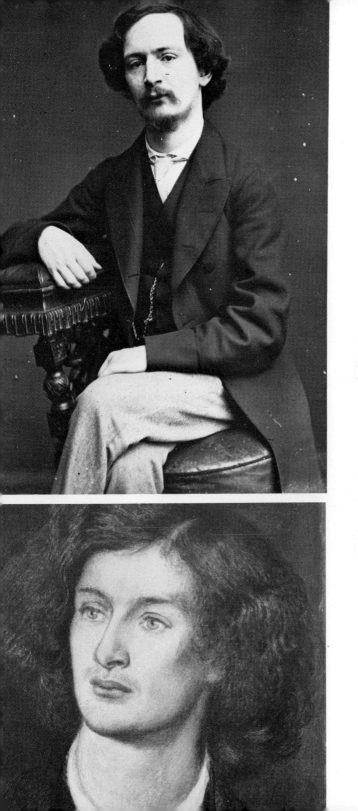

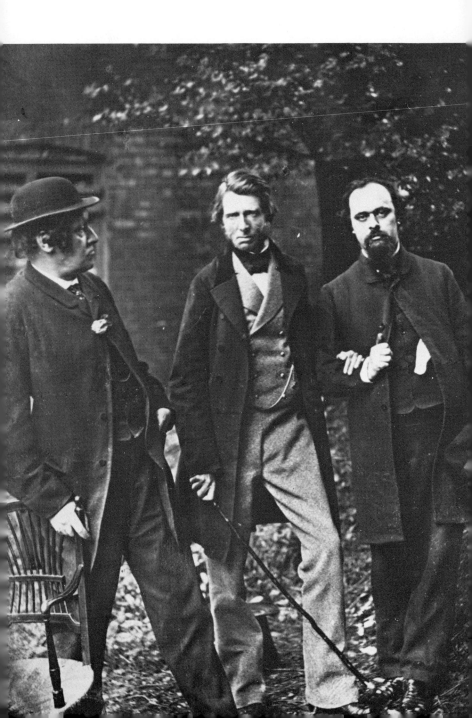

(*below*) John Ruskin arm-in-arm with Dante Gabriel Rossetti (*opposite*)
Harmony in Grey and Green (Miss Cicely Alexander)

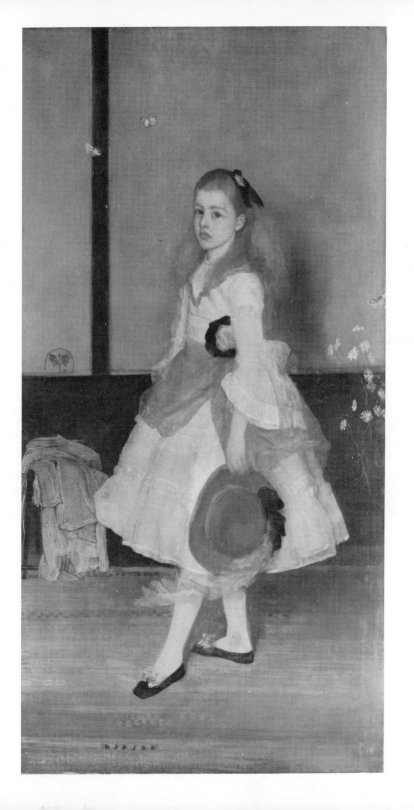

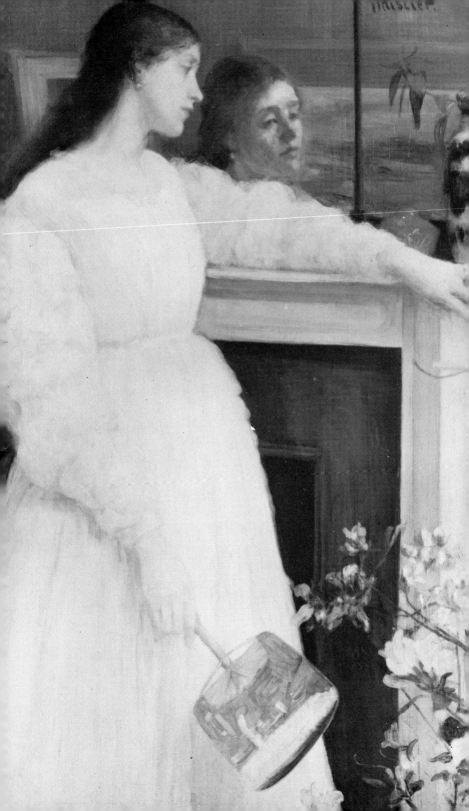

(*opposite*) The Little White Girl (Jo) (*right*) Cartoon by Max Beerbohm showing Whistler giving evidence in the case of Pennell v. *The Saturday Review* and Another (*below*) Oscar Wilde

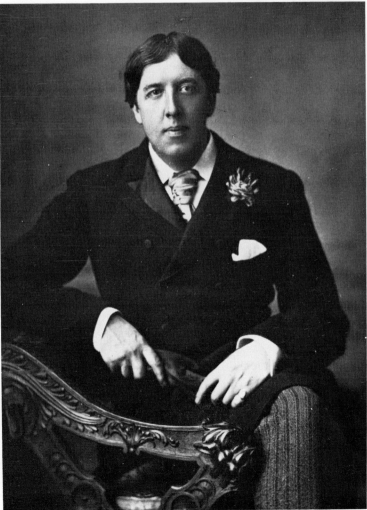

Detail of the Peacock Room, showing *La Princesse du Pays de la Porcelaine*

dent of the British Artists by the united minority of young
members, in defiance of the divided majority of older ones, at a
General Meeting on June 1st, 1886. He had arranged to visit the
United States in the autumn of that year, and though, as he said,
"one cannot continually disappoint a continent", his election
compelled him to cancel the trip. He was never to see his native
land after leaving it at the age of twenty-one.

Despotism in art, if the despot be an artist, is not a bad thing.
Whistler proceeded to make the Society sit up; and he kept it
awake as long as he was in command. He redecorated the galleries,
installed a velarium to soften the light, arranged the pictures at
intervals so that they could be seen, and converted what had been
a dealer's shop into an artistic exhibition. He devised a quiet
scheme of grey-brown with a hint of gold in places. While it was
being carried out he was absent for a brief period, and found on
his return that his design was being spoilt by a too-free use of gold.
The decorator explained that, as the gold was there, he thought it
had better be used. "Look here", said Whistler; "suppose I'm
making an omelette and you come along and drop in a seagull's
egg. I'm *using* eggs, but—see?" As the background was an im-
portant feature of the show and the pictures were not crowded,
much mediocre work had to be rejected, and those whose pic-
tures were not hung raised an outcry. Since then his decorative
methods and picture spacing have been copied in nearly every
public art gallery and even in the Royal Academy; but before
his influence began to extend, the average art gallery resembled an
auctioneer's room. To soothe the distress he had caused, he offered
to lend the Society £500 with which to pay their debts. It is
doubtful whether the offer was accepted, but it is not in doubt that
he would have had to borrow the money. For the visit of the
Prince and Princess of Wales he painted the doors and dadoes
yellow. The members criticised the effect, and he left the job
unfinished. "I never heard of this place, Mr Whistler, until you
brought it to my notice. What is its history?" asked the Prince.
"Sir, it has none; its history dates from today", answered the
courteous President. Those who had not found favour with the
hanging committee were especially wroth that their pictures
were not viewed by the princely eye.

The rage of the members was exacerbated by the gratitude they
were bound to express when Whistler obtained a Royal Charter

for the Society. In 1887 Queen Victoria celebrated her Golden Jubilee, and every art society sent loyal greetings. Without consulting his committee Whistler prepared and despatched a remarkable address, printed on old Dutch paper, bound in yellow morocco, and illustrated with designs and water colours by himself. In it he laid stress on the devotion of the Society to the sovereign and begged for the honour of a title which would show that the Society belonged especially to Her. The illustrations included the royal arms, Windsor Castle, Whistler's home in Chelsea, a battleship, and a butterfly, presumably stingless. After this had been forwarded to Windsor, he was asked by the committee to attend a meeting, whereat they proposed that the Society should send an address to Her Majesty. He asked how much they wished to spend on it, and was told a guinea. He said that it would cost more than twenty times that sum, and left them in dismay. When the Queen's acknowledgment of his address arrived, together with the command that the Society should henceforth be known as 'Royal', he went to another meeting at which he was violently criticised for, among other things, his insistence that members should not assemble, as heretofore, in shirt sleeves, but dress properly and attend to the business in a becomingly formal fashion, and his refusal to step down from the chair when making a speech. They also resented his presence on those occasions in evening dress. Having allowed them to expend their fury, he rose solemnly and announced the honour that he had been able to obtain for them. The atmosphere of the meeting instantly changed, and members rushed forward to shake him by the hand, but he waved them aside and concluded the agenda of the evening in the correct and ceremonious manner which he had introduced and they disliked.

It must be admitted that he did not behave as one who wished to work harmoniously with his colleagues. On the morning of the first exhibition to be held under his Presidency all the members assembled in the gallery to await his arrival. Expectation sat in the air, and the exhibitors were on tiptoe. The Master entered, and with jaunty footstep passed down the gallery, humming as he went. No one seemed to breathe. He went straight to his own picture, which he surveyed for some fifteen minutes, stepping backwards, forwards, dusting the glass with his handkerchief, fixing his monocle, letting it drop, viewing the work from different

distances and angles, while the audience gaped. Then he turned round, beamed upon his fellow-artists, cried enthusiastically "Bravo, Jimmy!" and left without glancing at another item in the exhibition.

Also he did a thing which in Victorian England almost amounted to blasphemy. He held Sunday afternoon receptions when pretty girls, dressed in harmony with their surroundings, distributed tea to smart society. At one of these functions, which the older members regarded as desecration of the Sabbath, a fashionable female asked him what he thought of her new gown, fresh from Worth in Paris. He adjusted his glass and said critically: "There is only one thing . . ." "Oh, Jimmy, what is it? Tell me where it is wrong." "Only that it covers you, madam." Such things got into the papers, and his Sunday afternoon tea-parties advertised the Society more effectively than the pictures. As to these last, there were diverse opinions. The younger members said that before the new President had revolutionised the exhibition the visitors had consisted mostly of loving couples who had come to enjoy one another's company instead of taking an intelligent interest in art. The older members said that the general public thought themselves robbed when they paid half-a-crown to see one or two rows of well-separated paintings instead of the covered walls to which they had been accustomed. We can obtain a pretty good idea of the quality of the work exhibited from a new and acute art critic, who was in sympathy with modern move-ments but could spot their weaknesses as clearly as their virtues, and who was trying hard to find a place in weekly journalism over the initials of 'G.B.S.' The date of his article in *The World* was April 13th, 1887, though the sense of what he said is dateless:

"The value of impressionism depends on the accuracy of the impressions. Mr Whistler, for instance, fixes for us an impression which, though incomplete, is exquisitely accurate as far as it goes. But the same subtlety of sense which enables him to do this must also compel him to recognise that there is not half-a-crown's worth of successful or even honest effort in some of the works conspicuously hung in the vinegar and brown paper bower he has made for his followers in Suffolk Street. These gentlemen are painting short-sightedly in more senses than one. The trick of drawing and colouring badly as if you did it on purpose is easily acquired; and the market will be swamped with 'new English

art', and the public tired of it, in a year or two. Then there will be vain lamenting over lost ground to recover, bad habits to correct, and association of names with unsaleability to be lived down. The 'new' fashion may be capital fun for Mr Whistler, Mr Sargent, and a few others who can swim on any tide; but for the feebler folk it means at best a short life and a merry one."

All that need be added is that Whistler had to make the best of his followers, and did not exert himself to get anyone's work exhibited in Suffolk Street except on one occasion, when against the general wish he insisted that a picture by Lady Colin Campbell should be passed without submission to the hanging committee. Perhaps he valued his office more for the position it gave him in the outside world than for the influence he could exercise in the sphere of art. He was invited to Westminster Abbey for the celebration of the Queen's Jubilee, to a garden-party at Buckingham Palace, to a Naval Review off Spithead, and to a reception at the Royal Academy, the last of which appealed to his sense of humour. The President, Sir Frederick Leighton, was receiving guests at the top of the stairs when he saw Whistler and went forward with extended hands to welcome him: "My dear Jimmy, this is the first time I have seen you here!" "Yes, Freddie, it is quite true, and I have such a rotten excuse to offer you. It is the first time I have been invited."

For two years the opposition to his leadership of the British Artists grew, and at last became open rebellion. His despotism had succeeded in uniting the majority. The hanging of pictures in an isolated manner, the decorations, the repainting of their signboard with the addition of a butterfly, the irritation of non-members who could not sell their works because they were not seen, the space given to a foreign artist, Monet, the arbitrary way in which the President had obtained a royal title for the Society, his declaration that members should resign from any other art society to which they belonged: all these things and a dozen more came boiling to the surface at a series of committee meetings, and Whistler defended himself by attacking his opponents. "I wanted to make it an art centre; they wanted it to remain a shop, although I said to them 'Gentlemen, don't you perceive that as shopmen you have already failed. Don't you see, eh?'" He also entertained some of them, and irritated others, with a parable:

"You know, you people are not well. You remind me of a

shipload of passengers living in an antiquated boat which has been stuck in the mud for many years. Suddenly this old tub, which hitherto has been disabled and incapable of putting out to sea to face the storm and stress of the waves, is boarded by a pirate. (I am the pirate.) He patches up the ship and makes her not only weather-tight, but a perfect vessel, and boldly puts out, running down less ably-captained ships and bearing a stream of wreckage in her wake . . . Naturally some of her original crew begin to notice the motion and feel rather uncomfortable. But I assure you, gentlemen, that this feeling does not last, and as soon as you get your sea-legs you will enjoy it immensely . . ."

As for their complaint of his peculiarities, he disposed of it easily:

"Now, you members invited me into your midst as President because of these same so-called eccentricities which you now condemn. You elected me because I was much talked about and because you imagined I would bring notoriety to your gallery. Did you then also imagine that when I entered your building I should leave my individuality on the doormat? If so, you are mistaken. No, British Artists: I am still the same eccentric Whistler whom you invited into your midst."

But the British Artists no longer wanted an eccentric pirate in command of their ship; and as the uncomfortable motion made them seasick, they threw him up. There was a meeting in May '88, at which a letter was read from eight members requesting President Whistler to ask James A. McNeill Whistler to resign his membership of the Society; and the annual election took place in June, when Wyke Bayliss received the majority of votes. "You can no longer say you have the right man in the wrong place", Whistler told the members, and he confessed to a friend "Now I understand the feelings of all those who, since the world began, have tried to save their fellow men."

His term of office did not close until December, and in the course of those last six months there were some lively exchanges between the outgoing and incoming Presidents, chiefly concerning the repainting of Whistler's signboard and the removal of its butterfly, though they also came to loggerheads over the number of pictures that had been sold under Whistler's reign, Bayliss trying to prove a serious decrease in receipts, Whistler explaining that the fault was not his. The latter had an irritating trick of mis-

pronouncing the surname of anyone he happened to dislike, and the childish habit of referring to "a Mr——" in print when the person was quite well known. During the last committee meetings under his chairmanship he called his successor 'Mr Baillie', until Bayliss had the happy thought of calling him 'Mr Whistle'. Having admitted the touch, Whistler began to accentuate the 'Wyke' in his opponent's name, and no doubt felt that he had won on points. If Bayliss had retaliated with 'Abbot', the score would have been even.

What Whistler described as "the sacrilegious era" came to an end in December '88, when he ceased to be a member of the Society to which he had given significance abroad and for which he had obtained a regal dignity at home. It cannot have caused him much pleasure when, as President of a Royal Society, Wyke Bayliss was knighted. But a witticism is remembered long after titles are forgotten, and Whistler's last words in a newspaper interview are still quoted:

"The organisation of this 'Royal Society of British Artists', as shown by its very name, tended perforce to this final convulsion, resulting in the separation of the elements of which it was composed. They could not remain together, and so you see the 'Artists' have come out, and the 'British' remain—and peace and sweet obscurity are restored to Suffolk Street! Eh? What? Ha-ha!"

His farewell to the Society was taken in characteristic style. He invited the members to drink champagne with him, and during the accompanying chatter his attention was called to a very small picture by Sir Frederick Leighton among the show of sketches. "Ah, yes, a perfect diamond in the sty", he said. Some twenty-five members, his crew of fuglemen, resigned with him. Sickert never again sent a picture to the British Artists lest he should offend Whistler. Menpes had resigned a month before, earning his Master's comment: "The early rat who leaves the sinking ship." On the evening of the day when the general withdrawal took place there was a supper at the Hogarth Club, and the followers, foreseeing a glorious future under the leadership of their Master, toasted him with acclamation. "What are you going to do with them?" asked Menpes. "Lose them, of course", replied Whistler. He kept his word.

CHAPTER X

Critical

EARLY in 1881 Whistler's mother died. Though he had been expecting the event ever since she fell ill five years before, he was not prepared for it. Unable to bear the sight of illness, he felt that he had neglected her in the last years of her life, though he had written regularly and gone to stay with her at intervals. She had lived at Hastings since '76. There was a deep affection between them, if not perhaps much understanding, for she had always wanted him to become a clergyman, while he had always wanted to be what he was. Yet he sobbed with remorse when walking with his brother Willie on the cliffs above the town after her death, vehemently declared that he had not been sufficiently kind and considerate to her, and cried passionately: "It would have been better had I been a parson!"

His brother had done well as a doctor, and his house in Wimpole Street was always used by Jimmy whenever he lacked a home of his own. He stayed there on his return from Venice; but in a week or two he was living with Maud at 76 Alderney Street, Warwick Square, Pimlico, and he had a studio at 13 Tite Street as well, for he disliked being far from the Thames. It was while they were in Alderney Street that "Mrs Whistler" became enceinte and disappeared to Paris for two months, where she was delivered of a daughter. Soon after she returned they moved to more commodious quarters in Fulham Road called the "Pink Palace", and he took a studio close at hand. By 1885 they were living in a secluded spot known as "The Vale", a turning off King's Road, Chelsea, and here he had a square early nineteenth-century house with iron verandahs, a fairly large but always unkempt garden, and a fine studio. His son John was a frequent visitor and helped him considerably during the British Artists period. In the following years John did well as an engineer.

There was never any bitterness in the relationship between father and son, nor between Whistler and Jo.

But the bitterness between himself and his sister's husband Seymour Haden persisted, and in 1881 they had a newspaper quarrel over the misattribution of some etchings. Soon afterwards Haden entered a gallery, caught sight of Whistler, and left at once. "I see! Dropped in for his morning bitters!" remarked his brother-in-law. All through the eighties indeed Whistler kept up hostilities with those who could not see with his eyes, seeming to take as keen an interest in bickering as in painting. "What are *we* to do who find ourselves in disagreement with Mr Whistler's principles?" plaintively asked Frederick Wedmore after hearing the artist hold forth at some reception. "Do, my dear Sir? Why, *die!*" was Whistler's emphatic rejoinder. Wedmore had written some stupid comments on the artist's work, and perhaps deserved the treatment he received at a dinner to which he had been invited as a distinguished guest. Whistler, sitting on the other side of the hostess, pretended he did not know Wedmore by sight, treated him as a city friend of their host's, and spoke of art critics as "dull dogs, my dear sir, dull dogs. You, of course, occupied all day in your business affairs, have not, I suppose, come across them", and so on. Their hostess nudged him, kicked his foot under the table, did everything possible to make him perceive the enormity of his behaviour; but he went on, and whenever Wedmore tried to get a hearing he told a comic story, amusing the other diners so much that the famous critic's presence was at last completely overlooked. Such scenes explain Whistler's description of himself as an unwelcome guest: "Well, you know, when I'm asked out to dinner, I always enjoy myself. But—well—I'm never asked to the same house twice." He did not bother to conceal his opinion of the critics, one of whom, M. H. Spielmann, was not gratified to hear, on Whistler's authority, that he had acquired his knowledge of art "by running to fires and reporting them." At length they became quite frightened not only of his pen and his tongue, but of his stick. Stopped at an exhibition by an attendant who wanted him to leave his cane in the cloakroom, he replied: "Oh, no, my little man; I keep this for the critics." In effect he undermined free criticism; at least it may be said that after the publication of his letters in *The Gentle Art* the critics feared to say whether this picture was good, or that bad,

because they never knew when their words would be used to ridicule them. In this respect his influence was harmful; for though it is true that nearly all the criticism of one generation seems absurd in the next, it is better to have outspoken criticism that is silly than timorous criticism that is nothing.

The Royal Academicians were as nervous of him as the critics. He scoffed at them openly and constantly. "They are the commercial travellers of Art, whose works are their wares, and whose exchange is the Academy", he wrote. Individually and collectively he had a low opinion of them, though he was able on rare occasions to admire one of their pictures or part of a picture by one of them. Standing before an interior by William Orchardson, he encircled a bit of yellow drapery with his forefinger and said "It would have been nice to have painted that"; but this may have been because Orchardson had a very high opinion of him. His usual attitude to works in the Academy was summed up when a young dramatist-to-be named Benrimo emerged from Burlington House, saw Whistler, introduced himself, and praised the Master's works effusively. "Been in there?" asked Whistler, indicating the famous gallery. "Oh, yes." "See anything worth while?" "Some splendid things, magnificent examples of——" "I'm sorry you ever approved of me", cut in Whistler disdainfully, and turned on his heel. He told Sickert that "We have only one enemy, and that is funk"; but when someone remarked that R.A.s painted to please the public and so reaped their reward, he did not agree: "I don't think they do. I think they paint as well as they can." In other words their paintings were commonplace because they were commonplace. "It is better to live on bread and cheese and paint beautiful things than to live like Dives and paint potboilers", he declared, though he knew that poverty, while it necessitated industry, harmed the artist; "Give a painter money and see what he'll do. If he does not paint, his work is well lost to the world. If I had had, say, £3000 a year, what beautiful things I could have done!"

His opinion of the exhibitions at Burlington House was quite honest, but his remarks on individual exhibitors were due to his exclusion from the inner ring, reinforced occasionally by personal animosity and always by an irreverent sense of fun. "Well, you know, when I first came to England I found I had to put my foot in it, and—well—I have kept it there ever since." That was the

individualist speaking. "Why do you go for him? He has one foot in the grave", said someone when Whistler was pitching into an ancient Academician. "Ah, that's not the foot I want to get hold of!" came the reply, which displayed personal antipathy. But as often as not the situation provoked him to comedy. In speaking of a certain painter as an R.A., he was told that the man was an A.R.A. "It is a difference without a distinction", said he. Asked why he was present at an Academy exhibition, he answered "Well, you know, one must do something to lend interest to the show—so here I am." On such occasions it was noticed that he paid scant attention to the exhibits. No doubt he felt that there was nothing new, that each painter had merely repeated himself, and that as he had seen *it* there was no need for him to see *them*. Perhaps his best quip on the subject was delivered when a circular addressed to him at the Royal Academy was endorsed "Not known at the R.A." and forwarded to his home. He let the press have it, with a note: "It is my rare good fortune to be able to send you an unsolicited, official, and final certificate of character."

His personal contacts with some of the leading Academicians were usually of a droll nature. "Because Alma-Tadema became an Englishman, the English have to protect all the abominable things he does", said Whistler; but when the two met at an Arts Club dinner they discussed politics and behaved as if neither of them had ever held a paintbrush. With Poynter he was always on easy terms, sometimes a little too easy. Once they were staying in a country-house and Poynter was painting in the park surrounded by an admiring group. Whistler joined it and asked: "What are you doing there, Poynter?" "Oh, I am only touching up a little thing I began here many years ago." "That's no excuse, Poynter." Burne-Jones, much against his will, had given evidence in the Ruskin case, for which Whistler never forgave him; and on the day his large canvas called *The Depths of the Sea*, displaying mermaids in their natural element, was first seen at the Academy, Whistler dashed up to a friend and dragged him off by the arm, saying in his extremely audible voice: "Come! Come with me! I must show you those unfortunate people in the tank!"

When J. J. Shannon became an A.R.A. Whistler told him to "resign and show your contempt for the Forty!" Shannon replied that he was not that kind of pigeon. For Whistler's own sake it was a pity that he too was not that kind of pigeon. Had he been

of a more conciliatory and diplomatic nature, he would probably have become one of the Forty, and this would have given him what he always lacked: a feeling that he belonged to something, was a part of something determined, unchangeable, tangible, an institution if not a country. But there was one drawback to this agreeable condition: in a very short time his colleagues would have felt that the Royal Academy belonged to him. He had too much of Napoleon, too little of Talleyrand, in his nature. *Aut Caesar aut nullus.* And always he was Whistler.

The pen-pricks which he distributed with such vigilant zeal to critics and Academicians alike were considered with as much care as his pictorial compositions. He spent hours over them, slept on them, read them aloud to acquaintances to watch their reactions, carried them about with him, was not satisfied until he had extracted the utmost particle of meaning from a semi-colon. Sometimes he went into a newspaper office with the intention of contributing a letter to the editor, who kept the famous "butterfly" signature in stock for immediate use. Asking for a room, he remained in it for hours, after which he emerged with a note of perhaps twenty lines, leaving the floor of the room thick with spoilt sheets. He strove for perfection in his writing just as he did in his painting. He had the lesser artist's dread of imperfection, which derives from a fear of reality, a shrinking from the imperfection of life. The sometimes monstrous and shapeless and extravagant productions of a Shakespeare shocked one who liked to see everything as a charming pattern; and though he professed an admiration for Edgar Allan Poe, it probably arose from the fact that Poe had been at West Point. His world was limited by his imagination; it was a world of fancy, of delicate designs, of commas in the right place, faces with the right expression, figures and words in the right setting, scenes in the right perspective; nothing to disturb the harmony.

He could not find the symmetry and congruity at which he aimed in the universe about him, because nature would not conform to his sense of fitness ("there are too many trees in the country") and human beings would not adapt their personalities to his will; so he created his world on canvas, and criticised the real inhabitants in print. One of these inhabitants, however, was more than his match and caused him more trouble than all the others ɔ ut together. The Grosvenor Gallery Exhibition of 1877

was reviewed in the *Dublin University Magazine* by an Oxford undergraduate named Oscar Wilde, who referred to two of Whistler's rocket-bursting Nocturnes: "These pictures are certainly worth looking at for about as long as one looks at a real rocket, that is, for something less than a quarter of a minute." Such a remark would not have earned the writer an invitation to one of Whistler's Sunday breakfasts; but the Master did not associate the critic with the tall pleasant youth whom he met at someone's reception, foresaw as a possible disciple, and invited to his house. Nor did he recognise the new caller at his house as the tall pleasant youth whom he had met elsewhere. But he found the young man's conversation so much to his liking that he issued an open invitation, and from 1878 onwards Oscar Wilde was constantly to be seen either at Whistler's table or in his studio.

It would be difficult to conceive two men so strangely at variance by nature, so outwardly accordant in intercourse. Wilde was twenty years younger than Whistler, and until he found his legs was anxious to play the disciple. Whistler was delighted to have such an intelligent and agreeable follower, and for some years the two were inseparable. They were oddly contrasted in appearance and style of conversation; Wilde tall, with soft and lazy speech; Whistler short, with quick, harsh utterance. The easygoing gentle disposition of the giant complemented the active malicious character of the dwarf, and for a period harmony reigned between them, especially as Wilde with the prerogative of genius was quietly absorbing everything of value that Whistler had to tell him, while Whistler with the egotism of the Master was eager to win the applause of such a pliant listener and witty companion. They were seen together at all sorts of places, the Café Royal, picture galleries, theatres and dinner-parties; and the younger man always deferred to his senior in a very flattering manner. Indeed it seemed at last as if Whistler had found the ideal disciple, clever without self-assertion, respectful without self-abasement, fascinating without self-affection.

But any intelligent onlooker could have foretold the inevitable disruption. Wilde quickly became aware of his unique gift as a talker, and beneath that friendly urbane manner was an ambition, an intention, to excel. For about two years he was content to play second fiddle to the Master; but then he showed a disposition to play solo. The crowd which had gathered round Whistler

whenever he appeared at a social crush began to get smaller, more and more of its units surrounding Wilde; and at last there was open competition between them. Whistler had his fanatical disciples who could not be seduced from his side, but Wilde's less exigent nature made a more general appeal, and soon there were more of his listeners than the other's followers. Such a situation bred bitterness in the older man; and when George Du Maurier's *Punch* cartoons satirising the aesthetic craze seemed to be giving publicity to Wilde as the leading aesthete, Whistler, whose colour-schemes and Japanese prints and Chinese pottery were part of the aesthetic set-up, was understandably irritated. "Which of you two discovered the other?" he rasped on seeing Wilde and Du Maurier chatting together at some function. "We have both discovered you", was Wilde's soothing reply. But it did not placate Whistler, who, on catching sight of his recent disciple in strange attire, rebuked him: "Oscar—how dare you! What means this disguise? Restore those things to Nathan's, and never again let me find you masquerading the streets of my Chelsea in the combined costumes of Kossuth and Mr Mantalini!"

A further cause of annoyance was Wilde's lecture tour in America, which received much publicity in England, showed that he was an accomplished platform performer, and proved that he could beat Whistler at the game of drawing everyone's attention to him. After that, their relationship became strained, and they started to fence in public. *Punch* printed a fanciful conversation between them on art and life, and Wilde sent a wire to Whistler: "*Punch* too ridiculous. When you and I are together we never talk about anything but ourselves." Whistler retorted by telegram: "No, no, Oscar, you forget. When you and I are together we never talk about anything except me." This interchange was sent to *The World* by Whistler, who did not think it necessary to subjoin Wilde's answer: "It is true, Jimmy, we were talking about you, but I was thinking of myself." Their discomfort in one another's company before the final break was expressed in the silly facetiousness of reputed humorists when on their guard. Finding themselves at a reception given by Mrs Jopling in Beaufort Street, when only their hostess and two others were present, they did not sparkle at their brightest:

"I hear that you went over to the *Salon* by Dieppe, Jimmy."

"Don't be foolish! I went to paint."

"How many pictures did you paint?"

"How many hours did the journey take?"

"You went, not I. No gentleman ever goes by the Dieppe route."

"I do often", said Mrs Jopling; "it takes five hours."

"How many minutes are there in an hour, Oscar?"

"I am not quite sure, but I think it's about sixty. I am not a mathematician."

"Then I must have painted three hundred."

At which point the Boswell of the moment must have closed his notebook in despair.

Serious trouble started when Wilde was asked to lecture the students of the Royal Academy. Whistler gave him a lot of advice, from which also he profited during a lecture tour in the provinces; and he was quoted as an authority on painting. The fact that he transmuted the information given him by Whistler into epigrams, as if to hide its source, made his conduct still less excusable in the eyes of the Master and his followers, and cries of plagiarism were henceforth raised. It certainly was infuriating to have one's opinions expressed more wittily by someone else; and it was the success of Wilde's lectures that made Whistler decide to give an oration of his own, in which he would try to out-shine his former disciple in wit and at the same time claim pater-nity of his own ideas and pronounce his credo as an artist. Mean-while he never lost an opportunity to expose Wilde as a literary thief, and either himself or Phil May in *Punch* probably invented the well-known story of how Wilde had once expressed the wish that he had made a clever remark by Whistler, who had promptly rejoined: "You will, Oscar, you will!" But that they remained on semi-friendly terms until after Wilde's marriage in 1884 is shown by Whistler's help with the decorations of Oscar's house in Tite Street, though his absence from the wedding was excused in a telegram which arrived at the church; "Am detained. Don't wait."

On February 20th, 1885, Whistler's famous *Ten O'Clock* lecture was first delivered in London, and Oscar Wilde's review of it was published the following day in the *Pall Mall Gazette*. To the lec-ture itself we shall return in the next chapter. Here we are merely concerned with its place in the slowly developing misunderstand-ing between the two men. Whistler attacked Wilde by implica-

tion in several passages, particularly when he said "The voice of the aesthete is heard in the land, and catastrophe is upon us." But Wilde treated the lecture good-naturedly: "The scene was in every way delightful; he stood there, a miniature Mephistopheles, mocking the majority! . . . Nothing could have exceeded their enthusiasm when they were told by Mr. Whistler that no matter how vulgar their dresses, or how hideous their surroundings at home, still it was possible that a great painter . . . could, by contemplating them in the twilight, and half closing his eyes, see them under really picturesque conditions which they were not to attempt to understand, much less dare to enjoy . . . But I strongly deny that charming people should be condemned to live with magenta ottomans and Albert-blue curtains in their rooms in order that some painter may observe the side-lights on the one and the values of the other . . ." Having naturally disagreed with the lecturer on the relative importance of the poet and the painter, and given priority to the former, Wilde described the performance as a masterpiece, Whistler as a master of painting and persiflage, and concluded with a compliment and a quip: "For that he is indeed one of the greatest masters of painting is my opinion. And I may add that in this opinion Mr Whistler himself entirely concurs."

The article was followed by a brief skirmish between the two in *The World*; then a pause in the hostilities; then a review by Wilde of a book on Whistler by Walter Dowdeswell, in which the latter was congratulated on his power of writing from dictation, "especially in his very generous and appreciative estimate of Mr Whistler's genius." In the later eighties Wilde's fame as a talker had grown considerably and his views on everything, including the art of painting, were repeated in social circles. This was more than Whistler could stand, and in November '88 he wrote a letter to the Committee of the National Art Exhibition, which had ill-advisedly asked Quilter and Wilde to join them: "What has Oscar in common with Art? except that he dines at our tables and picks from our platters the plums for the pudding he peddles in the provinces. Oscar—the amiable, irresponsible, esurient Oscar—with no more sense of a picture than of the fit of a coat, has the courage of the opinions . . . of others!" Whistler sent a copy of this to Wilde, with a note which ran: "Oscar, you must really keep outside 'the radius'!" and another copy to *The World* in which it appeared. Wilde replied in the same paper:

"Atlas, this is very sad! With our James vulgarity begins at home, and should be allowed to stay there." Whistler returned: "A poor thing, Oscar! but, for once, I suppose your own."

They were perhaps still on nodding terms; but now Wilde, with the audacity of genius, did a thing which must have convulsed his one-time Master. He wrote a duologue called 'The Decay of Lying' which was published in the *Nineteenth Century* (January, 1889). With a wit and humour entirely his own he set forth much that he had heard from Whistler about "foolish" sunsets and Nature creeping up to Art, and even went so far as to use in another connection Whistler's remark about himself: that he had the courage of the opinions of others. When these crimes were brought to the Master's notice, he wrote to *Truth*, which had just printed an article attacking plagiarists: "How was it that, in your list of culprits, you omitted that fattest of offenders—our own Oscar?" He also referred to the help he had given Wilde for a lecture to art students: "He went forth, on that occasion, as my St John—but, forgetting that humility should be his chief characteristic, and unable to withstand the unaccustomed respect with which his utterances were received, he not only trifled with my shoe, but bolted with the lachet!" Finally he enclosed a copy of the note he had just despatched to Wilde, in which he said that "for the detected plagiarist there is still one way to self-respect (besides hanging himself, of course), and that is for him boldly to declare, 'Je prends mon bien là où je le trouve.' You, Oscar, can go further, and with fresh effrontery, that will bring you the envy of all criminal *confrères*, unblushingly boast, 'Moi, je prends *son* bien là où je le trouve!'" Instead of pointing out that there was no difference between *mon* and *son* where it was a question of taking, since every saying had been originated by someone, Wilde assumed an air of self-importance: "As Mr James Whistler has had the impertinence to attack me with both venom and vulgarity in your columns, I hope you will allow me to state that the assertions contained in his letter are as deliberately untrue as they are deliberately offensive . . . as for borrowing Mr Whistler's ideas about art, the only thoroughly original ideas I have ever heard him express have had reference to his own superiority as a painter over painters greater than himself. It is a trouble for any gentleman to have to notice the lucubrations of so ill-bred and ignorant a person as Mr Whistler, but your publication of his insolent

letter left me no option in the matter." Whistler, who once described Wilde as "*bourgeois malgré lui*", won the final round, largely because, in personal controversy, Wilde found it difficult to combine wit with gentility: "O Truth!—Cowed and humiliated, I acknowledge that our Oscar is at last original. At bay, and sublime in his agony, he certainly has, for once, borrowed from no living author, and comes out in his own true colours—as his own 'gentleman'." After which they were not on nodding but on cutting terms.

Whistler's excessive vexation in this case was not alone due to those aspects of his character which were educed by the circumstances of his early years and later isolation. Taking practically no interest in literature, and having little appreciation of it, he could not be expected to recognise that an essay by Wilde owed far more to its author than to others, that what it owed to others was repaid with interest, and that his former disciple had become a genius in his own right. But his anger with those whom he had appropriated and who dared to assert their independence was rendered more violent than usual because Wilde's reputation was steadily increasing with the number of his admirers while Whistler's position throughout the eighties showed no signs of improvement. The Ruskin case, coupled with the persistent belittlement of his work by the critics, made people nervous of being painted by him because they would share in the ridicule with which his portraits were received, and encouraged those who took the risk to adopt a patronising air with him. He started an *Arrangement in Yellow* of the famous beauty Lily Langtry, but though she was frequently in his studio someone must have influenced her to discontinue the sittings. Lady Meux was the first to brave the laughter of the world, and her commission resulted in an "Arrangement" as well as a "Harmony", but the sessions were not always harmonious. "See here, Jimmy Whistler!" she once said. "You keep a civil tongue in that head of yours, or I will have in someone to *finish* those portraits you have made of me!" As he had already suffered much from complaints that his works were unfinished, he lost his temper completely, advanced upon her trembling with rage, choked, stammered, foamed, and at last hissed out "How dare you? How dare you?" She left, and did not return.

Walter Sickert gave an illustration of how, during this period, Whistler was almost compelled to fall in with the wishes of his

subjects. A pretty woman persuaded him by degrees to modify
the scheme of her portrait, until he perceived that his own con-
ception was being falsified. Whereupon he stopped work, put
his brushes down, removed his spectacles, and said: "Very well.
That will do. This is your portrait. We will put it aside and
finish it another day." He dragged out a fresh canvas, and added:
"Now, if you please, we will begin mine." Another sitter who
suggested "improvements" was Lady Archibald Campbell. He
had expressed a wish to paint her, and she had told him that, as
her husband did not wish to commit himself in any way, the pic-
ture must not be regarded as a commission. He started several
studies of her, but destroyed them. Sickert saw him one evening
standing on a chair with a candle in his hand closely inspecting the
day's work, uncertain whether to leave it or remove it. They
went out to dinner, and in the street Whistler suddenly said: "You
go back. I shall only be nervous and begin to doubt again. Go
back and take it all out." Sickert did so with a rag and benzoline.
Finally Whistler painted her in the dress she wore when calling
on him. There were "scenes" between them during its progress.
Once she was about to drive away in a hansom cab, threatening
that nothing would induce her to come again; but she was per-
suaded by one of the artist's admirers to get out of the cab and
continue the sitting. Exhibited at one of the Grosvenor Gallery
exhibitions, the picture was much admired, and Whistler told her:
"Every discretion has been observed that Lord Archibald could
desire. Your name is not mentioned. The portrait is known as
The Yellow Buskin." He thought highly of it, and when the magis-
trate H. G. Plowden, after admiring it, asked him at the Gros-
venor Gallery whether there were any other pictures worth seeing,
he cried: "Other pictures? There are no other pictures! You are
through!"

The painting ultimately found its way into the Wilstach Col-
lection at the Memorial Hall, Philadelphia; but one cause of
Whistler's fretfulness in the eighties was the lack of interest
shown in his work by his fellow-countrymen. True, the *Mother*
was exhibited at the Pennsylvania Academy of Fine Arts in '81, and
he was elected a member of the Society of American Artists the
following year; but neither individual nor institution in the
States would pay a thousand dollars for his most famous portrait.
It is hardly surprising that he should have replied, on being asked

why he did not visit America: "It has been suggested many times; but, you see, I find art so absolutely irritating to the people that, really, I hesitate before exasperating another nation." For him it was the same everywhere until the close of the decade. In '83 the *Mother* was exhibited at the *Salon* in Paris, and won a third-class medal. In '88, when President of the British Artists, he sent *The Yellow Buskin* to the International Exhibition at Munich, and was awarded a second-class medal, about which he wrote to the Secretary: "Pray convey my sentiments of tempered and respectable joy to the gentlemen of the Committee, and my complete appreciation of the second-hand compliment paid me." But the honour he most valued was bestowed upon him by the British public. In April '86 his Nocturne, *Old Battersea Bridge*, was put up for auction. Its appearance was greeted with ironical cheers, which, being mistaken for serious applause, were suppressed by angry hisses. The *Observer* reported simply that the Nocturne had been received with hisses, which drew a letter from Whistler to the editor: "May I beg, through your widely spread paper, to acknowledge the distinguished, though I fear unconscious, compliment so publicly paid. It is rare that recognition, so complete, is made during the lifetime of the painter, and I would wish to have recorded my full sense of this flattering exception in my favour."

Oratorical

THE phrase which Whistler more than anyone else had helped to circulate in England, "Art for Art's Sake", has vexed a large number of worthy folk. Those who feel that art should exercise a moral effect on people, that it is good for them like prayer or belief, and those who feel that it should be part of everyone's education, that it is justified by the breadth of its appeal, are alike opposed to the theory that beauty is created solely for itself. Perhaps the phrase would have been more acceptable if it had run "Art for the Artist's Sake", because that is as true about art as it is about other human activities undertaken voluntarily. Any artist worth a pot of paint or a pot of ink produces his work because of some mysterious urge to reveal himself. He may hope that it will make money, or that it will make him famous; but neither a desire for security nor a craving for notoriety provide the impetus to create, which arises from an inner necessity to express his joy or sorrow. His books or his music or his pictures are therefore brought forth to relieve his feelings, to give him pleasure or to ease his pain; and so for his own sake. If he is fortunate, his works will please and ease others; but that has nothing to do with his impulse to produce them.

Whistler painted for the joy of creating his own world, in which everything was transformed by his sense of beauty, and what was ugly in detail became lovely in effect. Probably it never occurred to him that the scenes and people he put upon canvas represented his idealism and revealed his discomfort in the presence of reality. He believed that his passion for perfection was objective, a striving to produce masterpieces of art for the sake of the work, not the worker, so that he could look at them when completed with the detachment of one who was able to judge them impartially, as if they had been etched or painted by some-

one else. The marks of struggle and travail and recklessness and negligence that are so often discernible in works of greater genius were abhorrent to him. The artist, he considered, should be concealed by his art, and one of his pronouncements ran: "Industry in Art is a necessity—not a virtue—and any evidence of the same, in the production, is a blemish, not a quality; a proof, not of achievement, but of absolutely insufficient work, for work alone will efface the footsteps of work."

The result was, in his case, that he spoilt innumerable pictures by trying to efface the signs of labour, sacrificing individuality to ideality. This was particularly so when he practiced the art of writing. Entirely lacking the readability of the born author, he coined phrases with as much solicitude as he mixed colours; but many well-minted phrases do not necessarily make pleasing paragraphs, and quite often result in tedious pages. Taken in more than small doses, he is perhaps the most unreadable writer of note in the English language. There is no charm, no spontaneity, in his accurate, semi-biblical, polished, economical and epigrammatical style, which is sharp as a needle, hard as steel, cold as stone, a sort of etching in prose. Aware of his inability to be effective at any length, he usually limited his literary expression to telegrams, brief notes to people, and pithy communications to the press. But once he let himself go in a lecture, which was as closely studied and written as if it had been his life's work. Lacking the fluency of good oratory, and consisting largely of his pronouncements on art over many years, it was as eloquent as aphorisms could make it. He read it aloud to friends; he repeated sentences and passages while painting; he chopped and changed it about, adding here, subtracting there, re-writing this passage, re-arranging that. Scores of times, as they paced the Thames embankment together, he recited parts of it to his disciples, practising elocutionary effects, trying his voice at different pitches, essaying various intonations. He knew it by heart long before the first performance, and was only anxious about audibility.

Mrs D'Oyly Carte made all the arrangements, and though she was extremely busy at the Savoy Theatre with *The Mikado*, which was to be produced three weeks after Whistler's lecture, he called at her office every evening to discuss matters, assuming that his public appearance was of far greater moment than the preparation

of a Gilbert and Sullivan opera. The St James's Hall, Piccadilly, was
booked for the occasion; and as it was famous for all sorts of shows,
from Nigger Minstrels to Symphony Concerts, irreverent journal-
ists speculated as to whether he was going to sing, draw cartoons,
do conjuring tricks, or stand on his head. The hour was peculiar:
ten o'clock at night. He had constantly seen people enter a
theatre after the curtain was up, and had once politely remon-
strated with a lady who squeezed past him during the performance
of a play: "Madam, I trust I do not incommode you by keeping
my seat." To save himself from being subjected to all the noise
and clatter of latecomers, he determined to give the men time for
their after-dinner port and cigars and the women time for their
gossip, so that everyone could arrive in a subdued frame of mind.
And to save his listeners from the inconvenience of straining to
hear what he said, he rehearsed the lecture before a few friends on
the day before the public recital.

The Hall was packed by a fashionable audience on February
20th, 1885, and the lecturer made an effective entrance. Perhaps
he did look a little like a conjuror as, in immaculate evening dress,
he stepped daintily on to the stage, carrying his gloves and opera
hat in one hand, his long cane in the other, and wearing his
monocle. He stood the cane against the wall, placed the hat and
gloves on the table, toyed with the monocle, glanced at his
notes, and suffered a spasm of stage fright. But as he warmed to
his theme after an apologetic opening, the nervousness left him,
and he spoke out "loud and bold", attacking those who wished to
popularise art, those who confused it with ethics, and those who
believed that there had been epochs in history when nothing
but the finest art would please the people.

"Listen!" he cried. "There never was an artistic period. There
never was an Art-loving nation."

The first artist was he who, instead of fighting, hunting and
digging like other men, "traced strange devices with a burnt
stick upon a gourd." He was joined in time by men of his own
kind who preferred creating to killing, "and the first vase was
born, in beautiful proportion." And the warriors and hunters
and delvers drank from the goblet made by the artist, "not from
choice, not from a consciousness that it was beautiful, but because,
forsooth, there was none other!" Then came luxury, and the
artists built palaces and made furniture, and the people "ate and

drank out of masterpieces—for there was nothing else to eat and drink out of. . . . Art reigned supreme by force of fact, not by election—and there was no meddling from the outsider. . . . And the Amateur was unknown—and the Dilettante undreamed of!" After many centuries "there arose a new class, who discovered the cheap, and foresaw fortune in the facture of the sham. . . . The taste of the tradesman supplanted the science of the artist, and what was born of the million went back to them, and charmed them, for it was after their own heart. . . . And the artist's occupation was gone, and the manufacturer and the huckster took his place. . . . And the people—this time—had much to say in the matter—and all were satisfied. And Birmingham and Manchester arose in their might—and Art was relegated to the curiosity shop."

He turned from history to a consideration of the artist's material. Nature contained all the elements, just as the keyboard contained all the notes of music, but the artist had to select, and "To say to the painter that Nature is to be taken as she is, is to say to the player that he may sit on the piano." Nature was nearly always wrong because she very rarely provided the artist with a completely satisfying picture: "The holiday-maker rejoices in the glorious day, and the painter turns aside to shut his eyes." Dignity was lost in distinctness; people loved to see things in detail merely for the sake of seeing them; but the artist looked at them with a different eye; and Whistler, thinking of himself and of the beauty he had discovered in a twilight Thames, produced a prose Nocturne:

And when the evening mist clothes the riverside with poetry, as with a veil, and the poor buildings lose themselves in the dim sky, and the tall chimneys become campanili, and the warehouses are palaces in the night, and the whole city hangs in the heavens, and fairy-land is before us—then the wayfarer hastens home; the working man and the cultured one, the wise man and the one of pleasure, cease to understand, as they have ceased to see, and Nature, who, for once, has sung in tune, sings her exquisite song to the artist alone, her son and her master— her son in that he loves her, her master in that he knows her.

Such things were not understood by journalist critics and Slade professors, and he described the class of people who were educating the public in art: "There are those also, sombre of mien, and wise with the wisdom of books, who frequent museums

and burrow in crypts; collecting—comparing—compiling—contradicting. Experts these—for whom a date is an accomplishment—a hall-mark, success!" They gravely established unimportant reputations, and lengthily speculated on "the great worth of bad work." Remembering Ruskin, he spoke of the "Sage of the Universities—learned in many matters, and of much experience in all, save his subject. . . . Filled with wrath and earnestness. Bringing powers of persuasion, and polish of language, to prove—nothing. Torn with much teaching—having naught to impart." Then there were the solemn dilettante and amateur, who went about talking of art and founding cults: "Forced to seriousness, that emptiness may be hidden, they dare not smile—While the artist, in fulness of heart and head, is glad, and laughs aloud, and is happy in his strength, and is merry at the pompous pretention—the solemn silliness that surrounds him. For Art and Joy go together, with open boldness, and high head, and ready hand—fearing naught, and dreading no exposure."

He ridiculed those who were always praising the past at the expense of the present, claimed that the artist was not the product of civilisation but stood alone in whatever age, that he had nothing to do with the glories and virtues of the State, and that he appeared in the most unlikely places, not where the civic and heroic virtues flourished as in Switzerland, but among the opium-eaters of Nankin and the slum-dwellers of Madrid. There had been few great artists, but many pretenders: "A teeming, seething, busy mass, whose virtue was industry, and whose industry was vice!" No need on that account to be despondent: "We have then but to wait—until, with the mark of the Gods upon him—there come among us again the chosen—who shall continue what has gone before. Satisfied that, even were he never to appear, the story of the beautiful is already complete—hewn in the marbles of the Parthenon—and broidered, with the birds, upon the fan of Hokusai—at the foot of Fusiyama."

The lecture was much appreciated by the audience but not by the critics, who talked of its eccentricity, its freakishness, its flimsiness, and one of them M. H. Spielmann, called it smart but misleading, on hearing which Whistler said: "If the lecture had not seemed misleading to him, it surely would not have been worth uttering at all." Within the year he repeated the *Ten O'Clock* at Cambridge and Oxford, before the British Artists and

the Students Club of the Royal Academy. Three years later he gave it at the Grosvenor Gallery, and finally in 1891 at the Chelsea Arts Club. It was published in the spring of '88 and reviewed in a manner that its author had come to expect. But one criticism led to another of those unfortunate quarrels which his friends had come to expect.

As we know, Algernon Charles Swinburne had been a close friend of Whistler's in their early London days. Time had cooled their feelings; and when Theodore Watts took Swinburne to live with him in Putney, the atmosphere was not favourable to other friendships. Watts nursed Swinburne back to health, and forward from poetry, cutting him off from the companions of his youth, a process which bred some bitterness in them. Watts became the theme of caustic comment, not lessened by his decision to call himself Watts-Dunton in order to distinguish himself from the painter Watts. Whistler promptly sent him a wire: "Theodore: what's Dunton?" and thenceforward the unamused recipient was ill-disposed towards the sender. But, so far as Whistler knew, Swinburne was still a friend, and the poet's criticism in the *Fortnightly Review* of his *Ten O'Clock* lecture came as a severe shock.

It was due to Watts-Dunton, who afterwards admitted that he had "persuaded Swinburne to write the really brilliant article." What he considered a really brilliant article was a really stupid one, because Swinburne played the old critical trick of misunderstanding a great deal of the *Ten O'Clock* and founding his attack on the misunderstanding. While doing justice to Whistler as a painter, he was unjust to the lecturer. After saying "I do not wish to insult Mr Whistler", he spoke of the meaning Whistler had given to the word "aesthete" as an abuse of language only possible to "the drivelling desperation of venomous or fangless duncery", which, if not insulting, might be considered unfriendly. Having implied that, in saying "Art and Joy go together", the lecturer was talking with his tongue in his cheek, he attributed to Whistler a remark he had never made: that tragic art was not art at all. The audience at the lecture, continued Swinburne, "must have remembered that they were not in a serious world; that they were in the fairyland of fans, in the paradise of pipkins, in the limbo of blue china, screens, pots, plates, jars, joss-houses, and all the fortuitous frippery of Fusiyama. It is a cruel but an inevitable

Nemesis which reduces even a man of real genius, keen-witted and sharp-sighted . . . to the level of the dotard and the dunce, when paradox is discoloured by personality and merriment is distorted by malevolence." Describing Whistler as "a jester of genius", Swinburne did not think that he could be excused on that ground: "A man of genius is scarcely at liberty to choose whether he shall or shall not be considered as a serious figure— one to be acknowledged and respected as an equal or a superior, not applauded and dismissed as a tumbler or a clown."

As with the Ruskin libel, this article seemed to justify the accusations of insincerity made by critics and professors, and it stung Whistler into sending Swinburne a touching and dig- nified protest, not at all characteristic of his usual light-hearted ripostes:

"Why, O brother! did you not consult with me before print- ing, in the face of a ribald world, *that you also misunderstand*, and are capable of saying so, with vehemence and repetition?

"Have I then left no man on his legs?—and have I shot down the singer in the far off, when I thought him safe at my side?

"Cannot the man who wrote *Atalanta*—and the *Ballads* beautiful—can he not be content to spend his life with *his* work, which should be his love,—and has for him no misleading doubt and darkness—that he should so stray about blindly in his brother's flower-beds and bruise himself!

". . . O Brother! where is thy sting! O Poet! where is thy victory! . . .

"Who are you, deserting your Muse, that you should insult my Goddess with familiarity, and the manners of approach common to the reasoners in the market-place . . .

"Do we not speak the same language? Are we strangers, then, or, in our Father's house are there so many mansions that you lose your way, my brother, and cannot recognise your kin?

"Shall I be brought to the bar by my own blood, and be borne false witness against before the plebeian people? Shall I be made to stultify myself by what I never said—and shall the strength of your testimony turn upon me? . . .

But this stately appeal to Swinburne's better nature did not satisfy the other side of Whistler's nature; and having considered the matter in a less exalted light, he sent a more idiosyncratic note, not only to the poet but to *The World*:

"Bravo! Bard! and exquisitely written, I suppose, as becomes your state . . .

"Thank you, my dear! I have lost a *confrère*; but, then, I have gained an acquaintance—one Algernon Swinburne—'outsider'—Putney."

Whistler's anger was also vented on Frank Harris, editor of the *Fortnightly* in which Swinburne's article appeared. Though Harris was the least reliable of reporters, his account of what took place between them may be accepted as substantially genuine because it rankled in his memory and he told it on several occasions to different people with not much variation of phraseology. The version that follows was given to the present writer. They were dining at someone's house, and when the women had retired, leaving the men to their port, Whistler opened fire:

"Your appointment as editor of the *Fortnightly* set everyone guessing. Is he perchance a man of genius, or just another of the able editors, don't ye know! always to be found by the dozen in merry old England? Well, we all went on guessing. Of course everyone knew how a genius would edit such a review, following such a steady reliable editor as John Morley. First of all would come a quite amazing number, something utterly unexpected, something never seen before. All the world would rush to buy the next month's issue; and again there would be a shock of surprise, for the editor is too busy gambling at Monte Carlo to bring it out. The month after, another prodigious number. A great actor would write on painting, and a great painter would write on acting, and everybody would try to be somebody else. And so it would go on, eh! what? Ha-ha! But no! You've not done it in the brilliant irresponsible way of genius. Every month the review appears regularly, and it is just what one expects: a publication of high-class English mediocrity, what we always expected, and got, from Morley. Lamentable, you know, quite lamentable!"

Everybody round the table laughed except Harris, who used to look rueful even when telling the story twenty years after the incident took place.

Within two months of his calling Swinburne an outsider, Whistler became for the first time in his life an insider: that is to say, he married, and at last could feel that he belonged to someone and that someone belonged to him. We shall hear more

about this shortly; but here it may be said that, as a direct result
of his union, he showed a disposition to finish quarrelling and
to live in harmony with the outside world. Of course his nature
was such that this could not be; but at rare intervals he made,
and continued to make, conciliatory gestures towards those who
showed themselves amenable to appeasement. The first sign of
benignity in him was manifested in a speech at the Criterion
restaurant, where his friends gave him a dinner in 1889 to celebrate
his election as an Honorary Member of the Bavarian Royal
Academy, which also bestowed upon him a first-class medal
and the Cross of St Michael. Two Royal Academicians were
present, William Orchardson and Alfred Gilbert, and the speeches
made in his honour moved him to an almost emotional reply:

"You must feel that, for me, it is no easy task to reply under
conditions of which I have so little habit. We are all even too
conscious that mine has hitherto, I fear, been the gentle answer
that turneth not away wrath.

"Gentlemen, this is an age of rapid results, when remedies
insist upon their diseases, that science shall triumph and no time
be lost; and so have we also rewards that bring with them their
own virtue. It would ill become me to question my fitness for
the position it has pleased this distinguished company to thrust
upon me.

"It has before now been borne in upon me, that in surroundings
of antagonism, I may have wrapped myself, for protection, in a
species of misunderstanding—as that other traveller drew closer
about him the folds of his cloak the more bitterly the winds and
the storm assailed him on his way. But, as with him, when the
sun shone upon him in his path, his cloak fell from his shoulders,
so I, in the warm glow of your friendship, throw from me all
former disguise, and, making no further attempt to hide my true
feeling, disclose to you my deep emotion at such unwonted
testimony of affection and faith."

He could not maintain this resipiscent condition, however,
though blushing honours came thick upon him. In '89 he received
a gold medal from Amsterdam, where some of his pictures were
on view, and a first-class medal at the Paris Universal Exhibition.
Two years later, when the *Mother* was bought for the Luxem-
bourg, he was made an Officer of the Legion of Honour, which
delighted him; but when the Chelsea Arts Club celebrated the

double distinction with a reception and the presentation of an address signed by a hundred members, his reply did not show a marked inclination to obliterate the past: "It is right at such a time of peace, after the struggle, to bury the hatchet—in the side of the enemy—and leave it there. The congratulations usher in the beginning of my career, for an artist's career always begins tomorrow."

In fact he had already buried the hatchet in the side of the enemy, and left it there for the amusement of posterity, by the publication in 1890 of *The Gentle Art of Making Enemies as Pleasingly Exemplified in Many Instances, Wherein the Serious Ones of this Earth, Carefully Exasperated, have been Prettily Spurred On to Unseemliness and Indiscretion, While Overcome by an Undue Sense of Right*. This compilation contains a record of his campaign against the critics, from Ruskin to Swinburne, and all the more crass things they had said and all the more cutting things he had said. At first he allowed an American journalist, Sheridan Ford, to collect and edit the items, and Ford had completed the job when it struck Whistler that the real author should benefit from the profit and prestige of the book. It is more than probable that his wife persuaded him to assume the credit of the publication. So he sent Ford a cheque for £10 in payment of the work that had been done and told him to proceed no further in the business. But Ford had no intention of dropping a project which he claimed was suggested by himself, and arranged for the book to be printed. Whistler got wind of what was going on, and through his solicitors stopped its appearance in England. Undaunted, Ford had the book printed in Antwerp, where again by the intervention of Whistler's solicitors the edition was confiscated; and also in Paris, where once more it was suppressed. After which Ford disappeared from history.

Whistler entrusted *The Gentle Art* to William Heinemann, an intelligent enthusiastic publisher who happened also to be an artist in book production, and the two men became close friends as well as collaborators. Whistler's wishes and interests became those of his publisher, who seemed to be under a spell when in the Master's company, for he neglected his correspondence, his appointments, his business, in the cause of *The Gentle Art*. Whistler drove down nearly every morning at 11 o'clock to discuss the book with his "publisher, philosopher and friend",

whom he would take to the Savoy for breakfast; and here, on the balcony overlooking the Thames embankment, they would talk and talk at a time when the place was deserted. To Whistler it was absurd that Heinemann should have anything else to do; and when the publisher happened to mention another book he was preparing or another author he was seeing, Whistler's expression became vacuous for a few moments, and then keen with interest as he thought of a more capricious butterfly for one of the illustrations. He took as much trouble over the book as he did over a painting or a letter or an omelette or his hair or his clothes. He designed the title-page, selected the type, arranged the spacing of the text, chose the cover, and put the butterflies wherever he wanted them to be, each in its precise relation to the text, each giving point to the paragraph it illustrated. Sometimes he would take hours over the placing or designing of a single butterfly. The book was to be a work of art, and the artist worked as if his life depended on its perfection.

In the years to come he used to refer to *The Gentle Art* as his Bible, telling his disciples, half-mockingly, half-earnestly, that they would find everything they wanted to know in it, and that they had not studied it as closely as they should have done. The critics did not consider it as a Testament of any sort. To them it was a joke in extremely bad taste; though, unwilling to be thought dull and anxious to show that their sense of humour equalled his, they were careful to treat the publication with an air of worldly facetiousness, as if they were in the joke and had the right measure of the joker. Between them all, the critics, the Academicians, the friends who had become enemies, they had helped him to write the story of his life in epigrams; and in his envoi to *The World* he approved the collation: "These things we like to remember, Atlas, you and I—the bright things, the droll things, the charming things of this pleasant life. . . . It was our amusement to convict—they thought we cared to convince! *Allons!* They have served our wicked purposes—Atlas, we 'collect' no more." But Atlas was misinformed.

CHAPTER XII

Social

I N the seventies Whistler had been primarily a painter. In the eighties he was chiefly a personality. By his sayings no less than his habits, by his appearance no less than his behaviour, he openly defied the mental and physical conventions of his time. Even had they admired his paintings, the Academicians could not approve his conduct. Some of them liked him; all were afraid of him. He was an extreme individualist, an incalculable unclassifiable human being, who conformed to no external authority or code; a man with a mission, no doubt, but the mission was himself. Always refusing to adapt himself to any given conditions, he was generally considered a failure; though in his own words he had made *un succès d'éxécration*, and he gloried in his notoriety. His pockets were always filled with hostile press criticisms, which he pulled out and read aloud to anyone who would listen. His conversation was much occupied with his quarrels, which were described in detail and constantly repeated to his disciples and acquaintances; and to the consternation of some he would also recite the eulogies written on his work, even those which had clearly been prompted by himself and inserted by a friend in the *Court Journal*.

Other people fared as badly with him as he did with the critics. A rich collector persuaded him to look at a number of paintings. He inspected each carefully, sometimes ejaculating "Amazing!" Having come to the end of the collection, he said: "Amazing! and there's no excuse for it, no excuse for it at all!" Another owner of pictures declared his intention to bequeath them to some institution, and wanted Whistler's advice. "I should leave them to an asylum for the blind", was the suggestion. Standing before a sketch in a private gallery, a woman asked whether he thought it indecent. "No, madam, but your question is." He was much

more gentle with his models than with connoisseurs. "Where were you born?" one of them enquired. "I never was born, my child; I came from on high." "Now that shows how easily we deceive ourselves in this world, for I should say you came from below." The fact that he was able to report this with relish displays a kindly side of his nature too seldom turned to the world. When dealing with unpretentious people, or helping those in need, he was both genial and generous, unaggressive and unaffected. Servants, models, workmen, errand-boys, anyone who could not score off him: to all these he was charming, sympathetic and natural. Walking with a friend in Chelsea one day they came upon a very grimy boy selling papers. Whistler examined him:

"How old are you?"

"Seven, sir."

"Oh, you must be more than that."

"No, I aint, sir."

"I don't think he could get that dirty in seven years, do you?" said Whistler to his friend as he paid for the interview. But he was not so expansive with his social equals, one of whom met him on the embankment and politely asked: "How do you do?" "I don't", he replied, passing on without a flicker of recognition.[1] The man thus affronted would have been surprised to learn that Whistler was in the habit of engaging as secretaries men who were unemployable in any capacity but whose incapability aroused his sympathy. Wandering about his rooms there was often to be seen a harmless-looking and rather futile person who passed for a secretary, though as he was never seen with a pen or pencil in his hand people used to wonder what he wrote. Or there was another man, also a secretary, who used to make sketches on any bit of paper he could lay hands on and did not appear quite right in the head. Such unfortunates were kept by Whistler, not because they were useful to him but because they were useless to anybody.

The man with a melting heart had a biting tongue; but his seeming inconsistency had a simple explanation. His egotism was flattered by an appeal for his protection and wounded by friction with other egotists. Much of the trouble in life arises from the fact that human beings have corns, which, when

[1] Personal information from James Pryde.

trodden upon, breed unfriendliness. Largely because he was always walking on alien ground, Whistler's corns were exceptionally tender, and it relieved him to stamp on other people's. Naturally the sufferers thought that his hostility was directed against themselves. Actually it was directed against the nature of things. When a fellow told him of a pleasant spot near London for an artistic sojourn, saying "I'm sure you'll like it", and he replied, "The very fact that you like it is proof that I won't" the fellow thought that Whistler was expressing personal animosity, whereas all he had wished to indicate was that their tastes were different. But he had a way of saying things that jarred on those with whom he was not in accord, and people fought shy of him for this reason.

His personal appearance was as intimidating as his manner. Throughout the eighties his clothes were more pronounced than ever, his laugh more loud, his sayings more acid. He wore fawn-coloured long-skirted frock-coats, carried a bamboo cane which seemed to get longer and longer, flourished his monocle with an added defiance, displayed his white lock with challenging emphasis, tilted a hat with a curlier brim, and was occasionally to be seen with pink bows on his shoes. When his frock-coat was black, his trousers were white, and whatever he wore drew attention to the wearer. In wet weather he sported a tightly-rolled umbrella for ornament not use; and if advised to put it up lest his hat should suffer from the rain, he objected "But I would get my umbrella wet." He was a walking advertisement of himself, and he hoped that if people looked at Whistler they might be induced to look at his work. They certainly looked both at the painter and his paintings, but they did not understand the oddities of either.

His actions were as carefully contrived to attract notice as his toilet. At restaurants he was finical in choosing his wine and food, and complained if the first were not served or the second not cooked to his fastidious taste. His arrival at a house for dinner was heralded by two resounding thwacks with the knocker and a violent pull at the bell, so that everyone knew it must be either Whistler or the postman. He was punctually unpunctual at every dinner to which he had been invited. On one occasion he was an hour late. "We are so hungry, Mr Whistler!" complained his host. "What a good sign!" he cordially returned. Even his

conversation seemed devised to make himself the centre of interest, his charm being consciously exercised, not an inseparable part of his nature, the action of the person, not the flavour of the personality. His desire to hold the centre of the stage was noticeable, too, in the crossing of streets and the confusion of travel, when he displayed a nervousness that, being uncustomary, was probably designed to provoke comment. And the rate of his progress along the pavement, either swift or slow, had a similar object. "Why are you walking so fast?" asked a breathless companion. "To see if my shadow can keep up with me."[1] In short, his butterfly preferred the limelight to the sunlight, and might easily have been mistaken for a mosquito, especially when he was not receiving the attention which he felt to be his due. "You seem to admire her", remarked a friend, after Whistler had been chatting for some time to their hostess. "Yes, I do", he admitted, "but I should admire her still more if while talking to me she would not make eyes at the footman over my shoulder."

As with so many men who are not at ease with their contemporaries, his tenderness was lavished on birds, animals and children; all of which could draw forth an affection too often frozen in social intercourse, and none of which could criticise him. He loved cats; they were so graceful, charming and friendly; and he sometimes kept a dog of the toyish variety. It was in connection with a pet French poodle that he suffered one of his rare reverses. The animal contracted a disease of the throat, and he sent for the famous throat specialist Sir Morell Mackenzie, who, though annoyed that he had been called in to treat a dog, pocketed a big fee and went off. Next day Mackenzie despatched an urgent message that he wished to see Whistler, who, thinking it concerned his dog, downed brushes and dashed out to call on the specialist. "Oh, good-morning, Mr Whistler", said Mackenzie. "I wanted to see you about having my front-door painted." But as a rule he was the victor in such skirmishes, of which we may give two examples. He was holding forth about his discovery of the Thames at dinner, being interrupted by a leading critic who said that people had appreciated the beauty of the river long before it had been caught on canvas. The argument became acrimonious, and at last the critic remarked "Conceit is no proof of ability." Whistler rejoined: "Quite

[1] Personal information from Robert Ross.

right. Conceit is what we call the other fellow's self-respect,
don't ye know." "The other fellow's excessive egotism",
grumbled the critic; at which point someone else half apologised
for the unnecessary intrusion of the critic, and Whistler spoke
into the air: "Yes, yes, he forgot himself; but then he is quite
right to forget what is not worth remembering." At another
dinner, all the guests being known as writers or painters or
sculptors, a young smartly-dressed fellow, who had apparently
done nothing of note, began to pontificate and even had the
temerity to contradict Whistler, who thereupon fixed his
monocle, gazed at the omniscient youth, and asked pleasantly
"And whose son are you?"

Whistler's religion was his art, into which went all his emotion,
his idealism, his love, his longing for peace, his belief in perfection.
He took very little interest in anything else. Politics meant
nothing to him: it was a silly game. His only excuse for the
masses was that they sometimes presented an effective blot of
colour, which might be useful in a picture. He seldom read
books, and only went to the theatre because first-nights were
social ceremonies at which it was necessary to be seen. He could
not listen to serious plays in a becoming frame of mind, and
Wilson Barrett as Claudian sent him into fits of laughter. To
religion in the ordinary sense of the word he was wholly indif-
ferent. He probably thought of the Almighty as a great American
artist rather like himself; at least that is the impression one gets
from his comment on Haydon's autobiography: "Yes, Haydon,
it seems, went into his studio, locked the door, and before
beginning to work prayed God to enable him to paint for the
glory of England. Then, seizing a large brush full of bitumen,
he attacked his huge canvas, and, of course—God fled." Giving
evidence in the Belgian courts on the occasion of the unauthorised
publication of *The Gentle Art* in Antwerp, he was asked to name
his religion, and hesitated. The judge made a helpful suggestion:
"A Protestant, perhaps?" Whistler gave a slight shrug, as if to
say "You can please yourself." But from his behaviour in
Brussels, which he visited in the middle eighties, he seemed to
have little affinity with the Roman Catholic Church. Strolling
round the city with a Belgian painter named Fernand Khnopff
they were caught in a shower of rain, and Whistler walked on
tiptoes in his pointed patent leather shoes. They entered a church

where Mass was being celebrated, and Whistler produced a small sketch-book, quickly filling a page with his drawing. Turning to Khnopff, he said "There's no room for my butterfly." A little later, at the elevation of the Host, he remarked "Yes, there *is* room for my butterfly", and made a few lines with his pencil. His companion was pained and perplexed, unable to account for such a wide divergence of taste. To him it was rank blasphemy, just as Ruskin's "pot of paint" criticism was blasphemy to the other.

Belgium and Holland were frequently visited by Whistler because there was nothing to remind him of the "little round hills with little round trees out of a Noah's Ark", as he described the Lake District in England. But he was not attracted to the inhabitants of those two countries. "The good Lord made one serious mistake", he said to William M. Chase, an American with whom he once toured the Netherlands. "What?" "When he made Dutchmen." The same comment applied to the Germans, who however did not, like the Dutch, regard an artist as a sewage collector. While etching on an Amsterdam canal, the women in the houses nearby emptied their pails of refuse into his boat, and he had to obtain the protection of a policeman. Throughout the eighties he made many etchings in England, France, Belgium and Holland, largely because he was unable to earn a reasonable living as a painter. Chase tells us that creditors were frequent callers at Whistler's studio in Fulham, and that the artist could estimate the amount of his debt by the resonance of the knock. A loud business-like bang brought from Whistler "Psst! That's one-and-ten." A less vehement one produced "Psst! Two-and-six." "What on earth d'you mean?" asked Chase. "One pound, ten shillings: two pounds, six shillings", elucidated Whistler: "Vulgar tradesmen with their bills. They want payment. Oh, well!" There followed a gentle knock. "Dear me, that must be all of twenty! Poor fellow! I really must do something for him. So sorry I'm not in."

Whatever his difficulties he dined out frequently, his favourite restaurant after the Café Royal being Solferino's in Rupert Street, where he used to meet the staff of the *National Observer*, headed by W. E. Henley. But more often he had an economical meal at home with Maud, a stream of visitors wandering in and out of his studio; for whether working or resting he liked to be

surrounded by people. Even when painting he managed to appear peculiar. He wore a white jacket and looked rather like a barman who might at any moment begin to serve out drinks, his thick black curly hair with the white lock intensifying the impression. In fact he did sometimes take up a little statuette as if it were a glass, dust it carefully, and replace it on a shelf. Someone asked him why he seemed to value it. "Well, you know, you can take it up, and, well, you can set it down", he explained. Fond though he was of good wine and good food, he forgot both in the absorption of painting. "How can you think of dinner and time when we are doing such beautiful things?" he complained to a sitter who felt hungry and weary. And even the necessity of collecting money did not interfere with his search for beauty. A friend was driving him down to the city where an American wanted to buy some of his etchings. They passed a greengrocer's shop on the way, and Whistler told the driver of the hansom cab to stop. "Beautiful! Lovely! I'm going to do that!" he cried. "But I think I'll have him move the oranges over to the right more; and that green, now—let me see . . ." With great difficulty he was persuaded to re-enter the cab and continue the journey. It was always the same. On catching sight of the Savoy Hotel being built, with huge steel girders thrusting upwards into the sky and outwards towards the river, he cried out to the friends from whose window he saw it: "Hurry! Where are my things? I must catch that now, for it will never again be so beautiful." Money was no object with him where art was concerned. He started a portrait of Miss Marion Peck, niece of the United States Commissioner to a Paris Universal Exhibition. When she had sat to him nineteen times she asked if the picture could be shipped to Chicago. He flung down his brush, overturned the easel, and rushed round the studio like a maniac, shouting: "What! Send a Whistler to Chicago! Allow one of my paintings to enter Hog Town! Never!" She failed to obtain possession of the portrait, which vanished.

The 1889 Universal Exhibition in Paris resulted in one of his many quarrels, this time with a fellow-countryman. Requested by the American Art Department of the Exhibition to contribute some of his work, he sent twenty-seven etchings and a portrait, *The Yellow Buskin*, receiving a letter soon afterwards

asking him to take away ten of the etchings as they had not won the approval of the jury. He at once called at the American head-quarters of the Exhibition in order to see General Hawkins, a cavalry officer who had been given charge of the Art Department. "I am Mr Whistler", he said, "and I believe this note is from you. I have come to remove my etchings." Hawkins regretted that they only had space for seventeen. Whistler replied "You are too kind, but really I will not trouble you." Hawkins urged him to reconsider his decision; but he withdrew the lot and allowed the English Department to hang a number of them, explaining to a press reporter that Hawkins had been embarrassed at their interview. "I did not mind the fact that my works were criticised, but it was the discourteous manner in which it was done. If the request to me had been made in proper language, and they had simply said 'Mr Whistler, we have not space enough for twenty-seven etchings. Will you kindly select those which you prefer, and we shall be glad to have them', I would have given them the privilege of placing them in the American Section." Hawkins promptly explained to the same press reporter that Whistler had been treated like all the other artists, none of whom had detected discourtesy in the judgment of the jury, nor in the request to remove certain of their works. Hawkins laughed at the idea that he had been embarrassed during the interview with Whistler, who, in a letter to the *New York Herald*, implied that he had paid the General a compliment: "The pretty embarrassment of General Hawkins on the occasion of my visit, I myself liked, thinking it seemly, and part of the good form of a West Point man, who is taught that a drum-head court martial— and what else in the experience of this finished officer should so fit him for sitting in judgment upon pictures?—should be pre-sided at with grave and softened demeanour." On reflection, perhaps, the General could have done without the compliment.

It may have been this episode which caused Whistler, for once, to praise the English at the expense of the Americans. "Would you say that Americans are as dense as the English?" he was asked. "Heaven forbid that the Englishman's one undeniable superiority be challenged!" he answered; "but an Englishman is so honest in his stupidity that one loves him for the—virtue; whereas the American is a 'smart Aleck' in his ignorance, and

therefore intolerable." But it is more likely that this rosy view of the English was due to his marriage.

Life in "The Vale" was becoming somewhat tempestuous in 1886. Whistler's friendship with E. W. Godwin did not slacken, and in '85 the architect made designs for a new house which Whistler thought "ravishing", though he could not afford to have it built. Godwin and his wife had separated. Their union had been wholly unsatisfactory. He seems to have possessed an exceptional fascination for women, and while his wife was leading a life of poverty he was spending his time "sympathising" with charming females who were discontented on account of their own marriages or his. Apart from his extra-marital experiences, life did not run smoothly at home. Mrs Godwin told a friend that her husband used to wake up in the middle of the night shaking with chills, that she had to swelter beside him under six pairs of blankets because they had not the money to buy two beds, and that she had spent three months in hospital as a consequence of chopping wood in the yard when he had demanded a fire one winter night. They agreed to live apart, though there was no ill-feeling between them and they often saw one another. Their separation resulted in a still warmer friendship between Whistler and Mrs Godwin, who were constantly together, and terrific quarrels between Mrs Godwin and Maud, especially when Whistler showed a disposition to sketch and paint the former instead of earning money by portraying less attractive sitters. Godwin died on October 6th, 1886, in the presence of his wife, Whistler and Lady Archibald Campbell, all of whom attended his obsequies. The coffin was taken from the train at a countryside station, placed in an open farm wagon, and used by them as a table off which they ate a meal as they jolted through the Oxfordshire lanes to Northleigh, near Witney, where the burial took place.

After that Mrs Godwin was such a frequent visitor at "The Vale" that she and Maud were on shouting terms. Lady Colin Campbell, then standing for her portrait, felt annoyed that Whistler should stop work the moment Mrs Godwin arrived. Maud became frantic, and once there was a terrible scene between the two women which Whistler brought to a close by pushing them into the street. Maud broke a blood vessel in the course of the row and Whistler dashed off to fetch a chemist, who refused to come,

not being a doctor. Presumably he obtained the assistance of a man with the proper qualification. His engrossment with Beatrice Godwin, whom he now called Trixie, was deepened by Maud's uncertain temper. If Jo had aroused his protective instinct, Maud aroused his self-protective instinct, and her rages were driving him more and more to seek consolation in the company of Trixie. The difficulty of his situation was eased by a queer occurrence. One of his disciples, William Stott of Oldham, a slavish admirer, copied his style of clothes, wearing a long frock-coat buttoned up close to the neck, a flowing black tie, and a tall stove-pipe topper with narrow brim. Stott also copied his style of painting, and on one occasion used the same model; the result being that at an exhibition of the British Artists Society in '87 a nude Venus with red hair by Stott in one room was obviously the same lady in bonnet and furs by Whistler in another, the latter being described by the critics as "in her right clothing." Much scandalous talk ensued, accompanied by laughter and shaking of heads, as the malicious gossip-mongers hinted that a shared model was the same as a common mistress. No one dislikes ridicule more than the man who practises it, and Whistler was furious, though the strained relations which followed this incident gave him an excuse to send Maud away. He wrote to the Stotts, who had been very kind to him in the past, saying that "Madame" was unwell and could she spend a few days with them? They invited her and she went.

At this point in the story the biographer is faced with con-flicting testimony. Louise Jopling-Rowe, a friend of Beatrice Godwin and Whistler, says in her book of memories that she invited them both to dine with herself and her husband at the Welcome Club in Earl's Court Exhibition, the other guests being Mr and Mrs Henry Labouchere. Believing them to be "engaged", Louise wanted to know when they were going to get married. They had not decided. She begged them to fix a date before she left town; and so it was arranged. On the other hand, Henry Labouchere, founder and editor of *Truth*, recorded that he had dined with Whistler, Mrs Godwin and others at Earl's Court: "They were obviously greatly attracted to each other, and in a vague sort of way they thought of marrying. So I took the matter in hand to bring things to a practical point."

"Jimmy", said Labby, "will you marry Mrs Godwin?"

"Certainly", replied Whistler.

"Mrs Godwin, will you marry Jimmy?"

"Certainly."

"When?"

"Oh, some day", said Whistler.

"That won't do. We must have a date."

They agreed that Labby should choose the day, the church, the clergyman, and give the bride away. He got the chaplain of the House of Commons to conduct the service at St Mary Abbott's Church in Kensington; and we may accept his version of what occurred because he was an old friend who could take liberties with Jimmy and one of the very few people who never quarrelled with the touchy artist over a period of nearly fifty years. His form of wit made a great appeal to Whistler, who frequently told the story of how Labby in his twenties was laying down the law on a dozen subjects in a London club, to the indignation of an old gentleman, who suddenly exploded: "Young man, I knew your grandmother!" on which the young man rose, bowed politely, and said gravely: "Perhaps, sir, I have the honour of addressing my grandfather." Labby happened to meet Mrs Godwin in the street the day before she became Mrs Whistler, and reminded her: "Don't forget tomorrow." She replied that she was just going to buy her trousseau. "A little late for that, is it not?" he queried. "No, for I am only going to buy a new toothbrush and a new sponge, as one ought to have new ones when one marries." The ceremony took place on August 11th, 1888, and it was noticed that Whistler looked about him nervously, fearful that Maud might appear and make the proceedings more dramatic than he wished them to be.

That evening the *Pall Mall Gazette* had an article headed "The Butterfly chained at last!" After the service Whistler's brother, the Laboucheres, the Jopling-Rowes and the chaplain went to a studio in Tower House, Tite Street, to which Whistler had just moved from "The Vale", and enjoyed a wedding breakfast supplied by the Café Royal, sitting on packing cases for want of chairs. "The happy pair, when I left, had not quite decided whether they would go that evening to Paris or remain in the studio", wrote Labby. Fear of Maud and lack of furniture probably decided in favour of the former.

Meanwhile Maud had been quietly reviving from a succession of shocks and brawls, and all was going well until the Stotts read the *Times* announcement of Whistler's marriage. Maud collapsed and for some time was seriously ill. They tended her carefully until she recovered. Many of Whistler's friends considered that his treatment of her was unpardonable, which made it easy for them to pardon him; but Stott, who had personally suffered from it, continued to feel sore; and when the two men came face to face in the Hogarth Club he called Whistler a liar and a blackguard, being seized by the scruff of the neck and kicked out of the room for his outspokenness. Whistler reported Stott to the committee for having used insulting and ungentlemanly language, and a meeting was convened to decide upon the incident. At the meeting Whistler urged that Stott be expelled from the Club if he refused to resign; but the members of the committee were antagonistic to Whistler, whose behaviour was described by one of them: "I could not help admiring the superb audacity of the strange creature in face of a crowded hostile room. During the silence in which the chairman's words were listened to, Whistler required a light for his cigarette. There was a lighted candle upon the table in front of the chairman, and in full view of us all Whistler stepped forward, and at arm's length—he could barely reach it—succeeded in lighting his cigarette with a nonchalant insouciance which by suggestion made light of the whole proceeding." Stott was not expelled, but he resigned. It seems that Whistler challenged him to a duel, but he left for Switzerland. "Well, he knew he was safe in the land of William Tell and the clock of the sudden cuckoo", remarked Whistler. Some years later John Lavery noticed a newspaper poster with the words "Death of William Stott on board ship", and drew Whistler's attention to it. "Umph! So he died at sea, where he always was", said the Master. Lavery made a sympathetic comment on Stott, but Whistler was not to be pacified. "I forgive when I forget", said he.

There is little to be added about Maud. She had nothing further to do with Whistler, but her behaviour exasperated Mrs Whistler, who was extremely jealous of her husband's past. When they settled down in Paris some four years after their marriage, Maud took an apartment nearby. Being poor, she posed to artists for a living, and still called herself "Mrs Whistler", which caused the

legal one to fret and fume. In time Maud married a rich South American, and at length became a wealthy widow with town and country houses, a motor car, and other solaces for a damaged heart.

The new Mrs Whistler was many years younger than her husband, beautiful in a Latin style, with dark liquid eyes and a tea-rose complexion. Though a little taller than Jimmy, her height being about five feet five inches, she seemed to dwarf him because she weighed at least forty pounds more than she ought to have done. They made a curious pair, her plumpness contrasting with his exility. Her egotism was quite as eloquent as his, but she seldom got the chance to unburden herself in his company. He adored her, and never let her out of his sight if he could help it, persuading her to sit in his studio while he was working and accompanying her on visits to her own friends. He took her advice on everything, and only protested feebly when she inter-fered with his painting. A girl with bright blue eyes was sitting for her portrait, and to harmonise with his scheme he made her eyes brown. Mrs Whistler took up a brush and dabbed the picture with the right colour, exclaiming "Blue, Jimmy, blue!" He wailed: "Don't, Trixie, don't!"

Before his wedding he had said "I don't marry, though I tolerate those who do." He had become so accustomed to having no ties of a permanent kind that he could not imagine himself in any fixed relationship with anybody or anything, and this had been mainly the cause of his contentiousness. But his marriage altered all that; and though his susceptibility to treatment which he construed as unfriendly remained as alert as ever, he ceased to look for trouble and tried to ration his quarrels. "If I died before Jimmy, he would not have a friend left in a week", declared his wife; and we have a revealing instance of his prickliness with one who both admired and liked him. Graham Robertson went with Whistler and his wife to call on Albert Moore. After their visit Robertson said he was off in the direction of Hammersmith and bade farewell to the others.

"What are you going down there for?" asked Whistler.

"I'm going to see Burne-Jones."

"Who?"

"Burne-Jones."

"Oh, Mister Jones." This was Whistler's sarcastic way of

referring to the man who had given evidence for Ruskin. "But what on earth are you going to see him for?"

"I suppose because I like him."

"*Like* him. But what on earth do you like him *for*? *Why* do you like him?" Whistler was in a temper, tapping the pavement with his cane, and standing between Robertson and Hammersmith.

"I suppose—because he amuses me", said Robertson, unable at the moment to think of a better reason and not wishing to catalogue Burne-Jones's virtues in the middle of Kensington High Street.

"Amuses you? Good heavens!—and you like him because he amuses you! I suppose *I* amuse you?" A furious look in the eyes and an angry tap of the cane.

Robertson was wondering how to answer in the negative without enraging the Master, or in the affirmative without infuriating him, when Mrs Whistler came to the rescue:

"Don't tease him, Jimmy. Surely he may choose his own friends."

Whistler rarely smiled, but he did so now, and Robertson found it irresistible. "He doesn't mind, do you?" said Jimmy; and Robertson felt that the smile had more than made up for the scene.

After his marriage Whistler ceased to be a social butterfly and painted very much less than he had done in the past. Far more of his time went to his wife than to pictures or parties, and it is even possible that his artistic tastes were influenced by hers. Asked one day in the National Gallery, whether one picture made a special appeal to him more than another, he replied "Yes, and here it is!" pointing to Tintoretto's *Milky Way*, which was his wife's favourite. But he never faltered in his admiration for Franz Hals, Hogarth, Velasquez, Canaletto and Rembrandt. On the holiday which they enjoyed together in the autumn of '88 he did etchings in Touraine, taking Chartres on the way, and they spent some time at Boulogne. But the period of his big portraits was behind him when they moved to No. 21 Cheyne Walk in 1890. This house, with a colour scheme of blue and white for the dining-room, stood near the mansion that had once been Rossetti's, then occupied by H. R. Haweis, a popular sensational preacher and music critic who wrote a book called *Music and*

Morals. When asking people to visit them, Whistler offered a further attraction on the cards of invitation: "To see the Haweises go out on tricycles." As usual Whistler's new abode was scantly furnished and gave the impression that he was just going or coming. "You see", he told a caller, "I do not care for definitely settling down anywhere. Where there is no more space for improvement . . . it is *finis*—the end—death. There is no hope nor outlook left." The remark discloses two leading features of his nature: his endless striving for perfection, and his rootlessness. His house revealed himself: it was never like a home and he never felt at home.

He painted his last big portrait here in 1890–1. It is interesting that he should have begun his career in close touch with a pheno-menal person, Charles Augustus Howell, and that he should have chosen for his final subject on a large scale another eccentric individual, Comte Robert de Montesquiou-Fezensac. Freakish characters made a lasting appeal to him because he was misunder-stood by the average man, with whom he lacked the fellowship born of a common heritage. Montesquiou was one of the queerest personalities of his age. J. K. Huysmans portrayed him as Des Esseintes in *A Rebours.* He was a poet, an exquisite, an adonis, an exotic, who loved solitude as much as he craved for society, and adored nature as fervently as he surrendered to the thrills of artificiality. Whether evoking the pageant of history at Versailles, or the mystery of art in the Louvre, or the wonder of creation among the mountains, he seemed a master of his theme and a lord of words. He lived at the top of his father's house on the Quai d'Orsay, and it was a weird experience to go from the austere rooms of the old Comte into the oriental atmosphere of his son's apartments, where the walls of the sitting-room were of different shades of red, where another room was entirely grey, and where the main feature of the bedroom was a black bulbous-eyed dragon which on inspection resolved itself into a bed. "It was all queer, disturbing, baroque", decided one visitor. Portraits of himself in different attitudes and outlandish costumes filled the walls, and strange scents filled the air. He was known among his acquaintances as "Chief of Fragrant Odours"; at one time he was frequently seen in society carrying a gilt tortoise; and it was generally believed that he was a connoisseur in various forms of vice.

This odd creature spent a month in London during 1890. Like all unbalanced people, he loved mystery, and it gave him great pleasure to masquerade as someone else. He decided to play at being half a dozen people while in England; and though hardly a soul knew him by name or sight, he passed under several aliases and went about stealthily at nightfall, avoiding the public haunts of men and slinking down dark and narrow passages, wrapped in a cloak which might have concealed a rapier. Whistler pretended to respect his desire for concealment, and furtively let him in and out of the studio; though if all the newspapers had announced in headlines that Count Robert de Montesquiou-Fezensac was in London, scarcely a reader would have been the wiser and no one would have taken any notice of him; which perhaps was a reason for his disguises and his sinister movements. He sat for Whistler seventeen times, no doubt enjoying the painter's mesmeric concentration on himself, but almost dropping with fatigue and being revived at intervals with what he called *vin de coca*. He was deeply impressed by Whistler's method: the fury, the passion, of the first sketching-in, followed by long sittings when the brush was continually brought close to the canvas without touching it, and was then thrown away for another, the actual number of touches in three hours never exceeding fifty, each "lifting a veil from the sketch." Whistler essayed two full-length portraits of the Count, the second of which was not finished. In the completed one, a *Harmony in Black and Gold*, Montesquiou was in evening dress, a fur cloak flung across his arm. Logan Pearsall Smith was persuaded by Whistler to act as sitter's substitute for the painting of the coat; and the experience was not pleasant, for the artist remained unaffected by the passing of the hours, while the sitter, not wishing to die in an attempt to immortalise the fur coat of a stranger, would beg for rest. "In a moment, in just a moment", came the cheerful response; but the moment was an age.

Whistler's portraits display the character of the painter more nearly than that of the subject; his desire for harmony, his distaste for reality. "Character! what is character? It's tone that matters!" he once exclaimed, and to achieve this effect he gave the subject an air of remoteness. The fashionable painter tried hard to make the subject "stand out" from the frame, when in Whistler's view the subject "should really, and in truth absolutely does, stand

within the frame— and at a depth behind it equal to the distance
at which the painter sees his model. The frame is, indeed, the
window through which the painter looks at his model, and
nothing could be more offensively inartistic than this brutal
attempt to thrust the model on the hitherside of this window!"
In his attempts to attain the perfection for which his soul hungered,
Whistler was a more severe critic than any of those who criticised
him. He described a later portrait of de Montesquiou as "damn-
able, and no more like the superb original than if it had been
done by my worst and most incompetent enemy. . . . There must
be no record of this abomination! It is neither for catalogue nor
posterity, and is the folly of proposing to produce the same
masterpiece twice over."

The lack of recognition from which he still suffered in England,
and a wish to begin anew in fresh surroundings with the change in
his domestic condition, made Whistler decide to wipe the dust of
London off his shoes, as he expressed it, and to live henceforth in
Paris. No doubt his wife thought that he would be more at peace
there and less likely to indulge in those quarrels which seemed so
inevitable in England. Indeed, another of these had recently
occurred, and she had innocently been the cause of it. Augustus
Moore, brother of George Moore, was editing a paper called *The
Hawk*, wherein appeared an offensive remark about Mrs Whistler's
late husband, E. W. Godwin. Knowing that Moore would be
present at the first night of a play called *A Million of Money*,
Whistler turned up at Drury Lane Theatre. During an interval
they met in the foyer, and Whistler struck Moore across the face
with his cane, crying with each stroke "Hawk! Hawk! Hawk!"
Describing the incident, Whistler said "Oh, you can take my word
for it, everything was done in the cleanest and most correct
fashion possible." Moore claimed that he had knocked his
opponent down: "My Irish blood got the better of me and before
I knew it the shrivelled-up little monkey was kicking about the
floor." Whistler's comment on this was "He never touched me."
The probability is that they were separated before they could
properly come to grips, and that Moore's Irish blood got the
better of him by stimulating his fancy. Whistler was requested
to leave the theatre, which he was the more willing to do because
he wanted to visit one or two editors in Fleet Street and get his
version of the episode into print.

After he had made up his mind to leave England, and was actually in the process of moving, the English suddenly awoke to an appreciation of his paintings. An exhibition of them was held in the Goupil Gallery, Bond Street, and for the first time his work was properly represented: the Nocturnes, the portraits, the seascapes: there was something of everything, and something of the best. Though most of his time in 1892 was spent in Paris, he wrote minute directions for the cleaning, varnishing and framing of his pictures, and returned to London in order to supervise the hanging. Again he prepared a catalogue in which the past fatuities of critics were quoted under the heading "The Voice of a People"; but this time the people did not laugh and the critics had to eat their words. The exhibition was a huge success; crowds daily packed the gallery; and the long uphill fight against stupidity and ridicule was over. Whistler claimed that even Academicians had come to scoff and remained, if not to pray, at least long enough to feel humble, and that only one thing was needed to cap the enterprise: Ruskin should have been given a season ticket. "Well, you know", he remarked, "they were always pearls I cast before them, and the people were always— well, the same people."

It was now safe to have one's protrait done by him, and eager requests arrived from the famous, the wealthy and the titled. Among others the Duke of Marlborough signified his desire to be recorded in paint, and asked the Whistlers to Blenheim. But he died suddenly and Whistler mourned: "Now I shall never know whether my letter killed him, or whether he died before he got it." Americans also clamoured to have their faces on canvas, and though he was anxious to fill his pockets with their dollars he wondered why they had not asked him to paint them long ago when he could have done it just as well and when he had needed the money as much as they now wished him to accept it. The cash value of his early pictures mounted quickly, selling for ten and twenty times as much as he had received for them. He disposed of *The Falling Rocket*, which Ruskin had priced at a pot of paint, for eight hundred guineas. Exhibitions as well as collectors demanded his paintings, and he was annoyed because those who had obtained them for paltry sums were minting his present reputation and enjoying continental holidays on the proceeds. Works of art, he continually asserted, belonged to the

artist and were only "lent" to their owners. But the owners
took a different view, making far more money out of him than
he had ever made out of himself; and the pictures which the
critics had scorned became the rage in the auction-room.

CHAPTER XIII

Magisterial

THE success of the Goupil Gallery exhibition was repeated at the *Salon* later that year, and though Whistler had waited a long time for public recognition he was still vital enough to enjoy it. In 1892 he and his wife settled down in Paris for life, as he hoped. While their apartments were being prepared they stayed first at the Foyot, then at the Hôtel du Bon Lafontaine. Early in '93 they moved into No. 110 Rue du Bac. "Peace threatens to take up her abode in the garden of our pretty pavilion", he said; but it was a brief peace. He also took a large studio at No. 86 Rue Notre-Dame-des-Champs, up six flights of stairs with a view over the Luxembourg Gardens.

Their rooms in the Rue du Bac, the ground floor of a 17th century house, were conveniently, pleasantly and privately situated. One approached them through a sort of tunnel between walls and shops, and entered a courtyard with a disused drinking-fountain. A door opening on to the courtyard was painted blue, from which the visitor might guess that the Master dwelt within; though one visitor said it was green and white, and drew the same deduction. The level of the interior was rather below that of the courtyard, and from the door several steps led down to a hall, at the far end of which was a large sitting-room furnished with Empire chairs, a couch, a grand piano, and a table. The walls were blue, the doors and window-frames white, and the floor was covered with blue matting. The dining-room, to one side of the sitting-room, was also in blue, and contained the old silver, the blue and white china, a Japanese birdcage in the centre of the table, flowers in porcelain bowls, and a Whistler picture on one of the walls. From the sitting-room one could step through a glass door into a large garden, thick with undergrowth, shaded with trees, and terminated by a convent wall. In the evenings

the chanting of a choir could be heard, and Whistler seemed to enjoy the sound for he usually stopped talking when it began. There were many birds in the trees, and the rustic atmosphere was complete. For a while they kept a white parrot; but it did not like Whistler, and in a fit of pique flew to the top of a tree, refused to come down and died of starvation, which much depressed him because he believed himself to have been the cause of it.

Many people visited them in this snug retreat, and for nearly two years Whistler passed the happiest period of his life, as did his wife of hers. Trixie made a real home for him; no longer was there a shortage of money; lithography absorbed him; far more people wanted to be painted by him than he wished to paint; new friendships were being made, new disciples recruited; and he enjoyed the company of his wife's mother and sisters. It was noticed that he always addressed his mother-in-law, Mrs Birnie Philip, as "M'am", and that he took her into dinner with the air of a courtier conducting a queen to her throne. Sometimes he would indulge in self-pity, saying that no one had ever paid a higher price than he for the crime of originality, that no one had ever been treated with such unmitigated stupidity by critics and public, that he had "created a world" by revealing the beauty of London, and had suffered poverty and humiliation in the course of his long and desperate fight. But as a rule his feelings were relieved by sarcastic comments on the English, who, he said, employed insolence to cover emptiness; and even the Englishwoman was not spared: "She succeeds, as no others can, in obliging men to forget her sex." In fact his strictures on the country and the people became increasingly tiresome, and his friends did their best to keep him off the subject. His antagonism was the obverse of his affection. His bitterness expressed, unconsciously, the unrequited lover's hate, and was all the more spiteful on that account. The accumulated resentment of years was soon to burst forth in an unexpected manner and with an intensity due to the concentration of his wrath on a single object; but before that happened he enjoyed a phase of relative tranquillity and a blitheness of spirit imparted by congenial surroundings.

Though he became friendly with certain French artists such as Puvis de Chavannes and Rodin, he was sought out by writers, scarcely at all by painters, and the closest friendship he formed

was with Stéphane Mallarmé, whose portrait he drew in lithography. The artistic centre of Paris had shifted in his time from Montparnasse to Montmartre, where the Impressionists flourished; but though the painters changed their quarters in the capital, they never changed their attitude to the outside world. In some respects Paris is the most provincial place on earth. To the French artist, whether writer or painter, the city is not only the centre of the universe but the circumference as well, and what is not taking place there is of no account. This helps to make it a hotbed of "movements", and Whistler the individualist could never take part in one unless he were the movement. At any rate the Impressionists had never accepted him as a component of theirs, and his opinion of them was broadly summed up in his comment on the sketch of a young girl's head by Cézanne: "If a child of ten had drawn that on her slate, her mother, if she had been a good mother, ought to have slapped her." He was therefore as much an outsider with his brethren of the brush in Paris as he had been with those in London, of whose work he had once exclaimed, on being told that modern pictures were liable to fade: "No, they do not fade, and therein lies their complete damnation!" But what the French artist in one medium will not acknowledge, the French artist in another medium will recognise, and the poet Mallarmé greatly admired the painter Whistler, translating his *Ten O'Clock* lecture and listening to his views on art with rapture. In the same way Oscar Wilde gained the appreciation of French painters while their poets looked askance. It may further be noted that such English writers as win favour with French men of letters are seldom of the front rank. Shakespeare is still suspect with them, and Shaw has not reached the years of suspicion.

Whistler, therefore, had to depend for the most part on the company of English and American visitors, with a sprinkling of French writers and an odd painter or two. His wife was of little help to him with the natives, as her French was shaky and she showed an open dislike of Frenchmen; but she welcomed the young painters who came to Paris from Great Britain and the United States and who regarded her husband as the leading figure in modern art. Of these the best-remembered today are the Englishman Aubrey Beardsley, the Irishman John Lavery, and the American John Singer Sargent.

When they met Whistler did not take to Beardsley, whom he
thought a typical aesthete and decadent, whose work he did not
like, and whose hirsute appearance provoked an outburst: "Look
at him! He's just like his drawings . . . hairs on his head, hairs on
his fingers ends, hairs in his ears, hairs on his toes!" But some years
later the two met at 14 Buckingham Street, Strand, where the
Pennells lived in rooms once occupied by William Etty. Beards-
ley had with him a portfolio containing his illustrations for
The Rape of the Lock, which Whistler first glanced at with indif-
ference, then looked at with interest, then examined with eager-
ness. At last he spoke deliberately: "Aubrey, I have made a very
great mistake—you are a very great artist." Beardsley burst into
tears, and Whistler was so taken aback that he could only repeat:
"I mean it—I mean it—I mean it." Such a scene would have
made the Academicians rub their eyes in amazement, but Whistler
was extremely generous with praise when his admiration was
aroused, and ready with encouragement when early work showed
promise of better to come. Young John Lavery's was a case in
point. Whistler said that one of his youthful pictures was well
thought out. "You will make the boy conceited if you tell him
that", said Lavery's father. "Dear sir, an artist knows very well
when he has produced something good", replied Whistler, who
instantly became the boy's hero. But he could not admire with
the crowd, his taste being different, and there was more honesty
than envy in his criticism of John Sargent, the most fashionable,
and in some eyes the greatest, portrait painter of the day. Whistler
regarded Sargent's work as that of "an acrobat in pain", of a
landscape painter who had been seduced into portraiture by
titled women; as no better than the rest. But Whistler liked
Sargent as a man and hoped his remarks on the painter would not
be repeated because "people will get the idea that I am ill-
natured, and that is absurd. I may be wicked, but—what?—
never ill-natured!"

Certainly he was more good-natured during these years than
he had ever been before, though perhaps the Englishman who
sat down beside him in a café would not have agreed. "Well, Mr
Whistler, how are you getting on?" "I'm not. I'm getting off",
and he suited the action to the word. Against this it is recorded
that he went out of his way to oblige another Englishman who
was having trouble with the language in a restaurant. "May I

help?" he enquired pleasantly. The man said haughtily that he required no assistance. "I fancied the contrary just now, when I heard you desire the waiter to bring you a pair of stairs", said Whistler. He enjoyed the society of young people more than that of his contemporaries, partly because the young liked him better and admired him more, but he could not resist his old pastime of leg-pulling. "I went to the Louvre this morning", he observed at a dinner of youthful American artists, who stopped talking and waited for parnassian pronouncements. "And I was amazed", he went on, while the youngsters held their breath, "to see the amazing way they keep the floors waxed." After that, they too would have been amazed had they watched him at work, in an agony of concentration, the sun going down, the shadows creeping up, struggling on when it was too dark for anyone else to see what he was doing, working to the verge of collapse, and then, dissatisfied, destroying the incessant labour of hours.

Chiefly for the sake of his wife, he visited Normandy and Brittany, and spent occasional days in the country, at St Germains, Barbizon, Fontainebleau; but much of his time was spent in the garden, and a good deal in his studio, slaving at the art of lithography. The peaceful days lasted until 1894, when the internal discord which marriage had temporarily allayed came again to the surface and left him no peace for the remainder of his life. In replying to the commonplace remark "It is wonderful what a difference there is between people!" he was thinking of himself: "Yes, there is a great difference between matches too, if you will only look closely enough, but they all make about the same blaze." Not all, for few people in history have blazed so furiously as he, though struck ever so lightly.

The first sign of inclement weather came from America, where a novel called *Trilby* by George Du Maurier was being serialised in *Harper's Magazine*. Whistler was easily indentifiable in the description and character of "Joe Sibley", whose "enmity would take the simple and straightforward form of trying to punch his ex-friend's head; and when the ex-friend was too big he would get some new friend to help him ... he was better with his tongue than his fists ... But when he met another joker he would collapse like a pricked bladder." Whistler was furious and threatened the author with physical violence. "J. W. seems to me to have gone quite crazy", wrote Du Maurier to a friend. The

editor of the magazine had to apologise, while the author was compelled to omit all reference to "Joe Sibley" in the book, to suppress the offending passages, to substitute a personage called "Bald Anthony" who might have been anybody, and to submit the changes to Whistler, who was thus placated: "I wired to them over in America compliments and complete approval of author's new and obscure friend Bald Anthony." But all this was a gentle shower compared with the savage storm just blowing up.

Sir William Eden was a wealthy and wretched man, a self-tormented Byronic egotist to whom molehills were mountains. As dictatorial, touchy and quarrelsome as Whistler, all his friends became his enemies on the least provocation, and his children were terrified of him. Incidentally, one of his children, Anthony, was to become Foreign Secretary in several Conservative Administrations. Sir William was generous with his money and waspish with his tongue. He hated noise, and was therefore irritated by boys and dogs; he disliked smoking, and loathed anything that struck him as ugly. A typical English fox-hunting squire and eccentric, he nevertheless worshipped beauty, and had so many points in common with Whistler that there was bound to be friction between them. Lady Eden was beautiful and the principal object of her husband's worship. She was painted by various artists, including Sargent, but Sir William wanted her to be the subject of a "Whistler", made enquiries about the terms, and found that he would want five hundred guineas. Eden thought this sum excessive for a mere "head" and asked George Moore to introduce him to the artist, so that they could agree on a reasonable price. Moore forgot that

> 'Tis dangerous when the baser nature comes
> Between the pass and fell incensed points
> Of mighty opposites,

and arranged a meeting between the two men, which passed off amicably, Whistler agreeing to do a "little painting" of Lady Eden for something between a hundred and a hundred and fifty guineas. "I think there can be no difficulty about the sum", said Whistler, a remark that must head any list of false prophecies since the beginning of time.

He was delighted with his subject, a patient and willing sitter, of whom he did a small oil painting, some twelve by eight inches

in size. Before it was finished Sir William Eden, about to leave Europe, called at Whistler's studio on St Valentine's day '94 and handed him an envelope, saying in a jocular manner "Here is your Valentine!" On his departure Whistler opened the envelope and found a cheque for a hundred guineas. He sat down at once and wrote to Eden: "I have your Valentine. You really are magnificent!—and have scored all round. I can only hope that the little picture will prove even slightly worthy of all of us . . ." Eden lost his temper and returned to the studio. "What do you mean by this letter?" he demanded. Whistler's reply was evasive. "You say 'you really are magnificent!'" pursued Eden. "Well, are you not?" countered Whistler. "You seem to wish to insinuate, sir, that I have been mean in my dealing with you. If you tear up that cheque, I will give you this one for a hundred and fifty guineas." "The time has gone by", said Whistler, who afterwards described the offer as "tardy generosity, in flagrant form of hasty hush money." Eden left the studio, protesting so volubly as he descended the six flights of stairs that Whistler, from the top, made unflattering comments on the manners of Englishmen.

Instead of returning the cheque or delivering the portrait, as he ought to have done, Whistler paid the cheque into his bank and exhibited the picture. Eden brought an action against him, and the case came before the Civil Tribunal in Paris early in '95. Before it was heard Whistler instructed his solicitor to return the hundred guineas; he also substituted someone else's head for Lady Eden's in the picture. The verdict was unfavourable: he was ordered to hand over the portrait, to pay back the hundred guineas, and to cover Lady Eden's expenses in Paris. He appealed against this, and at the end of '97 obtained a more propitious judgment from the *Cour de Cassation:* he was allowed to keep the picture, but he must refund the hundred guineas to Sir William (which he had already done) and pay Lady Eden's expenses. The cost of the first trial was to be borne by him, that of the appeal by Eden. The result was not exactly a cause for jubilation, but Whistler regarded it as a triumph, claimed that the case had made history by granting the artist the right to his own work, that it had added a new clause to the *Code Napoléon*, that he and Napoleon would be bracketed together in French legal history, etc., etc., and above all that he had wiped the floor with the Baronet.

But wiping the floor with Eden did not content him, and he

embarked on a campaign of floor-wiping with every personal acquaintance who did not share his view of the Baronet. This went to such lengths that some people thought his brain had been affected. He saw William Rothenstein in the company of Eden, and saw him no more. He spoke with scorn of Eden's brown boots, implying thereby that the man was a yokel. Anyone on friendly terms with the Baronet was outside the pale; anyone on nodding terms with him was hostile to Whistler, who took the messianic view: He that is not with me is against me. When the New English Art Club hung some of Eden's paintings, he described those responsible as toads, and thenceforth the Club was anathema. Laurence Housman met him in the studio of Charles Ricketts and C. H. Shannon, and this time Walter Sickert was the grievance. "What? Have you heard the news? No? Oh, yes! Walter has been seen walking down Bond Street with the Baronet. Walter's mistake is that he began life as an actor. On the stage there is always an exit; now Walter is going to find that there is no exit: he's been seen walking down Bond Street with the Baronet"—and so on, in a slow nasal drawl, the burden of a monologue that bored Housman so much that he left. Sickert called on Whistler and left a card, receiving it back with 'Judas Iscariot' written on it.

Eden refused every attempt to be dragged into controversy. He concisely summed up his view of Whistler and left it at that: "There never was a more vulgar and indomitable cad or a more vain and vicious beast. The man thinks no one dare collar him." George Moore was less prudent. As the means whereby the two men had come together, Whistler did not spare him and sent an offensive letter. Moore's reply touched a very sensitive spot, for he spoke of Whistler's advanced years, and the *Pall Mall Gazette*, followed by the French papers, printed his remarks. Whistler promptly challenged Moore to a duel, appointed his seconds, one of whom was Octave Mirbeau, and awaited the result. But he knew perfectly well that Moore was only bellicose on paper, and the answer to his challenge took the form of a newspaper interview. "Of course you don't know what fear is", said a disciple to Whistler. "Ah, yes, I do", he replied. "I should hate, for example, to be standing opposite a man who was a better shot than I, far away out in the forest in the bleak, cold, early morning. Fancy I, the Master, standing out in the open as a target to be shot

at! Psha! It would be foolish and inartistic. I never mind calling a man out; but I always have the sense to know that he is not likely to come." To say that Moore would not be likely to accept a challenge to mortal combat was an understatement. Nothing would have induced him to do so foolish a thing; and he willingly joined the band of martyrs whom Whistler had mentally destroyed. "George Moore? He does not exist. He died many years ago", said the Master not long before his own death.

It was generally agreed that Whistler had a bee in his bonnet, or more adequately a hornet in his hat, on the subject of Eden. He compiled a book entitled *The Baronet and the Butterfly*, which appeared in Paris in the spring of '99. It contains the speeches of the advocates and judges at the trial and appeal, and is perhaps the dullest book ever produced by a witty man. He dedicated it "To those *confrères* across the Channel who, refraining from intrusive demonstration, with a pluck and delicacy all their own, 'sat tight' during the struggle." A realistic toad accompanies the dedication, denoting the sycophantic *confrères*, and the butterfly is again in evidence, though the contents suggest that it should have been a caterpillar. All his acquaintances were of course subjected to readings from the book during its preparation, but no one enjoyed the experience, and its publication was almost ignored, which naturally made him feel that the world was still in a conspiracy against him. He believed that he had won a great battle for his colleagues in art, who were wholly unworthy of their dauntless champion. In fact he was suffering from what his French friends called *la folie de la persécution*, which reached its maximum during this affair. Everything about Sir William Eden reminded him of all that enraged him in the English people: the patronage, the lordly manner, the indifference to his own feelings, the tradesman's attempt to get something for nothing, the complacency, the spurious connoisseurship, the sportive estimate of his art implied by "the Valentine." That Eden had not the least intention of offending him, and was innocent of all these causes of vexation, did not occur to one who snatched at every chance to express his anglophobia. For him Eden was the symbol of all that he had suffered in England. In his inflamed fancy Eden *was* England, and the piled up bitterness of years fell on the unfortunate Baronet's head.

So extreme was his mortification that he kept up the vendetta

all through the tragic illness of his wife. Towards the close of '94
Trixie showed symptoms of cancer. He would not believe the
worst and took her to London in December to see the specialists.
He stayed with his brother Willie in Wimpole Street while she
remained under the care of a physician in Holles Street. He had
just won the Temple Gold Medal from the Pennsylvania Academy
and another Gold Medal from Antwerp, but the awards gave him
no comfort. He tried to work, but could not give himself to it,
and destroyed what he had done. The doctors held out little hope;
he refused to believe his brother, who told him that Trixie was
dangerously ill; and they returned to Paris, where he put her case
into the hands of an obscure French doctor, who was about to
perform a useless operation when Dr Whistler got to hear of it
and dashed over to France just in time to prevent it, saying frankly
that Trixie could not recover and that an operation would merely
cause unnecessary suffering. Whistler was furious with his
brother, and was even angry with his wife for telling people that
she had cancer. The brothers quarrelled violently, and Jimmy lost
his best friend. Their quarrel upset Willie so much that he took to
drink, and Jimmy did not even tell him of Trixie's death when it
occurred. But it was from this brother that Whistler unknow-
ingly received his highest tribute as a man; for when he got to
hear that Willie was in financial difficulties, he sent money
through his half-sister Lady Haden, to whom the doctor said: "It
is Jimmy all over, generous and open-handed as I have always
known him", having often given to others what he lacked him-
self, "the pluckiest fighter against odds and the most splendid
worker that I have ever known."

But Jimmy had a sad road to travel before his brother needed
help. In the late summer of '95 he and Trixie were back in Eng-
land, staying at the Red Lion Hotel, Lyme Regis, where hope
must have been renewed in him, for he painted two of his finest
pictures, *The Little Rose of Lyme Regis* and *The Master Smith*, as
well as his one large landscape, showing the town and the hill
behind it. At the end of the year the Fine Art Society held an
exhibition of his lithographs; but it gave him no pleasure, for his
wife was getting worse and they spent the winter in a succession
of London hotels, Garlant's, the De Vere Gardens, and the Savoy.
He took a studio at the back of No. 8 Fitzroy Street, on the first
floor, where he did a certain amount of work, but so many

nights were spent sleeplessly by his wife's bedside that he had little energy to draw or paint. In the spring of '96 he moved her to St Jude's Cottage, Hampstead Heath, where the rugged and mountainous country, rising in places to five hundred feet above sea-level, was too primitive for his Dutch taste. "It is like living on the top of a landscape" he repined. By now he had abandoned hope, and seemed hardly conscious of his actions, appearing one day with different coloured shoes on his feet. Trixie died on May 10th, when a friend met him running and stumbling across the Heath, unaware of his surroundings, careless of his appearance, insensible to sound and sight. The friend tried to stop him, but "Don't speak! Don't speak! It's terrible!" he cried, and rushed onwards. She was buried at Chiswick, where he too would one day rest by her side, and he was frantic with grief. He knew that nothing could ever make up for the loss, that no one could fill the gap left by another, that human beings created their own places and so were irreplaceable. The morning after the funeral he wandered with a fellow-artist round the Fitzroy Square and Tottenham Court Road district until they were tired and entered a public house. They happened to sit on a couch directly under an engraving of W. P. Frith's *Margate Sands*. He smiled when his attention was drawn to it, and then talked seriously of entering a monastery or retiring to the top of a mountain.

Instead he spent the rest of his life in the busy haunts of men. One of his wife's sisters, Ethel Philip, had recently married the well-known critic Charles Whibley, and Whistler made the other, Rosalind Birnie Philip, his ward, heiress and executrix, establishing her with her mother in the Rue du Bac. He then went to live with his friend and publisher William Heinemann, whose flat in Whitehall Court practically became his home, and he would speak of "my guest Heinemann." Yet he was too restless to remain for long in any one place, and we hear of him soon after his wife's death making trips to Rochester and Canterbury and Whitby, driven therefrom by the food supplied at the inns, and to Honfleur, where the food was civilised. But he never felt at home in rural scenery and could not enter a country inn without wishing himself in a city restaurant. "My man, would you like to sell a great deal more beer than you do?" he once asked an innkeeper. "Aye, sir, I would that." "Then don't sell so much froth."

Overwhelmed though he had been by his wife's death, his nature was not purged by sorrow, and though he was never to be quite the same man afterwards, the alteration was not noticeable on the surface. His tongue was as quick as usual, if not always so sharp. Someone described how a boatload of Egyptians was floating down the Nile with the thermometer at 120 degrees in the shade, and no shade. "And no thermometer", interjected Whistler. He did the cover for Charles Whibley's *A Book of Scoundrels*, his design being a mere scribble of a gallows; and when the publisher objected that the gallows looked rickety, he said "Strong enough to hang you on!" Sometimes his witticisms had a mellow note, as on the occasion of the death of the President of the Royal Academy, Lord Leighton. A group of English and American artists were discussing their late chief's versatility:

"Exquisite musician. Played the violin like a professional", said one of them.

"A brilliant speaker", said another.

"Amazing linguist", said a third.

"Superb essayist", said a fourth, and the rest chimed in:

"Charming host."

"Danced divinely."

"Dressed to perfection."

Whistler had been silent during the anthem; but while the rest were pausing to recall further qualities he made a small contribution:

"Painted, too, didn't he?"

His views were always surprising because he never followed the fashion, arriving at his decisions independently. He infuriated the admirers of Turner by saying that "he alone has dared to do what no artist would ever be fool enough to attempt", namely, paint the sun. But he could appreciate contemporary work when it revealed an artist who was thinking and feeling for himself. Of a woman's crude but imaginative picture, he said "She can't draw." After a pause he added: "She can't paint." Another pause and then: "But she doesn't need to." And at a moment when he could hardly speak for grief over the death of Puvis de Chavannes, he told a friend that there was a superb picture in the *Salon* by a young fellow named Brangwyn. In his opinion the great thing was to remain uncontaminated by "schools" of thought or painting or criticism, to be unpretentious and unaffected. Peter

Chalmers Mitchell once lured him into the National Gallery and
begged to be told what pictures he ought to admire and why.
"Ought to admire?" exclaimed Whistler. "There is no ought
about pictures. You either like them or don't like them—unless
you wish to be a fool of a critic and lose all sense of painting!"
He never became reconciled to the critics, of whom he remarked:
"*Ce que je dis ils ne comprennent pas, et ce qu'ils comprennent je n'ai
jamais dis.*" The middlemen, the tradesmen, the dealers, who
allowed artists to starve when alive and made fortunes out of them
when dead, who first 'cornered' a man's work and then created
a craze for it: of these he had a just contempt, saying of one: "He
knows a great deal more about my things than I do; but then he
doesn't know enough to know that everything he does know is
wrong."

The influence of Trixie had not softened his feelings towards
old enemies. For some months after her death he was not seen in
public, but towards the end of '96 he attended a dinner given by
the Society of Illustrators, of which he was a Vice-President. He
did not sit at the high table with the other officials, but among the
members with Heinemann and the Pennells. Another Vice-Presi-
dent, his brother-in-law Seymour Haden, was sitting on the
President's right hand, and when the soup was served Whistler
caught sight of him, letting out a shrill "Ha-ha!". Haden, who had
been unaware of his relation's presence, looked up, dropped his
soup-spoon, and fled. Worse was to come. Walter Sickert wrote
an article in the *Saturday Review* criticising an exhibition of litho-
graphs by J. Pennell. Sickert's view was that the lithographer
should work directly on the stone, which incidentally meant that,
unless he had a slave to superintend the transport of the stone, he
would have to go about with it in a wagon. The usual process was
to transfer the design made on lithographic paper to the stone,
which remained in the studio. The article implied dishonesty
in the exhibitor, and Pennell demanded an apology. The editor,
Frank Harris, stood by Sickert, declined to apologise, and both
of them were proceeded against by Pennell for libel. Whistler
at first did not wish to give evidence for the prosecution. He was
trying hard to paint; he was looking after a poor and dying artist,
C. E. Holloway, whose needs he provided; and he felt no desire
to take any part except a leading one in a public dispute. However
the Pennells persuaded him that the case was quite as much his as

theirs, and on April 5th, 1897, he was again seen in a witness-box, where he admitted that he also had made lithographs on paper. Asked if he were angry with Sickert, he expressed his disgust that "distinguished people like Mr Pennell and myself should be attacked by an unknown authority, an insignificant and irresponsible person."

"If Mr Sickert is insignificant and irresponsible, what harm can he do?" queried the defendant's counsel.

"Even a fool can do harm, and if any harm is done to Mr Pennell it is done to me. This is a question for all artists", and he described Sickert's flattery of his own work in the same article as "a most impertinent piece of insolence, tainted with a certain obsequious approach."

When it was suggested by defendant's counsel that Whistler was sharing the costs in the action, the prosecuting counsel, Sir Edward Clarke, wanted to know if there was any foundation for the question. "Only the lightness and delicacy of the counsel's suggestion", replied Whistler, who, at the close of the cross-examination, deliberately placed his hat on the rail of the witness-box, leisurely pulled off his gloves, carefully adjusted his monocle, and addressed the judge:

"And now, my Lord, may I tell you why we are all here?"

"No, Mr Whistler", said the judge with a smile. "We are all here because we cannot help it."

Pennell was awarded £50 damages, and it is improbable that a speech by Whistler would have influenced the jury to increase the sum.

He was ever prone to exposition, and it happened that his magisterial tendency was about to be encouraged by public recognition of his mastership. A number of young artists determined to put art on a cosmopolitan basis in Great Britain by holding an international exhibition of pictures, and early in '98 they founded the International Society of Sculptors, Painters and Gravers. Whistler was chosen as their President, and a prime mover in the enterprise, John Lavery, as their Vice-President. Lavery attributed his own appointment to the fact that he was always respectful to the Master, calling him "Sir" and "Mr Whistler", while others called him "Jimmy", rather to the annoyance of the President, who described familiarity as "the lowest form of intimacy." But Lavery took a risk in proposing that Walter Sickert should

be an original member of the Society. "What!" said Whistler; "my Walter, whom I put down for a minute and who ran off. Oh, no; not Walter", accompanying the words with a movement of his hand as if taking something from his breast pocket.

The Society rented Prince's Skating Rink in Knightsbridge from Admiral Maxse for their first exhibition in May '98. Maxse was a great admirer of Mrs Brown Potter, a famous American beauty of the time, whose portrait by Mortimer Menpes the Admiral wished to be prominently displayed. On hearing of this Whistler asked "Who is Menpes?" and said that he could not have bum-boats like that on the quarter-deck. The Admiral replied that Menpes was not a bum-boat but a first-class frigate that would be a great addition to the fleet. Whistler returned: "My dear Admiral, why not place your first-class frigate on rollers and run him round the rink in the season?"

The galleries were decorated in Whistlerian fashion; many foreign artists co-operated; and the exhibition was a success. The *Times* critic referred to "the vanished hand" which had painted the portrait of Miss Alexander, a remark that Whistler printed in the catalogue along with an earlier judgment by the *Times* on the same picture as "uncompromisingly vulgar", his comment being "Other times, other lines." The younger generation, in the person of Lavery, wanted to know how Whistler managed to hide the work he put into a picture. Fixing his eyeglass he went close to one of his paintings, scrutinised it with the utmost care, and then said: "You see, my dear Lavery, that's how we do it." Whistler remained President to the end of his life, taking a keen interest in the smallest detail of the Society's management, supporting its activities in every possible way, refusing to allow members of the Royal Academy to be members of the International, and compelling the Council to accept his ruling in everything.

Not content with running a Society whose members were approved by himself, he decided to start a Company whose membership was limited to himself. Dealers had made fortunes out of his work, and he saw no reason why he should not be his own dealer. "The Company of the Butterfly" was formed for this purpose at No. 2 Hinde Street, Manchester Square, and he believed that it would do a lively trade in "Whistlers". Unfortunately this did not prevent buyers from calling at his Fitzroy

Street studio, since they wished to conduct business with him instead of with a shopman whose ignorance necessitated the reference of every purchaser's proposal to the artist. He hoped that the Company in Hinde Street would reduce the company in Fitzroy Street; but he was disappointed; and when an offer was made at his studio he dealt with it briskly:

"How much for the whole lot, Mr Whistler?" asked a rich American collector.

"Five millions."

"What?"

"My posthumous prices. Good-morning."

The company floated along for two or three years, costing him much more money than he made out of it, and sank without a trace.

Meanwhile his energy had found another outlet in 1898. A one-time model of his named Carmen Rossi opened a school in the Passage Stanislas, a turning off the Rue Notre-Dame-des-Champs, and it was announced that Whistler would attend twice a week to instruct the pupils. It was called the *Académie Carmen*, and F. MacMonnies, the sculptor, was to be the other visiting professor. By that time Whistler's name was enough to ensure the success, at least the early success, of the undertaking. The younger artists regarded him with reverence as a famous rebel who had been victorious in the fight against conventions and as a great Master in his own right. He inspired the prescriptive veneration of a myth no less than the personal allegiance of a man. Consequently the Academy was thronged when he first appeared. Knowing the effect of suspense, he waited a week before showing himself to the students, who by then were almost fainting from postponed excitement. Then, dressed up for the part, he made an actor's entrance in a deathly hush. He was so different from all the other teachers they had known, so amusing, so courteous, so quaint, that they were fascinated and would have painted head downwards with brush in mouth if he had said that such was the correct procedure. He emphasised the necessity of being familiar with the precise position of the colours on their palettes, so that they could paint in the dark if need were: the palette, not the canvas, was the field of experiment: and he advised one student to clean her palette so that he could show them "the easiest way of getting into difficulties." He told them that "the power of the

great artists was that they could go on indefinitely building on what they had done, but the modern artist dreads to add another touch for fear of concealing the cleverness of the touches that preceded. His friends stand about him saying 'For the Lord's sake don't touch it; you might spoil it!'"

The young female students adored him, because he took pains to help them and made them feel easy. One day three fresh pupils were encouraged in this manner:

"Where have you studied?"

"With Chase."

"Couldn't have done better. And where have you studied?"

"With Bonnat."

"Couldn't have done better. And where have you studied?"

"I have never studied anywhere, Mr Whistler."

"Couldn't have done better."

In a different mood he paused at the easel of another pupil, looked at her work in profound silence, finally put in his eyeglass and turned to her:

"From New York?"

"Yes."

"Pupil of Chase?"

"Yes."

"Um-m! I thought so. Why did you paint a red elbow with green shadows?"

"I am sure I just paint what I see."

"Ah! but the shock will come when you see what you paint."

Once he tried to obtain a certain effect on a student's canvas, but it would not come right. At last he said to the class "I suppose you all know what I am trying to do?" A chorus of "Oh, yes, sir!" "Well, it's more than I know myself." As usual his kindness was manifest. Discovering that a certain pupil was too poor to dress and feed herself properly, he gave Carmen the money to supply her needs.

But the male students were not so well disposed towards the Master, who introduced certain puritanical restrictions which they regarded with disfavour. Studies of the nude in mixed classes were not permitted; singing and talking were disallowed; charcoal drawings on the walls were frowned upon; he was to be treated as a Master, not as a companion in shirt-sleeves; and, worst of all, the sexes were to be formed into different classes,

men apart from women. Smoking, too, was prohibited, and a fellow who ignored the rule was remonstrated with: "Er—my dear sir—I know you do not smoke to show disrespect to my request that the students should refrain from smoking on the days I come to them; nor would you desire to infringe upon the rules of the *atelier;* but—er—it seems to me—er—that when you are painting—er—you might possibly become so absorbed in your work as to—er—well—let your cigar go out." Another young man whose superior manner did not recommend him to the Master was catechised in these terms:

"Been to College?"

"Yes."

"I suppose you shoot?"

"Yes."

"Fish?"

"Yes."

"Play football?"

"Yes."

"Then I can let you off painting."

All things considered it is hardly surprising that the men's class dwindled, and died in two years. Indeed his constant absences from ill-health and other causes reduced the *Académie Carmen* by the beginning of 1901 to two pupils, both of whom showed so much promise that he revived the ancient "Deed of Apprenticeship" whereby they were bound to their Master "to learn the Art and Craft of a painter, faithfully to serve after the manner of an Apprentice for the full term of five years, his secrets keep and his lawful commands obey", etc. This appealed to his romantic sense, to his feeling of fitness in the old-fashioned association of Master and Apprentice; but chiefly to his sense of power, his need of disciples, his magisterial passion, and the craving of his nation-starved nature for a defined relationship, for something immutable.

CHAPTER XIV

Mortal

IN the winter of '97-8 Whistler began to get nervous about the state of his health. A bout of 'flu left him languid and he perceived to his distress that his capacity and will to work had temporarily deserted him. His heart had always been weak, but up to now he had fought against illness, which reminded him of death, and he dreaded extinction as only an extreme egotist can. To comfort himself he took to "Spiritualism" and his faith in a future life was fortified by table-rapping and such-like materialistic phenomena. It does not seem to have struck him that, since the Spirit of God is manifested through the medium of man, a glance at one of his own Nocturnes would have been more reassuring. Though by nature abstemious, he took no precautions against illness, and when someone dilated on the benefits of vegetarianism he refused to pursue the subject: "Well, you know, when you begin to talk about the stomach and its juices, it's time to stop dining." He went on steadily climbing the six flights to his studio in the Rue Notre-Dame-des-Champs, and a friend, noting that he almost collapsed on reaching the top, made a suggestion: "Why don't you have a studio on the ground floor?" He replied: "When I die I will." Pestered with visitors even here, he usually refused to answer a knock at the door. But once, expecting someone else, he opened it to an acquaintance who had brought a titled tuft-hunter. "Ah, my dear Whistler, I have taken the liberty of bringing Lady D—— to see you. I knew you would be delighted." His dear Whistler was equal to the occasion: "Delighted, I'm sure! quite beyond expression; but" (he lowered his voice and half closed the door) "my dear Lady, I would never forgive our friend for bringing you up six flights of stairs on so hot a day to visit a studio at one of these—eh—pagan moments when" (he glanced slily behind him and almost closed

174

the door) "when it is absolutely impossible for a lady to be
received. Upon my soul, I should never forgive him." He shut
the door and went on with the portrait of an old gentleman who
was sitting for him. At the Hôtel Chatham, where he was staying,
he had to dodge the people who were waiting to see him. One
day he dashed upstairs followed by the cards of several folk who
had caught sight of him. "I knew it!" he cried: "the damned Pea-
Shooters asking me to dinner, thinking they can eat their way in!"

He was famous in two hemispheres at the close of the century,
and the American Commissioner at the 1900 Universal Exhibition
in Paris, John M. Cauldwell, treated him with extreme deference,
after a faulty start. Cauldwell asked him to call on a particular
date at 4.30 sharp. He replied that he had never managed to be
anywhere at 4.30 sharp. The Commissioner adjusted his engage-
ments to the less rigid time-table of the artist, and Whistler's
exhibits won a *Grand Prix* both for painting and etching. He was
prospering financially too, and living at a high rate of expen-
diture. In 1900 he had rooms at the Hôtel Chatham in Paris,
Garlant's Hotel in London, studios in both cities, as well as the
apartments in the Rue du Bac and the offices of his "Company"
in Hinde Street. He also discovered that he had £6000 in his bank.

His friend Heinemann married early in '99, and the flat in
Whitehall Court was no longer his home. He acted as best man
at the wedding, which took place in Italy, and he paid his one
visit to Rome, which he likened to an old ruin by the side of a
railway station. The sun glared, the wind blew, and the sky was
hard. St Peter's impressed him, and suggested one of his silliest
sayings: that Christopher Wren had "robbed Peter's to build
Paul's"; but he thought that Michael Angelo, though "a tremen-
dous fellow", lacked repose. The Swiss Guards at the Vatican
reminded him of the Three Musketeers in Dumas. Heinemann's
marriage was not a success, and he obtained a divorce some three
years later. It grieved him that Whistler did not write a word
of sympathy when this happened, and he mentioned the omission
to a friend, who passed it on. "Please tell Heinemann from me that
if it had been the *right thing* to express sympathy on such an occa-
sion, I should of course have done so", said the ex-cadet of West
Point. But the right thing for Whistler was the wrong thing for
Heinemann, who once invited a party to hear a young Danish
'cellist at his house. The moment the youth started to play,

Whistler started to talk. Heinemann tried to hush him, but without effect, and the unfortunate 'cellist played his piece to the accompaniment of Whistler's loud voice and the laughter of a girl whom he was amusing. Yet, after his divorce, Heinemann again offered to share a flat with Whistler, who would have done so had it not been that

> this fell sergeant, death,
> Is strict in his arrest.

In the last seven years of his life most of Whistler's time was divided between London and Paris; but occasionally he went to Holland, and sometimes spent a few weeks at Dieppe, where Sickert saw him in the late nineties, looking very well and dignified, though forbidden by the doctor to paint out of doors. "Poor old Jimmy! It was all such fun 20 years ago", lamented Sickert. But perhaps the serious ex-disciple was more to be pitied than the funny ex-master, for ten years later Sickert was telling Robert Ross that he violently disliked the writings of Oscar Wilde "because they have always . . . seemed to me a sort of glorification of nonsense. The English tendency is already so prone to flippancy, that I am 'agin' anything that seems to me to nourish it." He need not have worried, for the deplorably flippant nation was soon to save civilisation from the earnest Germans in two wars. Wilde and Whistler were to meet once more, at the door of a Paris restaurant, one entering, the other emerging. Wilde, now a social outcast, had recently been in prison; and if their positions had been reversed, he would have greeted Whistler warmly. One might have thought that Whistler's anglophobia would have favourably disposed him towards Wilde, but he stared unflinchingly at his old enemy and passed by. "My sentence and imprisonment raised Jimmy's opinion of England and the English", explained Wilde. "Nothing else could have done so. Perhaps he is now a pro-Boer on account of my release."[1]

The South African War had in fact given Whistler a splendid opportunity to gird at the British, whose generals in that campaign were not among the major strategists of history. The Spanish-American conflict, just concluded, had of course been "a wonderful and beautiful war" because fought on correct West Point principles. But the blunders of the British and the bravery

[1] Personal information from Robert Harborough Sherard.

of the Boers in South Africa were themes on which he dilated with all the enthusiasm of a man who has never seen a battlefield. He carried newspaper cuttings with him wherever he went, pulled them out on the slightest pretext, or on none at all, and joyfully read the nice bits about the Boers and the nasty bits about the British. He wearied people with his anti-English diatribes. "Oh, be reasonable!" urged a friend. "Why should I?" was the response. In his opinion the Colonial Secretary, Joseph Chamberlain, was corrupt, the English generals were incompetent, the English soldiers were cowardly. He revelled in British disasters and ridiculed the excuses for them. His criticisms had the virulence and persistence that might be expected from one whose sole experience of active service was to lead a cavalry charge out of danger. But sometimes he was amusing, as when he said that Buller had been made commander-in-chief partly because he was beefy and partly because, finding no general under the letter 'A' who was not an octogenarian, the War Office had discovered him under 'B.' Someone excused Buller by saying that he had retired from a certain engagement without losing a man or a flag or a gun—"or a minute" added Whistler. Breakfasting at Heinemann's an English guest happened to remark "The trouble is we're too honest; we've always been stupidly honest." Whistler addressed a German who was present: "You see, it is now historically acknowledged that whenever there has been honesty in this country, there has been stupidity." Inefficiency, however, had its advantages, and he suggested that D. S. MacColl, art critic of the *Saturday Review*, should be put in the infantry, so that he could be marched into one of the Boer traps for the British and be shot, "that we hear him and read him no more."

Whistler regretted that the United States did not fight with the Boers as an act of courtesy; but when in 1900 America joined with the other powers to suppress the Boxer Rising in China, he took a different view. The movement, partly religious, partly political, was directed against foreign influence, and began with a massacre of missionaries. Whistler thought it preposterous that the western powers should force their beliefs on a people whose religion was incomparably older than Christianity, and that one of the most polite nations in the world should be invaded by a horde of impolite soldiers, who would destroy a lot of exquisite blue and white porcelain. On reading that Pekin was under siege, he

exclaimed: "Dear, dear! I hope they will save the palace. All the Englishmen in the world are not worth one blue China vase." And the report that a number of ministers had been murdered drew from him: "Well, it is the Chinese way of doing things and there is no redress. Better to lose whole armies of Europeans than harm one blue pot!" While holding forth on the subject at a dinner-party, one of those present objected that the development of art in a country was a sign of decadence. "I don't know", said he; "a good many countries manage to go to the dogs without it."

That he did not mellow with age is shown by his statement about a casual acquaintance: "I do not know him well enough to avoid him." Some of his characteristics seemed to harden with the years. Charles Conder met him in Paris and stopped to speak, but he gazed blankly. Conder mentioned where they had met before and gave his name. "Conder! Of course! Good-bye, Conder!" and Whistler walked on. While staying with the Heinemanns at their house in Norfolk Street, Mayfair, he made no attempt to conciliate Sir Walter Armstrong, the art critic who had become director of the Irish National Gallery. Armstrong uttered the usual string of platitudes expected of him, in the course of which he said that there never was such a thing as an artistic people or period. "Dear me!" interrupted Whistler; "it's very flattering to find that I have made you see it at last; but really, you know, I think I shall have to copyright my little things after this!" Armstrong boiled with rage: "Oh, you mean it one way, and I quite another!" Whistler did not trouble to ask precisely how Armstrong meant it. He was getting too tired to say over again what he had been saying all his life; though he was never exhausted enough to forget his animosity against the official big-wigs of art:

"Who is Sir William Robinson?" asked a companion in Holland.

"Oh, well, this man, you know, is the individual who walked into the South Kensington Museum by one door, swept the floors, and came out a knight at the other end."

"As in our country a pig is put into a machine one end and comes out a toothbrush at the other", remarked an American.

"In this case, it was just the reverse", said Whistler, "for this man went in a toothbrush and came out a pig."

Notwithstanding these somewhat unsociable incidents, it should be said that nearly everyone enjoyed his company when he was feeling well; he remained gay and amusing and courtly, and could enjoy a joke against himself if the joker were intelligent. Mark Twain visited his studio, pretended to be completely ignorant of art, and commented on an almost finished painting: "Not at all bad, Mr Whistler, not at all bad. Only here in the corner, if I were you, I'd do away with that cloud", and he made as if to rub it out.

"Gad, sir!" cried Whistler in horror: "do be careful there! Don't you see the paint is not yet dry?"

"Oh, don't mind that!" said the amiable Mark. "I'm wearing gloves, you see."

After which they got on splendidly, and Mark Twain was charmed by his manners, which may have been put on for the occasion but were not the worse for that. An Italian lady once criticised the manners of the Latin peoples as being all on the surface. "Well, you know, a very good place to have them", said Whistler, whose appearance remained as singular as his manners were ceremonious. The arrangement and luxuriance of his hair, and the combination of white duck trousers with a dinner-jacket and straw hat, an attire he often affected in the summer evenings, made him look rather like a music-hall artist; and it is not surprising that a waiter at the Cavour restaurant in Leicester Square showed a disinclination to accept his signature on the bill in lieu of cash payment. Whistler disclosed his identity. "But I don't know you", said the waiter. Up went the monocle: "Dear me! You must be an R.A." J. Boldini painted him at this period, and the result shows everything that was unpleasant in his character, the pose, the defiance, the harshness. "Well, they tell me it is very like me, but, thank God, I am not like it", he said. It was the outward aspect of him, the posture he imposed on the world, the actor who at last resembled the part he had been playing, and who maintained it by colouring his cheeks, dressing in a manner that accentuated his slender build, and telling people, when past his sixty-sixth year, that he was fifty-eight, or possibly fifty-nine.

But there was another side of his nature, glimpsed occasionally by friends when off his guard, and revealed in his later choice of subjects, mostly girls whose grave faces display his love of mystery,

his delight in innocence, and his final surrender to the dream-world of his desire. There were times too when the mask slipped and those most intimate with him discerned, beneath the brilliant artificial exterior, a pathetic child who longed for a home and the comfort of an understanding mother. There were other times, when, after an evening spent in talking loudly and conceitedly of himself and his achievements, a friend would find him stooping over a copper-plate, a spectacled old man, working patiently for hours, his whole being possessed by a fanatical urge towards perfection. And there were times when he felt uncertain of himself, and suffered from a sense of failure. William Rothenstein caught him at one such moment. It was night-time in his Paris studio, and he was inspecting his pictures with the aid of a light, peering closely at them. "There was something tragic, almost frightening, as I stood and waited, in watching Whistler; he looked suddenly old, as he held the candle with trembling hands, and stared at his work, while our shapes threw restless, fantastic shadows all around us."

Many people have wondered why such an individual artist and exquisite craftsman did not leave his mark on the theatre of his time. Here surely was a man who had been born to paint the scenery and design the costumes for a play with an eastern setting. But instead of engaging the creator of the Peacock Room, the actor-managers chose Alma-Tadema for their more ambitious productions. Perhaps they feared that if Whistler were brought in they would never get him out again. One of them, the most original and daring, did make a tentative approach, and the episode is here recorded for the first time.[1] The proprietor of Her Majesty's Theatre in the Haymarket was Herbert Beerbohm Tree, for whom the theatre had been built in 1896–7. It seems that Whistler went to see Tree's production of Shakespeare's *King John*, because when they met in the autumn of '99 the painter was uncomplimentary:

"That scenery! There was so much of it that I had to turn my eyes away. Even then I could smell the paint from the sixth row of the stalls. Tell me, now, in confidence: does Mr Thingummy paint with the pot or with the brush. There are two schools. One uses the pot, the other the brush; one daubs, the other dabs . . ."

[1] All the details that follow were given by Tree to his chief scenic artist, Joseph Harker, from whom the writer heard them.

"Well, well; very funny; yes. But what did you think of the performance?"

"Oh, good enough! Not at all bad; sufficient for the purpose, if one must have Shakespeare at all, eh? But he's often funny without meaning to be. That bit about 'Come the three corners of the world in arms and we shall shock them'—oh, you'll shock 'em all right! You've shocked me for forty years. 'If England to itself do rest but true.' A dreadful thought! An endless vista of dullness and stupidity. If only England could be untrue to her usual form, there'd be some hope for her, what?"

An unpropitious opening: but Tree never minded a little out-burst of nonsense and frequently indulged his own inclination for it. He now informed Whistler that he intended to produce a play by Stephen Phillips on Herod, the scene of which was to be laid in the hall of that monarch's palace, with a view of Jerusalem through a colonnade at the back, and he wondered whether the artist would care to paint it. Whistler expressed pleasure and talked excitedly about the colour-scheme, the dresses, etc. Suddenly he paused, looked very solemn, and announced that he would paint a large picture on one of the walls. Tree demurred that Herod could hardly have engaged Whistler to paint a picture for him; the dates were a little . . . "If he had the good taste to have his hall decorated by me, he would surely wish to beautify it with one of my masterpieces", said the anachronist. Tree tried to explain the difference between the decoration for an appropriate setting in the first century and an original picture by an artist of the nineteenth century. Whistler listened attentively, was obviously convinced, and said "You are right. It would be a mistake." Tree gave a sigh of relief. "If one of my pictures were on the wall, no one would look at the actors", continued Whistler thoughtfully. Tree feebly protested. "There should be *two* of my pictures, one on the right wall, the other on the left. Then no one would listen to the play." Tree gave it up.

Perhaps it was as well that nothing came of this proposal, for the artist would not have made a good job of it in 1900. His health was bad and his zest for work had seriously diminished. In February his brother Willie's death grieved him deeply, and for a while he lost grip of things. The fact that he appointed the Pennells as his official biographers in the spring of that year shows that his interest in life was beginning to wane. In 1896 he had

started an autobiography with these words: "Determined that no mendacious scamp shall tell the foolish truths about me when centuries have gone by, and anxiety no longer pulls at the pen of the 'pupil' who would sell the soul of his master, I now proceed to take the wind out of such speculator by immediately furnishing myself the fiction of my own biography, which shall remain, and is the story of my life . . ." Though he once complained that "the one thing occurring in my daily life I cannot be responsible for is the daily story about me", it is clear from the foregoing that he would have invented a quantity of daily stories if he had persisted with "the fiction" of his life. Fortunately he resigned the task to the Pennells, who did it remarkably well considering their hero-worship of him, and Mrs Pennell started a diary in which his sayings and reminiscences were thenceforth noted down.

His normal enjoyment of existence left him in 1900. Asked if he had eaten enough at dinner, he replied wearily "Well, you know, I have already had too much, and too much is enough." In the summer he could not make up his mind whether to visit Holland or Ireland. "I wish there was someone just to take hold of me and tell me what to do and get me ready to do it." He compromised by going to both. First he took a house called "Craigie" at Sutton, about six miles from Dublin, on the stretch of sand between the Hill of Howth and the mainland. Having sent Mrs and Miss Philip there, he changed his mind and left for Holland, spent a week at Domburg on the coast, and then joined the Philips at Sutton, which he soon quitted because of the bad weather and the situation of the house on the wrong side of the bay. In any case he disliked all landscapes except those of London and Holland.

Many little things were beginning to vex him. He tried to take legal action against a woman who shook her carpets into his garden from the first-floor in the Rue du Bac; but the only result was that the woman proceeded against him for keeping a carpet that had fallen from her window. Though he was not living in the Rue du Bac, the Philips were, and it remained his official home. One day in the Arts Club he was asked by a member if he would meet a young fellow who admired his work enormously. "He wants to be an artist", said the member. "Poor devil!" said Whistler, moving away. He expressed a strong wish that none of his pictures should remain in any of the English national collections, for though he loved London more than any place on

earth his anger with its inhabitants was never appeased, and every Londoner in his eyes was a potential critic. He still worked hard if well enough, and the Pennells relate how one afternoon in the summer of 1900 he was at his easel in the Fitzroy Street studio when tea was brought up. "We must have tea at once before it gets cold", he said and continued to paint. Ten minutes later: "We must have tea at once." Half an hour went by: "Come! Tea! Why are we waiting?" He put down his brush, gazed at his work for another ten minutes, and then said "Now for tea!" By November the doctor pronounced his general health as low in tone, which the patient attributed to living so long in the midst of English pictures, and advised him to take a sea-trip, spending the winter in Tangier. His friends noticed that he sometimes fell asleep over dinner and begged him to go for a holiday.

He started for the south in the middle of December, feeling lost away from London, and hating the wind and rain and sky and sea at Tangier and Algiers. After a fortnight's illness at Marseilles, he gradually recovered from the effect of visiting health-resorts, and went to Ajaccio in Corsica, from which he wrote to a friend: "You will be surprised at this present address. But it's all right— Napoleon and I, you know." The weather was bad, and he was confined to the Hotel Schweizerhof, feeling dreadfully lonely; but Heinemann released him from solitude, spent some days with him, and taught him to play dominoes, which he did frequently for the rest of his life, openly cheating and taking a childish delight in winning. The trouble was that he could not rest, could not do nothing. Because he had never wasted time, he found that time had wasted him; and when an acquaintance drew his attention to the fact that he was a bundle of nerves, he tried hard to forget his occupations and preoccupations, even going so far as to advise an American public man to do nothing further on his behalf, as "you cannot serve the republic . . . and Whistler." Then, driving everything to the back of his mind, he sat in the sun and slept, the treatment doing him so much good that he returned to London in May 1901 in a cheerful mood, worked again in his studio, and renewed his interest in the Boer War, or rather in the Boer General De Wet, who was keeping up the good old game of making the British army look ridiculous. Another figure in European politics seemed to be as anti-British as Whistler, who however dismissed the German Kaiser as an anachronism: "Emperors are

absurd now. It was all very well when they could say: Cut off this man's head or that man's head, and it was done at once; or as they can now if they happen to be Emperor of China or Russia. But for the others it is nonsense." Nevertheless the impotent Wilhelm II managed to cause more slaughter than any monarch in history.

Throughout the summer Whistler's health remained good; but in October he decided to get rid of his apartment and studio in Paris, and went there for the purpose, driving about from place to place because he could not walk in his tight little shoes, and refusing to see anyone when not feeling well except the American millionaire Vanderbilt, a potential purchaser of pictures. Back in London he moved into Tallant's Hotel, North Audley Street, the landlady of which assured him that she entertained royalty and the nobility. Showing him into a bedroom, she recommended it: "In this room, sir, Lord Ralph Kerr died." He was not impressed: "What I want is a room to live in." He did not stay there long, and December found him in Bath for the winter, whence he made several excursions to London. In March 1902 he returned to Tite Street, Chelsea, and lived with the Philips, who apparently did not care for his friends, because no one was allowed to visit him there. He also could not unburden himself on the subject of the Boers in the company of his mother-in-law and sister-in-law, so he arranged a clandestine meeting with Professor Sauter, secretary of the International Society, who sympathised with his views, and they had a glorious interchange of anti-British sentiments.

The seclusion of Tite Street preyed upon his mind, and in April he took his last house, No. 74 Cheyne Walk, not far from the one he had first occupied in London. Its front door was of beaten copper, and this, with the other decorations, made him call the place "a successful example of the disastrous effect of art upon the British middle classes." The owner was an architect and designer named C. R. Ashbee, who, Whistler complained, had been designing enough first to let the house and then to start building operations next door. The continual sound of hammering drove the new tenant to distraction, and he instructed his solicitor to set the law in motion.

In May a distinguished Frenchman breakfasted with him: Auguste Rodin, who was to be, after his death, the second Presi-

dent of the International Society of Sculptors, Painters and
Gravers. Having carefully hidden as much of his work as possible,
and stacked his pictures against the wall back to front, Whistler
was rather hurt because Rodin did not ask to see anything—"not
that I wanted to show anything to Rodin, I needn't tell you, but
in a man so distinguished it seemed a want of, well, what West
Point would have demanded under the circumstances."

Informed by his solicitor that the law could not interfere with
house-construction, and unable to endure the perpetual noise of
knocking, he went in June 1902 for peace and quiet to Holland,
the doctor having warned him that agitation would weaken his
heart. His companion was Charles L. Freer, who in due course
gave his collection of "Whistlers," the biggest in the world, to the
National Gallery at Washington. They stayed in the Hôtel des
Indes at The Hague, and here Whistler became so ill that no one
thought he could live. Freer, Heinemann and the Philips in turn
looked after him, and the hotel staff did everything in their
power. A rumour that he was dying reached the London *Morning
Post*, which published an article that read like an obituary. But
he recovered slowly, saw the article, and on August 3rd wrote a
letter which appeared in the paper on the 6th. It was phrased in
the stylish if stagnant manner peculiar to him, and must be
quoted here as the last and most typical sample of his prose:

"I feel it no indiscretion to speak of my 'convalescence', since
you have given it official existence.

"May I therefore acknowledge the tender little glow of health
induced by reading, as I sat here in the morning sun, the flattering
attention paid me by your gentleman of the ready wreath and
quick biography!

"I cannot, as I look at my improving self with daily satisfaction,
really believe it all—still it has helped to do me good! and it is
with almost sorrow that I must beg you, perhaps, to put back into
its pigeon-hole, for later on, this present summary, and replace it
with something preparatory—which doubtless you have also
ready. . . .

"It is my marvellous privilege, then, to come back, as who
should say, while the air is still warm with appreciation, affection,
and regret, and to learn in how little I had offended!

"The continuing to wear my own hair and eyebrows, after

distinguished *confrères* and eminent persons had long ceased their habit, has, I gather, clearly given pain. This, I see, is much remarked on. It is even found inconsiderate and unseemly in me, as hinting at affectation.

"I might beg you, sir, to find a pretty place for this, that I would make my apology, containing also promise, in years to come, to lose these outer signs of vexing presumption.

"Protesting, with full enjoyment of its unmerited eulogy, against your premature tablet, I ask you again to contradict it, and appeal to your own sense of kind sympathy when I tell you I learn that I have, lurking in London, still 'a friend'—though for the life of me I cannot remember his name."

When he was well enough he went into rooms near the hotel, and several Dutch artists called to pay their respects, one of whom described him as "*tout a fait charmant entre camarades*", as gentle, amiable, enthusiastic and unpretentious. Among the first things he did was to leave cards on the Boer Generals, who were being honoured at The Hague. Professor Sauter and his wife called, and the three of them visited the Haarlem Gallery to see the Franz Hals collection of portraits. Whistler forgot all about his health in his joy over Hals, of whose methods and subjects he talked with rapture. In his excitement he crept under the railing and got close to a picture, but was ordered by an attendant to creep back again. With the departure of the other visitors permission to view the pictures from within the railing was granted by the chief attendant, who knew all about "the great painter" Whistler, and they were given the freedom of the gallery. He mounted a chair and went into ecstasies. "Look at it—just look; look at the beautiful colour—the flesh—look at the white—that black—look how those ribbons are put in. Oh, what a swell he was!—can you see it all?—and the character—how he realised it!" His hands seemed to caress the pictures, and at one moment he cried with exultation "Oh, I must touch it—just for the fun of the thing", while his fingers strayed tenderly over the face of an old woman. He remembered that Hals had been described by some people as a drunkard, a coarse fellow, and he spoke with angry contempt: "Don't you believe it! *They* are the coarse fellows! Just imagine a drunkard doing these beautiful things!" He confessed that he, like Hals, would like to develop as a painter, progressing steadily

to the end, and added: "Oh, I would have done anything for my art!" The emotional disturbance caused by seeing these works once more was too much for him, and the Sauters were relieved when they got him into a carriage, happy but exhausted.

He returned to London in September, but not to peace. The next-door knocking continued. The stairs were too much for him, and he now slept in a small ground-floor room looking on to the street. His clothes were a sign of his health, for he wore a shabby brown fur-lined overcoat indoors instead of a dressing gown, and this was buttoned over a white silk night-shirt, black trousers and short black coat. As usual the place was uncomfortable, but he did not seem to care. "The ladies", as he called his late wife's mother and sister, were often with him, and conversation in their presence was strained, as so many things could not be discussed before them. Much of his time was spent dozing in an easy chair; he could not sleep at night, and consequently became semi-conscious at odd moments in the daytime, occasionally dropping his head on the table during meals and remaining in that position for an hour or so. He owned and adored a little cat, coloured brown and white and gold, keeping it supplied with fresh milk and letting it sleep on his lap. When it had kittens, they ran wild over the studio and he enjoyed watching their antics. His hair had been allowed to go flat on his head, which made his face look small and thin. He did not welcome any visitor who had recently been ill, saying "What if there are microbes hanging about him? I can't have any more microbes—I have had enough of them." Once, when John Lavery helped him to bed during a heart-attack, he said "I don't like this at all, Lavery, not at all."

He rarely went out in the last months of his life, and then usually for a carriage-drive. Very seldom was he seen on foot, a shadow walking among shades. But there were moments of resurgence when his heart gave him breathing-time and he could again take up the brush. One of his last sitters was a lovely Irish girl named Dorothy Seton, whose abundant red hair must frequently have recalled Jo and Maud to his memory. He worked as always with limitless patience and untiring concentration, sometimes delighted, sometimes dejected. Once, unable to obtain some effect, he walked across the floor exclaiming: "You cannot do it— your day is done!" Then he pulled himself up, said with determination "You can do it—you must do it as long as you live",

and returned to the easel. Seeing the girl's surprised face, he patted her on the head: "Take no notice of me, child; I am growing an old man, and getting into a habit of talking to myself." That evening he worked longer than usual. After innumerable attempts, including many failures and gleams of success, *Daughter of Eve* was completed one morning in a couple of hours. But in this last year of life he destroyed far more pictures than he painted, many that came from his Paris studio being burnt: "To destroy is to exist, you know."

He would not have been himself if another form of destruction had not appealed to him, although he knew that he was in the waiting-room of death. One of his later pictures was being exhibited, and Wedmore, the object of much past pleasantry, had implied that it was not a recent work. At the end of 1902 Whistler wrote to the *Standard* describing Wedmore as Podsnap, and was so elated by his contribution that he wanted to publish the full story in a pamphlet. Graham Robertson called just after he had completed his letter, and of course was compelled to hear it read aloud. "Well? Eh? Well? How's that, d'you think?" Whistler chortled. Robertson thought it involved, laboured, and too long, and might have said so if Miss Philip had not whispered: "Don't tell him *now* if you don't like it. He has been over it all the morning and he's so tired." Soon he was too tired to see his projected pamphlet through the press, too tired to paint, too tired to do anything but play a game of dominoes. Once or twice his high spirits returned. He took a keen interest in the annual dinner of the International Society, of which he was still President, and though he could not attend it he gave advice about the menu and actually sent instructions concerning the preparation of the salad. "Was that your note about the International Dinner in this morning's *Chronicle*?" he asked Mrs Pennell the day after it had been held. "Yes." "How could you make no reference to the President's absence, the one fact of importance?"

Another bright moment occurred when the art critic D. S. MacColl wrote to ask if he might call to discuss a matter of importance. Whistler naturally assumed that the subject would be closely connected with art, anticipated an amusing interview, and asked him to lunch one Sunday. On arrival MacColl was shown into the drawing-room upstairs and handed a copy of *Reynold's*, a radical newspaper much enjoyed by Whistler on account of its

abuse of British imperialism. When after an interval MacColl
descended to the studio, he found Whistler in the best of spirits,
the reason for which was quickly apparent: "Well, I hope you
have been enjoying *Reynold's*? You know that it is the paper
you long to read at the Club but are ashamed to be seen with!"
All through lunch the Master carefully avoided the subject of art,
thinking his guest was bursting to mention it, and talked of noth-
ing but West Point. At length MacColl managed to get a word
in and explained the matter of importance that had brought him
there: Would Whistler accept an honorary degree from the
University of Glasgow? Whistler instantly stopped fooling and
expressed his sincere appreciation of the offer. It appeared that
MacColl had been asked to sound him by the two men chiefly
responsible for the gesture: Sir James Guthrie, President of the
Royal Scottish Academy, and Professor Walter Raleigh. After
the official announcement was made in March 1903 that the degree
of LL.D. had been conferred on Whistler, his letter of acknow-
ledgment was composed with the habitual expenditure of mental
toil to get the telling word and the striking phrase. As usual, the
distinction had been awarded to a deserving man who, if not
dead, was not really alive.

Somehow he survived the winter, and his friends were hopeful
that his health would improve with the weather; but as the spring
of 1903 changed into summer they knew that the end was not
far off. He spoke little, dozed much, and his eyes lost their
sparæle. He wanted people to come and see him, but when they
came he could not speak to them. He hated to be left alone, yet
he was almost unaware of those in the room. "You are not
going to leave me, Bunny", he once said to his sister-in-law Mrs
Whibley. "Must you really go away today?" Mrs Pennell called
on July 1st and found him in a state of stupor; he spoke twice with
difficulty, and seeing how ill he was she refused Miss Philip's offer
of tea. "No wonder you go from a house where they don't give
you anything to eat", he said as she left. On the 6th she saw him
out of bed and dressed; but though he had been for a drive, he
scarcely seemed conscious of his surroundings. On the 14th he
was a little better, though his face had shrunk and his eyes were
lifeless. "I only wish I felt as well as you look", he said to her.
A cup of chicken broth was brought for him. "Take the damned
thing away!" he cried, and at once apologised charmingly for the

fretful outburst, explaining that he would have no appetite for dinner if he obeyed the doctor's order to eat something every half-hour. On the 16th he went out for a drive, and was so much more animated than usual that Mrs Whibley jokingly said he would soon be dressing again for dinner.

But it was the flash of light heralding the final darkness. He died on the afternoon of Friday the 17th July, 1903, within sight of the Thames, "the place where I also at last hope to be hidden, for in no other would I be." Both his sisters-in-law were present, and to one of them it appeared that, just before the end, he could see something which the living could not see. But he had always seen something that others could not see until he revealed it; and his last vision may have been of his beloved river, from which he had long ago watched the lights of Cremorne, and painted his paradise in silver and blue.

AUTHORITIES

(Selected)

The Gentle Art of Making Enemies, by J. McNeill Whistler, third edition, 1904.

The Life of James McNeill Whistler, by E. R. and J. Pennell, fifth revised edition, 1911.

The Whistler Journal, by E. R. and J. Pennell, 1921.

Whistler: the Friend, by Elizabeth Robins Pennell, 1930.

Whistler, by James Laver, second edition, 1951.

Whistler, as I Knew Him, by Mortimer Menpes, 1904.

Recollections and Impressions of James A. McNeill Whistler, by Arthur Jerome Eddy, 1903.

Whistler Stories, collected and arranged by Don C. Seitz, 1913.

Whistler, by Haldane Macfall, 1905.

With Whistler in Venice, by Otto H. Bacher, 1908.

Memories of James McNeill Whistler, by T. R. Way, 1912.

James McNeill Whistler, by W. G. Bowdoin, 1902.

James McNeill Whistler, by Frank Rutter, 1911.

The Baronet and The Butterfly, by J. McNeill Whistler, 1899.

Thomas Armstrong C.B., A Memoir, edited by L. M. Lamont, 1912.

Murray Marks and his Friends, by Dr G. C. Williamson, 1919.

An Artist's Life in London and Paris, by A. Ludovici, 1926.

Time Was, by W. Graham Robertson, fifth impression, 1938.

The Young George Du Maurier: a Selection of Letters, 1860–7, edited by Daphne Du Maurier, 1951.

The Life and Letters of Joseph Pennell, by Elizabeth Robins Pennell, 2 vols., 1930.

Men and Memories, Recollections of William Rothenstein (1872–1900), 1931.

With Brush and Pencil, by G. P. Jacomb-Hood, 1925.

From Toulouse-Lautrec to Rodin, by Arthur Symons, 1929.

The Life and Opinions of Walter Richard Sickert, by Robert Emmons, 1941.

The Life of a Painter, by John Lavery, 1940.
The Tribulations of a Baronet, by Timothy Eden, 1933.
The Conscious Stone: The Life of Edward William Godwin, by Dudley Harbron, 1949.
The Pre-Raphaelite Tragedy, by William Gaunt, 1942.
The Aesthetic Adventure, by William Gaunt, 1945.
Some Reminiscences of William Michael Rossetti, 2 vols., 1906.
William Heinemann, by Frederick Whyte, 1928.
Memories of Life and Art, by Walter Shaw Sparrow, 1925.
Adventures of a Novelist, by Gertrude Atherton, 1932.
Portraits of a Lifetime, by Jacques-Emile Blanche, 1937.
Life, Work and Setting of Philip Wilson Steer, by D. S. MacColl, 1945.
The Life and Death of Conder, by John Rothenstein, 1938.
The Eighteen-Nineties, by Holbrook Jackson, 1913.
Contemporary Portraits, by Frank Harris, 1915.
Henry Irving, by Laurence Irving, 1951.
The Life of Algernon Charles Swinburne, by Edmund Gosse, C.B., 1917.
Albert Moore, by A. L. Baldry, 1904.
Twenty Years of My Life, by Douglas Sladen, 1915.
Twenty Years of My Life, by Louise Jopling, 1925.
Vale ("Hail and Farewell"), by George Moore, 1914.
Unforgotten Years, by Logan Pearsall Smith, 1938.
The Unexpected Years, by Laurence Housman, 1937.
Ellen Terry's Memoirs, 1933.
Mrs J. Comyns Carr's Reminiscences, edited by Eve Adam, (c. 1926).
Fifty Years of a Londoner's Life, by H. G. Hibbert, 1916.
Recollections of a Savage, by Edwin A. Ward, 1923.
Anglo-American Memories, second series, by George W. Smalley, 1912.
As We Were, by E. F. Benson, 1930.
My Fill of Days, by Sir Peter Chalmers Mitchell, 1937.
Social and Diplomatic Memories, (*1884-93*), by the Right Hon. Sir James Rennell Rodd, G.C.B., 1922.
The Days I Knew, by Lillie Langtry, 1925.
Yesterday: the Autobiography of Robert Hichens, 1947.
Brangwyn's Pilgrimage, by William de Belleroche, 1948.
I Have Been Young, by H. M. Swanwick, 1935.

A Player Under Three Reigns, by Sir Johnston Forbes-Robertson, 1925.

The World, May-June, 1878, 1886–8.
The Studio, 1904–5.
Truth, 23 July, 1903.
The Morning Post, 6 August, 1902.
London and Provincial Press, 26–7 November, 1878.
London and Provincial Press, 18 July, 1903.

INDEX

Alexander, Cicely, 60, 170
Alma-Tadema, Sir Lawrence, 72, 76, 92, 116, 180
Américaine, L', 63
Angelo, Michael, 175
Angelus, L', 20
Armstrong, Thomas, 11, 105
Armstrong, Sir Walter, 178
Arrangement in Black, 65
Arrangement in Black and Brown, 33, 64–5
Arrangement in Grey and Black, 57, 59–60
Arrangement in Grey and Black II, 58–9
Arrangement in Yellow, 123
Ashbee, C. R., 184
Atalanta, 132
At the Piano, 17, 26

Bacher, Otto, 95
Bain, Le (Déjeuner sur L'herbe), 26
Baronet and the Butterfly, The, 164
Barrett, Wilson, 141
Barthe, M., 35
Baudelaire, Pierre Charles, 28
Bayliss, Wyke, 111
Beaconsfield, Lord, 60–2
Beardsley, Aubrey, 158–9
Benham, Captain, 9
Benrimo, 115
Bernhardt, Sarah, 48
Bibby, 32
Blue Wave, The, 23
Boldini, J., 179
Bonnat, Léon Joseph, 172
Bonvin, F. S., 18
Book of Scoundrels, A, 167
Boswell, James, 120
Botticelli, Sandro, 67
Boughton, George, 46
Bowens, Charles S. C., 78
Boxall, Sir William, 57
Bracquemond, Felix, 26, 28
Brangwyn, Sir Frank, 167
Brown, Ernest, 93, 97
Brown, Ford Madox, 35, 67
Brown, Oliver Madox, 35–6
Buller, Sir Redvers Henry, 177
Bunney, R., 96
Burne-Jones, Sir Edward Coley, 31, 67, 72–3, 79, 116, 149–50

Campbell, Lady Colin, 110, 124, 145
Campbell, Lord Archibald, 124
Canaletto, Antonio, 150
Canfield, Richard A., 65
Carlyle, Thomas, 58, 73, 75
Carr, Comyns, 72
Cauldwell, John M., 175
Cézanne, Paul, 158
Chamberlain, Joseph, 177
Chase, William M., 52, 142, 172
Clarke, Sir Edward, 169
Coleridge, Mary, 90
Collins, Wilkie, 26
Colvin, Sidney, 91
Conder, Charles, 178
Corder, Rosa, 33, 64
Corot, Jean Baptiste Camille, 95
Courbet, Gustave, 18, 37
Craig, Gordon, 76
Crane, Walter, 73

Damien, Father, 102
Daughter of Eve, 188
David, Jacques Louis, 18
Davis, Jefferson, 8
Decay of Lying, The, 122
De Chavannes, Puvis, 157, 167
Degas, Hilaire Germain Edgar, 28, 103
De Grey, Lady, 89
Delacroix, Ferdinand Victor Eugène, 18
Delannoy, Ernest, 14–17, 20, 23
Delâtre, 17, 28
Depths of the Sea, The, 116
Derby Day, 84
De Wet, General C. 183
Dickens, Charles, 51, 66, 91
Dowdeswell, Walter, 121
D'Oyly Carte, Mrs Richard, 127
Du Maurier, George, 10, 21–2, 24–6, 29, 71–2, 105, 119, 160
Duveneck, Frank, 94–5

Eden, Lady William, 161–2
Eden, Robert Anthony, 161
Eden, Sir William, 161–4
Effie Deans, 63
"Eloise" (Fumette), 13–14
Etty, William, 159
Evelyn, John, 1

195

Falling Rocket, The, 73–4, 79–80, 82–4, 154
Fantin-Latour, 18, 20, 23, 26, 53, 75
Faust, 45
"Finette", 14
Ford, Sheridan, 135
Fors Clavigera, 74
Franklin, Maud, 63, 93–4, 113, 142, 145–9, 187
Freer, Charles L., 70, 184
Frith, W. P., 79, 84–5, 166
Fur Jacket, The, 63

Garibaldi, Menotti, 13
Gentle Art of Making Enemies, The, 78, 80–2, 85, 114, 135, 141
Gilbert, Alfred, 134
Gilbert, W. S., 71–2, 128
Gilchrist, Connie, 56
Giotto di Bondone, 92
Gleyre, Charles Gabriel, 10, 18
Godwin, E. W., 76–8, 92, 97, 145
Godwin, Mrs Beatrice (née Philip), *see* Whistler, J. A. M. (Mrs)
Gold Girl, The, 56
Gold Scab, The: Eruption in Frilthy Lucre, 70, 90
Goncourt, de Edmond and Jules, 28
Greaves, Mrs, 35
Greaves, Walter and Harry, 33–6, 45, 50, 58, 68
Grossmith, George, 71
Guthrie, Sir James, 189

Haden, Annie, 24
Haden, Deborah (née Whistler), 2, 4, 17, 21, 165
Haden, Seymour, 17, 20–1, 24, 40, 97, 114, 168
Hallé, Charles, 72
Hals, Franz, 150, 186
Hamerton, P. G., 56–7
Harker, Joseph, 180
Harmony in Black and Gold, 152
Harmony in Grey and Gold, 50
Harmony in Grey and Green, 60
Harris, Frank, 133, 168
Harte, Bret, 66
Haweis, H. R., 150–1
Hawkins, General, 144
Haydon, Benjamin Robert, 141
Heffernan, Joanna (Jo), 22–4, 36–7, 63, 114, 146, 187
Heffernan, Patrick, 22
Heinemann, William, 135–6, 166, 168, 175, 177–8, 183, 185
Henley, Bill, 25
Henley, W. E., 142
Hogarth, William, 3–4

Holker, Sir John, 78–83
Holloway, C. E., 168
Horsley, Fred, 106
Housman, Laurence, 163
Howell, Charles Augustus, 30–3, 65, 76, 87, 89, 151
Huddleston, Baron, 78
Hunt, Holman, 73
Huysmans, J. K., 151

Ingres, Jean August Dominique, 18
Ionides, Alec, 21–2
Ionides, Alexander, 21–2
Ionides, Luke, 21–2, 25
Irving, Henry, 45, 63–4, 83

Jeckyll, Tom, 24, 67–9
Jopling-Rowe, Mrs, 119–20, 146
Jopling-Rowe, Mr and Mrs, 146–7

Katherine of Aragon, 64
Kerr, Lord Ralph, 184
Khnopff, Fernard, 141
Kossuth, Louis, 119

Labouchere, Henry, 56, 146–7; Mrs, 146–7
Lalouette, 16
Lamont, T. R., 11, 57
Langtry, Lily, 123
La Touche, Rose, 74
Laver, James, 64, 71, 97
Lavery, John, 148, 158, 169–70, 187; father, 159
Lee, Robert E., 6
Legros, Alphonse, 18, 20, 25–6, 40
Leighton, Sir Frederick, 73, 76, 105, 110, 112, 167
Lewis, Mary, 35–6
Leyland, Frederick, 65–70, 89–90; mother, 66; wife, 70
Liberty, Lazenby, 28
Little White Girl, The, 22, 29, 36
Little Rose of Lyme Regis, The, 165
Lindsay, Sir Coutts, 72, 75
Lippi, Lippo, 67
Loves of the Lobsters, The, an Arrangement in Rats, 90

MacColl, D. S., 103, 177, 188–9
Mackenzie, Sir Morell, 140
MacMonnies, F., 171
Major, Rosa, 22
Mallarmé, Stéphane, 158
Margate Sands, 166
Marks, Murray, 67
Marlborough, Duke of, 154
"Marquis de Marmalade," 38
Marriage Feast at Cana, The, 14

Martini, Signor, 47
Master Smith, The, 165
Manet, Edouard, 26, 103
May, Phil, 120
Maxse, Admiral, 170
McCarthy, Justin, 102
Menpes, Mortimer, 101–4, 112, 170
Meredith, George, 29
Mère Gérard, La, 16, 55
Meux, Lady, 123
Mikado, The, 127
Milky Way, 150
Millais, Sir John Everett, 26, 61, 64, 73, 76, 98
Mirbeau, Octave, 163
Mitchell, Peter Chalmers, 168
Monet, Claude, 110
Montesquiou-Fezensac, Comte Robert de, 151–3
Moore, Albert, 25, 34, 67, 83, 149
Moore, Augustus, 153
Moore, George, 35, 153, 161, 163–4
Morley, John, 133
Morris, William, 71
Morse, Sydney, 32
Mother, The, 124, 134
Mount Ararat, 90
Murger, Henri, 12
Music and Morals, 151
Music Room, The, 24

Napoleon I, 117
Napoleon III, 26
Nathan, Messrs, 119
Nicholas I, Emperor, 4

Old Battersea Bridge, 73, 81, 125
Orchardson, William, 115, 134

Paddon, 32
Paddon Papers, The, or The Owl and the Cabinet, 32
Parnell, Charles Stewart, 102
Parry, Sergeant, 78, 84–5
Peck, Miss Marion, 143
Pellegrini, Carlo, 90
Pennell, Mrs E. R., and J., 100, 159, 168–9, 181–2, 188–9
Pepys, Samuel, 1
Petherham, Mr, 78
Philip, Beatrice, *see* Whistler, Mrs Beatrice
Philip, John Birnie, 77
Philip, Mrs John Birnie, 157, 182, 184–5, 187
Philip, Rosalind Birnie, 166, 182, 184–5, 187–9
Philip II, 64
Phillips, Stephen, 181
Pigott, Richard, 102

Plowden, H. G., 124
Poe, Edgar Allan, 117
Poems and Ballads, 29, 132
Potter, Mrs Brown ,170
Poynter, Edward, 11, 34, 73, 76, 101, 105, 116
Princesse du Pays de la Porcelaine, La, 36, 66–7
Pryde, James, 88, 138

Queen Mary, 63
Quilter, Harry, 90–2, 121

Railway Station, 84
Raleigh, Professor Walter, 189
Rape of the Lock, The, 159
Raphael, 10
Rebours, A, 151
Redesdale, Lord, 31, 68
Rembrandt, 27, 150
Richmond, Sir William Blake, 72
Robinson, Sir William, 178
Ricketts, Charles, 163
Rivière, Briton, 92
Robertson, Graham, 48, 65, 148–9
Rodin, Auguste, 157, 184–5
Ross, Robert, 44, 140, 176
Rossetti, Dante Gabriel, 28–33, 37, 66–7, 82
Rossetti, William Michael, 82–3
Rossi, Carmen, 171–2
Rothenstein, William, 163, 180
Rothschild, Baron, 11
Rowley, Joseph, 11
Ruskin, John, 30–2, 73–6, 78–80, 82, 85–6, 94, 98, 123, 131–2, 135, 142, 150, 154

Sarasate, Pablo de, 65
Sargent, John Singer, 158–9
Sauter, Professor George, 186–7
Scharfe, Sir George, 59
Seton, Dorothy, 187
Shakespeare, William, 117, 158
Shannon, C. H., 163
Shannon, J. J., 116
Shaw, Bernard, 64, 86, 109, 158
Shaw, Norman, 46, 67
Sherard, Robert Harborough, 176
Sickert, Nellie, 103–4
Sickert, Walter, 39, 48, 55, 101–5, 112, 123–4, 163, 168–70, 176
Simpson, Joseph, 60
Snowstorm, The, 84
Spartali, Christine, 36
Spielmann, 114, 130
Steer, Philip Wilson, 19
Stone, Marcus, 92
Stott, William and family, 146, 148

Sullivan, Arthur, 128
Swinburne, Algernon Charles, 28–30, 55,
131–3, 135
*Symphony in White, No. III, or The Two
Little White Girls*, 56

Talleyrand, Charles Maurice de, 117
Taylor, Tom, 85–6, 90
Teck, Duke of, 97
Tennyson, Alfred Lord, 87
Ten o'Clock, The, 120, 130–1, 158
Terry, Ellen, 48, 76
Thackeray, William Makepeace, 26, 66, 91
Tissot, James Joseph Jacques, 28
Thomas, Sergeant, 23–4
Tintoretto, 11, 150
Traghetto, The, 95
Tree, Herbert Beerbohm, 180–1
Trilby, 10, 160
Turner, Joseph Mallord William, 24, 33, 84–5, 167
Twain, Mark, 179
Two Little White Girls, or Symphony in White No. III, 56

Vanity Fair, 87, 90
Veronese, Paolo, 14
Velasquez, 18, 52, 85, 150
Victoria, Queen, 108
Vie de Bohême, La, 12

Wales, Prince of, 47, 99, 107
Wales, Princess of, 99, 107
Watts, George Frederick, 58, 67, 73
Watts, Theodore (later Watts-Dunton), 131
Way, Thomas, 89
Wedmore, Frederick, 98, 114, 188
Whibley, Charles, 166–7
Whibley, Mrs Ethel (née Philip), 166, 189–190
Whistler v Ruskin: Art and Art Critics, 87
Whistler, Anna Mathilda (née McNeill), 2–6, 8, 25–6, 29, 34, 57, 113
Whistler, Mrs Beatrice (née Philip, formerly Mrs Godwin), 77, 145–9, 153, 156–7, 160, 165–8
Whistler, George, 3, 7

Whistler, George Washington, 2–5
Whistler, James Abbott McNeill: antecedents, 1, 2; childhood, 2–6; Russia, 3–4; England, 3; Connecticut, 5; school, 5–6; West Point, 6–7; with the U.S. Coast and Geodetic Survey, 8–9; studies in Paris, 10–19; London and the Thames, 20 *et seq.*; arrival of mother, 25–6; Brittany, Paris again, Spain, 23; etching, 28; Japanese art, 28, 45; Chile, 37–8; Paris, 40; expelled from Burlington Fine Arts Club, 40; clothes, 41–3, 139; host and cook, 46–7; engagement, 66; the Peacock Room, 67–70; the Ruskin Case, 75–92; *The Gentle Art*, 78, 80–2, 85, 114, 135, 141; the White House, 87–90; bankrupt, 89–90; Venice, 92–6; the Fine Art Society, 93–9, 165; devotees, 33–6, 99–112, 146; the Society of British Artists, 105–12; death of mother, 113; critics and the Royal Academy, 114–25; orator, 126–36; Brussels, 141–142; Holland, 142; Universal Exhibition, Paris, 143–4; marriage, 147; success, the Goupil Gallery, 154; *Trilby*, 160; the Eden case 161–3; the Society of Illustrators, 168, court witness, 168–9; the International Society of Sculptors, Painters and Gravers, 169–70; the Académie Carmen, 171–3; ill health, 174, 176, 183, 187 *et seq.*; spiritualism, 174; the South African War, 176–7; stage design, 180–181; Dublin, Holland, 182, 185–6; legal, 182; Paris and London, 183–4; Cheyne Walk, 184, 187; death, 190
Whistler, John, 22, 63, 90, 113
Whistler, Willie, 3, 7, 37, 113, 165, 181
White Girl, The, 22, 26, 33
Wilde, Oscar, 47–8, 103, 118–23, 158, 176
Wilhelm II, Kaiser, 184
Wills, William Gorman, 83
Woman in White, The, 26
Worth, Charles Frederick, 109
Wren, Christopher, 175

Yates, Edmund, 91
Yellow Buskin, The, 124, 143

Zola, Emil, 28